ANSELM KIEFER AND
ART AFTER AUSCHWITZ

Anselm Kiefer and Art After Auschwitz examines the possibilities and limits of painting in the aftermath of the Holocaust. Positioning Kiefer as a deeply learned artist who encounters and represents history in painted rather than written form, Lisa Saltzman contends that Kiefer's work is unique among postwar German artists in his persistent exploration of the legacy of fascism. Formally, thematically, and philosophically, Kiefer's work probes the aesthetic and ethical dilemma of representing the unrepresentable, the historical catastrophe into whose aftermath the artist was born. Kiefer's work mediates the relation between a deeply traumatic history that he, as a German born after the Second World War, and we, his post-Holocaust spectators, cannot fully know but to which his work bears witness and provides access.

Lisa Saltzman is Assistant Professor of art history at Bryn Mawr College.

CAMBRIDGE STUDIES IN NEW ART HISTORY AND CRITICISM

General Editor
Norman Bryson, *Harvard University*

Advisory Board

Stephen Bann, *University of Kent*
Natalie Boymel Kampen, *Barnard College*
Keith Moxey, *Barnard College*
Joseph Rykwert, *University of Pennsylvania*
Henri Zerner, *Harvard University*

This series provides a forum for studies that represent new approaches to the study of the visual arts. The works cover a range of subjects, including artists, genres, periods, themes, styles, and movements. They are distinguished by their methods of inquiry, whether interdisciplinary or related to developments in literary theory, anthropology, or social history.

ANSELM KIEFER AND ART AFTER AUSCHWITZ

LISA SALTZMAN

CAMBRIDGE
UNIVERSITY PRESS

PUBLISHED BY THE PRESS SYNDICATE OF THE UNIVERSITY OF CAMBRIDGE
The Pitt Building, Trumpington Street, Cambridge CB2 1RP, United Kingdom

CAMBRIDGE UNIVERSITY PRESS
The Edinburgh Building, Cambridge CB2 2RU, UK http://www.cup.cam.ac.uk
40 West 20th Street, New York, NY 10011-4211, USA http://www.cup.org
10 Stamford Road, Oakleigh, Melbourne 3166, Australia

© Lisa Saltzman 1999

The poems "Deathfugue" and "Tübingen, January," as translated in John Felstiner,
Paul Celan, Poet, Survivor, Jew (1995), reprinted by permission of Yale University Press.

First published 1999

Printed in the United States of America

Typeset in 10/14 Bauer Bodoni and Futura in QuarkXPress [GH]

*A catalog record for this book is available from
the British Library.*

Library of Congress Cataloging-in-Publication Data
Saltzman, Lisa.
Anselm Kiefer and art after Auschwitz / Lisa Saltzman.
p. cm. – (Cambridge studies in new art history and criticism)
ISBN 0-521-63033-9 (hb)
1. Kiefer, Anselm. 1945– – Psychology. 2. Kiefer, Anselm, 1945–
– Criticism and interpretation. I. Kiefer, Anselm, 1945– .
II. Title. III. Series.
N6888.K43S26 1999
709′ .2 – dc21 98-34706
CIP
Publication of this book has been aided by a grant from the
Millard Meiss Publication Fund of the College Art Association. MM

ISBN 0-521-63033-9 hardback

CONTENTS

LIST OF ILLUSTRATIONS

ACKNOWLEDGMENTS

This book is based on my doctoral dissertation, and I would like to thank faculty members, past and present, in the Department of Fine Arts at Harvard University: to my advisers, Norman Bryson and Yve-Alain Bois; former professors and continued supporters of my work, Anna Chave and John Czaplicka; and a figure of continuity and inspiration, Irene Winter. The origins of *Anselm Kiefer and Art After Auschwitz* may be found in work I began as an undergraduate at Princeton University with Dorothea Dietrich, to whom my study of both art history and postwar German culture owes a great deal.

In seeing this project into its present form, I am deeply indebted to the continued support of Norman Bryson. I am grateful to my colleagues and graduate students at Bryn Mawr College, who offered productive suggestions and sound advice as I worked to transform the manuscript into this book.

Earlier versions of Chapters 1 and 2 were presented at conferences and appeared in resulting anthologies. An earlier version of Chapter 1 was presented at the College Art Association annual conference in Boston in February 1996 and appeared in Catherine Soussloff, ed., *Jewish Identity in Art History: Ethnicity and Discourse* (Berkeley: University of California Press, 1998). An earlier version of Chapter 2 was presented at Georgetown University in April 1995 and appeared in Peter C. Pfeiffer and Laura Garcia-Moreno, eds., *Text & Nation: Crossdisciplinary Essays on National and Cultural Identities* (Columbia, SC: Camden House, 1996). I am grateful to the respective editors for those opportunities. I am additionally grateful to audiences at

Harvard, Yale, Bryn Mawr, Emory, Washington University St. Louis, University of Delaware, University of Virginia, University of Pennsylvania, and Reed College.

This project is indebted as well to financial sources of support that made possible its research, writing, and illustration. For that generosity, I offer thanks to the Department of Fine Arts at Harvard, the Deutscher Akademischer Austauschdienst (DAAD), the Mellon Foundation, Bryn Mawr College, the Lucius Littauer Foundation, and the College Art Association Millard Meiss Award. And I am deeply appreciative of the help I received from the Marian Goodman Gallery in New York, with special thanks to her archivist, Catherine Belloy. I thank Françoise Bartlett for her respectful yet careful copyediting and Christina Viera for the handsome page layouts.

In the end, perhaps most important to the realization of this book has been the continued support of my family and friends.

Despite the inadequacy of any such gesture, it is to the memory of one friend, Rosanna Webster Graham (December 13, 1965–July 27, 1993), that I dedicate this book.

Bryn Mawr, Pennsylvania L. S.
October 1998

ANSELM KIEFER AND
ART AFTER AUSCHWITZ

INTRODUCTION

Comment être encore un Allemand?

– Marguerite Duras

In 1969, at the age of twenty-four, a young German law student named Anselm Kiefer dressed himself in Nazi regalia and gave the Heil Hitler salute. Captured photographically, in locations both public and private, his was a patently defiant act. It was an act in which the law, both literally and metaphorically, gave way to the extroverted operations of masquerade. Yet, although that double turning from the law might be read as but one more iconoclastic cultural or political gesture in the heady days of student revolt and rebellion, circa 1968, I would suggest that more profoundly it marked not simply the beginning of an artistic career but the beginning of an artistic career that would be defined by the repetitive negotiations of a historically compromised national identity. For Kiefer's work, from its performance-based experimentation with the transgressive practices of the historical avant-garde to its aesthetic and thematic invocation of German romanticism to its enactments of the recapitulations and eclecticism of postmodern culture, is linked, if not unified, by a singular and defining preoccupation with the historically determined self, as it is inscribed and negotiated in cultural practice.

Yet, as much as Kiefer's work is driven by the repeated explorations of a specifically German identity, by the ontological question of what it means to live as a German in postwar, post-Holocaust Germany, it is

1

also, and perhaps necessarily, animated by a concomitant aesthetic exploration of artistic identity, by the question of what it means to create, to create aesthetically, culturally, in the aftermath of fascism and genocide. That is, in Kiefer's work, the act of aesthetic creation, the possibility of creation, is never allowed the autonomy, the pure self-reflexivity, granted to the category of aesthetic production in either modernist practice or theory. Rather, in Kiefer's work the very act of creating, and the very fact of being an artist, is always bound up with, or founded in, its place in the present, a present shaped by the legacy of historical trauma. Thus, whether plumbing the depths of Babylonian myths of origin or exploring the aesthetic lessons of kabbalistic theories of creation, Kiefer's work, or so I will contend, is always marked by its place in and relation to history, and with that, historical trauma.

If Kiefer's work could thus be said to represent history, albeit at times obliquely and certainly not in the form of the conventional, or traditional history painting, it does so only with the foregrounded acknowledgment that such an endeavor is fundamentally compromised, if not impossible. As I will come to argue more fully in the ensuing chapters, as I explore the aesthetic, ontological, psychological, historical, and anamnetic function of his art, Kiefer's work mediates the relation between a history (a deeply traumatic history) that he (as artist, as second-generation German) and we (as post-Holocaust spectators) cannot fully know but to which it nonetheless bears witness and provides access.

Laden with the burdens of historical belatedness, Kiefer's work positions itself in that liminal space between impossibility and possibility, deferral and realization, repression and acknowledgment. It is work that, as I will contend in Chapter 1, demands to be considered in relation to Adorno's much qualified, regretted, and misunderstood utterance, "After Auschwitz, to write poetry is barbaric."[1] That is, formally and philosophically, Kiefer's work probes, thematizes, and instantiates the aesthetic and ethical dilemma that both frames and drives its very being as post-Holocaust art: how to represent the unrepresentable. For as much as Kiefer's pictorial thematization and instantiation of the unrepresentable may be seen as upholding the

underlying task of Romanticism, bearing pictorial witness to the unrepresentable, the inexpressible, the sublime; and, as much as his artistic practice may be seen as recapitulating the broadly delineated project of pictorial modernism in its deep ambivalence toward and mistrust of representation, his work necessarily differentiates itself from these instances of historical modernism in the particularity and specificity of its historical moment and referent. Thus, Kiefer's is work that derives its very being from its historical position, its position after 1945, after Auschwitz.[2]

More specifically, and perhaps, more important, in the context of post-Holocaust Germany, Kiefer's is work that takes as its recurrent subject Germany's now absent other, the Jew. I will argue that whereas Adorno's postwar proscription derives its ethical and aesthetic force from an iconoclasm that is at its essence deeply Hebraic, Kiefer's involvement with things Jewish transcends the theoretical implications of what could be termed a hebraic ethics of both representation and spectatorship. That is, beyond the representational and spectatorial questions Kiefer's works at once instantiate and engender, they, more than that of any artist working in postwar Germany, take up Jewish subjects with a determined if not troubling persistence.

That representation both occurs in the aftermath of, and finds its subject in, historical trauma, that Kiefer's visual representations are steeped in belatedness, suggests that as much as his art may function as a concretized visualization and instantiation of philosophical and ethical concerns, it also functions as a visual trace, or record, of psychological processes. In effect, his art becomes a visually concretized symptom. In other words, Kiefer's imaging of the German self against a historically determined backdrop, be it the scorched earth of Nazi military campaigns in the East or the architectural edifices of Albert Speer and Wilhelm Kreis, suggests that the very identity of the German subject negotiated in his canvases is founded in the historical trauma which that subject survives and inherits, if only by virtue of the belatedness of his birth. More specifically, insofar as artistic identity for Kiefer is an identity staged in and against the paternally indexed legacy of both cultural and political history, and insofar as that identity is thematized as fundamentally compromised by that very legacy, I will

explore the ways in which the thematic operations of Kiefer's work are at once deeply oedipal, and, in turn, deeply melancholic.

Departing from the concatenation of philosophy, ethics, critical theory, and poststructuralism that shapes my discussion in Chapter 1, Chapter 2 will engage psychoanalytic and post-Freudian psychoanalytic discourse as a means of situating and interpreting the intensely filial thematics of Kiefer's work. The chapter will also introduce history, both social and cultural, more manifestly than Chapter 1 as I move toward embedding Kiefer's work less in the broader context of postwar culture and thought than in the specificity of its postwar German context. That history and psychoanalysis come together in this chapter, that history can be seen to produce psychological symptoms, in this case concretized in the form of painting, as visualized and thematized wound, suggests a certain convergence of the social, historical, psychological, and cultural, providing an emphatic expression of Fredric Jameson's assertion that "history is what hurts."[3] For in Kiefer's painting, history, and its deferred or belated aesthetic confrontation and articulation, are indeed shown to be deeply painful social and cultural processes.[4]

The psychoanalytic framework so central to my discussion in Chapter 2 will in some sense become the subject of my discussion in Chapter 3 as I interrogate the implications and limitations of a psychoanalytically informed language of mourning and melancholia to describe, or diagnose, cultural production in postwar Germany and beyond. For if, as the Mitscherlichs's 1967 study *The Inability to Mourn* contends,[5] German society of the 1950s was psychically and, in turn, culturally paralyzed by its melancholic inability to confront and mourn the losses of the Second World War, on their account specifically the loss of Hitler as an ego ideal, then Kiefer's aesthetic negotiations of that past would seem to constitute aesthetic acts of mourning. And yet, as much as Kiefer's work is or can be construed as aesthetic *Trauerarbeit* ("work of mourning"), in its very being as cultural work and in its engagement with German history, myth, and identity, his work is nevertheless fundamentally melancholic in its thematics, mood, and allegorical operations.

Finally, if ontological questions, be they philosophical or psycho-

logical, can be seen to drive art practice in the postwar era, I will argue in my final chapter that they also can be seen to shape art criticism. For the deeply conflicted reception of Kiefer's work in Germany suggests an analogous, if not identical, struggle to painting's own in the postwar negotiation of cultural identity. What Kiefer represents as an artist, at once thematically, in his work, and, by extension, in his very role as representative contemporary German artist in an international art market, is an enduring subject of critical contemplation, anxiety, and reflection. For it is German criticism, perhaps even more acutely than Kiefer's painting, that seems fundamentally burdened in its writing by the specter of Nazism and the concomitant legacy of historical trauma.

Taken together, the individual chapters on Kiefer's work and its reception should paint a portrait of contemporary art practice that is at once historically specific and theoretically broad. Although the manifest goal of my study is to situate Kiefer's work quite firmly within the cultural and social history of postwar Germany and, more specifically, to explore the implications of Kiefer's aesthetic negotiations of the postwar German self in the aftermath of historical trauma, the underlying goal of my project is to raise and answer questions about the role and fate of aesthetic representation as a practical, theoretical, and ethical category in an era whose temporality is conceived as coming after – after the Second World War, after Auschwitz, and, in the end, after modernism. For the belatedness of Kiefer's work in relation to its historical subject may ultimately be the belatedness of our own radically contingent identities as we navigate our way through the cultural condition we know as the postmodern.

❖ ❖ ❖ ❖ ❖

Before proceeding further, I should make manifest that although perhaps seemingly monographic, my account of Kiefer's work in the context of postwar Germany, and postwar thought and aesthetic practice more generally, is by no means strictly or traditionally so. For one, it is not my intention to discuss or account for every work Kiefer produced. Nor is it my intention to treat his work in a strictly linear,

chronological progression. Nor is it my intention to see Kiefer's work in isolation. Rather, I have sought to isolate and analyze certain patterns, be they recurring thematic preoccupations or aesthetic strategies, and to situate those recurrent structures in relation to their historical, cultural, and theoretical contexts.

I should add that I will not interpret Kiefer's work in relation to the private aspects of his life or family history. I could justify that methodological decision, or interpretive position, as being consistent, in broad terms, with poststructuralist indictments of Western metaphysics, and, more specifically, with Barthes, Foucault, and others in their aftermath who called into question not just the self-identity of the subject but the belief and investment in the artist as authorial presence.[6] But more fundamentally, that the self – the postwar, German, male artistic self – is repeatedly inscribed in Kiefer's work and that I take that self as subject is wholly different from exploring Kiefer as the unique individual behind those artistic inscriptions.

Unlike many artists who have made their private lives a public spectacle, or, like Kiefer's teacher Joseph Beuys, who have created a mythic and absolutely central public persona, Kiefer's reticence and general reclusiveness have provided his audiences with only the barest personal and biographical information, though admittedly that artistic persona is the material of myth. Kiefer's only work that expressly foregrounded his unique biography was a schematic, chartlike project, more an episodic time line than an aesthetic endeavor, *Autobiography*, of 1976, which, perhaps more than any of his other works, is deeply indebted to and reflective of Beuys's own, namely, Beuys's *Life-Course/Work-Course* of 1964. Save this one artistic assertion of the autobiographical self, or the extant quotations or passages from the isolated interview or round-table discussion, the self that I take to be Kiefer is the mediated self, the postwar German artist whose thematized existence lives only in and through his work.

That Kiefer was born to non-Jewish German parents in western Germany in 1945, a year that sets his birth and evolution alongside that of postwar Germany, is the only biographical fact I consider truly necessary for my study. For it is precisely the degree to which Kiefer's aesthetic negotiations of the self echo and amplify the cultural and

political negotiations of identity that have so marked postwar Germany, particularly since 1968, that makes his work such a valuable subject. For all its uniqueness, Kiefer's work is at the same time fundamentally symptomatic, if not emblematic, of the postwar generation of Germans, the *Nachgeborenen*, those born after.

I should also explain what will surely be noted as the seeming methodological eclecticism of my approach to Kiefer and his work. Many a reader might ask how I reconcile a methodology that would seem to move between the positivist hermeneutics of historical materialism, or social art history, and the hermeneutics of doubt and skepticism unleashed by poststructuralism. First, I would argue that if poststructuralism teaches us that myth and history are but one pair of deeply troubled terms whose opposition masks their shared origins in discursive systems, that is not to say that there is no historical reality. Rather, poststructuralism constitutes a theoretical acknowledgment of the ways in which history, from the very moment of its transformation from an experienced present to a recounted and represented past, gives itself over to the operations of language. We know history only through its representations, be those representations written texts or visual images.

Second, and more important to the formulation of my project, I would assert that poststructuralism itself is deeply historical, or, more accurately, a deeply historical phenomenon. For I would contend that it is history itself, specifically the history of catastrophe and genocide, that has darkened the twentieth century, that has given shape to the ontological and epistemological doubt articulated so acutely within poststructuralism. Thus, for all of the ways in which we may find traces of poststructuralist thought in earlier historical epochs, see the seeds of deconstruction in earlier philosophical or critical writing, in, for example, the writings of Nietzsche and Heidegger, I would contend that it is only in the aftermath of 1945 that poststructuralism as a critical practice and philosophical position emerges fully formed and fully meaningful.

Further, I would suggest that the methodological variety that indeed characterizes this project, one that moves from the historical underpinnings of social art history to the theoretical and interpretive

possibilities of psychoanalysis, poststructuralism, and feminism, takes shape not only in a moment defined by the very decline of master narratives, of *grands récits*, but specifically in response to Kiefer's historically circumscribed project. That is, it is only fitting to turn to psychoanalysis as an interpretive framework when Kiefer's work insistently inscribes its project within a discourse of mourning and melancholia. Similarly, it is only logical to turn to poststructuralism as a theoretical framework when Kiefer's work insistently problematizes the possibilities of reference and representation. And finally, it is necessary to turn to feminism, to the study of gender, when Kiefer's work involves not simply the exploration of postwar German identity but the specific and particular articulation of a masculine identity.

Most fundamentally, my project is one that insists upon the relation between history, in this case a deeply traumatic history, and cultural practice. Notably, despite the centrality of history and its legacy to Kiefer's work, its historical embeddedness has not been the dominant rubric through which his work has been interpreted. To date, the only work that has to my mind adequately situated Kiefer's work within the exigencies of its historical context is that of Andreas Huyssen, whose two articles "Anselm Kiefer: The Terror of History, the Temptation of Myth" and, more recently, "Kiefer in Berlin," served as a confirmation of what I took to be the fundamental historical, if not aesthetic, significance of Kiefer's work.[7] And it will be Benjamin Buchloh's forthcoming monograph on Gerhard Richter, as is augured in his article "Divided Memory and Post-Traditional Identity: Gerhard Richter's Work of Mourning," that will further the task of properly situating postwar German painting within its sociohistorical matrix.[8]

In part, the defining historical dimensions of Kiefer's work have been eclipsed by the general critical preoccupation with the "return to figuration" that his work, and that of the so-called neo-expressionists, were seen to augur and then embody. Although much of Kiefer's work defies categorization as figurative and is not uniquely, if at all, expressionistic in its perceived stylistic affinities or indebtedness, his work was nevertheless included in a critical rubric that united a diverse and diffuse group of German painters, painters who were all

seen to have moved painting away from the dominant idiom of post-war abstraction.[9]

Those painters with whom Kiefer was variously associated included Georg Baselitz, Jörg Immendorff, Markus Lüpertz, A. R. Penck, and the Berlin students of K. H. Hödicke, who earned the particular appellation *neue Wilden*, namely, Luciano Castelli, Rainer Fetting, Helmut Middendorff, Salomé, and Bernd Zimmer.

The differences among even these painters are marked and varied. Baselitz, the eldest of the group, first studied painting in East Berlin, coming to the West in 1957. Despite, or perhaps precisely because of his training in both socialist realism and then postwar abstraction, Baselitz came to create what could be termed the most patently expressionistic figurative canvases. Although by 1969 he came to undermine the expressly figurative, or representational, aspect of his work, first by fracturing the image and then by inverting the image, his paintings remained consistently expressionistic in their visual vocabulary.

Jörg Immendorff, despite his studies in Düsseldorf in 1963–4, first produced paintings, indebted to socialist realism, and then happen-ings, indebted both to Fluxus and the politically engaged prewar avant-garde. Beginning in 1978, after an encounter with Penck in the East, Immendorff painted what would become his signature images recording the political pressures, legacies, and realities of artistic and countercultural identity in a divided Berlin.

Markus Lüpertz, who trained both in Krefeld and Düsseldorf, moved to Berlin where he founded, along with Hödicke, Bernd Kober-ling, and Lambert Wintersberger, the gallery Großgörschen 35. There, Lüpertz created intensely figurative and often highly symbolic forms, which nevertheless rigorously avoided representing the actual human figure.

A. R. Penck, who knew Baselitz in the East during the 1950s and continued to visit him in Berlin until the eve of the building of the Berlin Wall, worked in the East until 1980. There, he refined a pictor-ial style and language in which he relied almost exclusively on a highly schematic and reductive language of pictograms.

And finally, the *neue Wilden*, painters who constitute what is in

effect a second generation of neo-expressionist painters, gathered, worked, and exhibited in the Galerie am Moritzplatz in Kreuzberg, producing images of the contemporary urban subject of West Berlin, its streets, its bars and clubs, and its denizens, in a visual language most emphatically indebted to German expressionism of *die Brücke*.

Kiefer, whose practice is as indebted to the work of Jackson Pollock and Lawrence Weiner as it is to German romanticism, has perhaps the most minimal of stylistic or conceptual affinity to expressionism, and with that, neo-expressionism. Thus, rather than continue the critical and art-historical practice of linking his work solely with that of the neo-expressionists, it would seem more apt, and more telling, to connect his work as well with a different constellation of artists, his roughly contemporaneous compatriots Gerhard Richter, Sigmar Polke, Blinky Palermo, Hanne Darboven, Jochen and Esther Gerz, Wolf Vostell, and Hans Haacke, even if Kiefer demonstrates a very different relation to the aesthetic preoccupations of that putative neo-avant-garde. For I would contend that despite their aesthetic dissimilarities, these artists demonstrate a shared preoccupation, albeit to varying degrees, with the legacy of fascism.

More broadly, I would contend that Kiefer should not only be seen alongside the aforementioned artistic compatriots but alongside such writers as Günter Grass, Heinrich Böll, Heiner Müller, and Christa Wolf (albeit Müller and Wolf wrote in the East) and such filmmakers of the New German Cinema as Rainer Werner Fassbinder, Alexander Kluge, Hans-Jürgen Syberberg, Helma Sanders-Brahms, Volker Schlöndorff, Margarethe von Trotta, and Wim Wenders. For Kiefer's work, like theirs, takes part in the cultural negotiation of memory and identity in the aftermath of fascism.

Despite such evident points of congruence and affinity, Kiefer, and the artists with whom I have associated him, rarely are interpreted against the legacy of fascism that so shapes and defines their work. In making such claims for Kiefer's work, I may in the end ally myself less with art historians than with film historians working on the same period. Let me explain that statement by referring to film history, if only briefly and schematically.

From the work of Siegfried Kracauer to Anton Kaes, German film

theorists and historians have posited film as the twentieth-century medium in which history saw its most vivid articulation and reflection. From the historically prescient films discussed in Kracauer's *From Caligari to Hitler*[10] to the "return of history *as* film" treated in Kaes's *From Hitler to Heimat*,[11] the history of German cinema has been constructed to read as a history of the German nation. More specifically, in Kracauer's later *Theory of Film*, the film screen has been posited as a technological descendant of "Athena's polished shield,"[12] upon whose ephemeral surface the traumatic history of the twentieth century can be screened, if only to be viewed indirectly. And in Kaes's study, among others, postwar German film is treated as one of the most important arenas for a cultural confrontation with history and its legacy.[13]

That art might be the site for historical inscription and possess certain anamnetic functions was a possibility denied to it, or at least its interpretation, within a critical paradigm of rigorous Greenbergianism and an aesthetic paradigm of abstraction. That is, twentieth-century painting has seldom been seen as the site for historical inscription. Picasso may have painted *Guernica*, but more important, he pushed painting one step closer to understanding its unique role in the self-reflexive exploration of its formal possibilities and limits.[14] More pointedly and specifically, if aspects of prewar German visual culture manifested signs of its political and historical rootedness, in work ranging from the expressionistic cityscapes of the *Brücke* artists to the insistently referential collages and montages of the Berlin Dadaists, demonstrating its resistance rather than adherence to the teleological tenets of modernism, German painting in the immediate postwar era, particularly in the 1950s, almost universally conformed to the rigors and strictures of an autonomous and hermetic language of prewar and then postwar abstraction, from New York School painting to French *tachisme* and *informel*.

Of course, a more exacting and particular analysis of the postwar period reveals the persistent presence of a figurative tradition in Germany after the war,[15] as well as a more various and politically embedded practice of abstraction.[16] Nevertheless, in the homogenization of ideology and culture that took place in the aftermath of Nazism,

abstraction was effectively established in the Federal Republic as the official style of restored modernism.[17] A passage from a speech by Günter Grass, delivered at the Academy of Art in Berlin in May 1985, marking the fortieth anniversary of Nazi Germany's capitulation to the Allies, evokes in its vivid reminiscences the conditions of artistic production in Germany during the 1950s. As Grass recalled, and I cite his remarks at length for their descriptive value and critical acumen:

When I moved to Berlin as a young sculptor in January 1953, the arts were in some danger of drifting into vapidity. . . . In visual art Modernism was very much to the fore, but only on the condition that it presented itself in an abstract form. All that unpleasantness was safely behind us, and the less that was seen of it the better. Ciphers, yes. Ornaments, by all means. Materials and structures galore. Pure form. Just nothing too explicit, that was all: nothing that might hurt. There was no Dix, no Kirchner, no Beckmann, to force the remembered horror back into the picture.

The controversy in the early 1950s between the "objective" painter Carl Hofer and the apologist of the "nonobjective," Will Grohmann, extended into the ranks of the Künstlerbund. This was no ordinary dispute. It was about the perception or non-perception of reality, as seen in a country that was defeated and divided, that had genocide on its conscience, and that, in spite or because of this, was busily engaged in repressing – or as I say, making non-objective – all that might evoke the past and act as a drag on its headlong retreat into the future.

There came into being a strange, composite avant-garde: the avant-garde of streamlined technical progress, dedicated to economic growth, and the avant-garde of the large-format, reality-masking canvases. Very soon, the walls of executive suites all over the country – everywhere that a Beckmann triptych might have broken the bank – were hung with pompously titled specimens of vapidity, perfectly adapted to the architecture and the *Zeitgeist* of reconstruction.

Meanwhile, over in the German Democratic Republic, there was a "Socialist Realism" that depicted anything but reality. And so, in spite of antithetical labels, an all-German consensus was taking shape: the non-objective carried all before it. On both sides of the border, anyone who rubbed himself up against reality was ruled out of court. It was Will Grohmann, not Carl Hofer, who had the last word. It may seem curious today, but then it was a fact of life: in internal politics the power structures of a sovereign state were being re-established, and at the same time, for external consumption, an uncritical

avant-garde, all of whose conflicts were formal ones, was presented as evidence of the new Germany's modernity and openness to the world.[18]

If, as Grass quite polemically suggests, the presumed mute surfaces of abstraction were the perfect screen on which to project the new beginnings of the Federal Republic, the blank slate with which the Federal Republic could visually symbolize the *Stunde Null*, the "zero hour," the new beginnings of the *Wiederaufbauung*, the "rebuilding," a cultural present devoid of a past, then the emergence of such artists as Beuys and, later, Richter, Kiefer, and others marked a radical departure from both the aesthetics and ideology of postwar abstraction.[19]

Signaled, if not immediately experienced or received, with Beuys's 1955 competition entry for an Auschwitz memorial, German artists began to break with the visual silence of abstraction and aesthetically confront the legacy of the Nazi past.[20] Beuys's submission to the competition was a vitrine (Fig. 1) composed of rows of sausage-shaped matter, sketches of emaciated female figures, blocks of tallow, electrodes and wires, maps of the railroad tracks leading to the death camp, and chimneylike cylindrical forms. Were Beuys's vitrine to be juxtaposed with any one of the canvases of the ZEN49 artists from the same period, the referentiality of Beuys's work would only seem all the more emphatic. Significantly, many of the forms and materials Beuys employed – the tallow/fat, the electrodes and wires – would recur in his performances and vitrines throughout the 1960s and 1970s. That these objects can now be seen to signify Beuys's own personal mythology, a deeply ahistorical mythology of the death and rebirth of a German Luftwaffe pilot at the hands of the Tartars,[21] as much as they do the death camps, renders them an ethically, if not aesthetically, compromised point of origin for an emerging generation of postwar artists who would begin their own negotiations of artistic identity in and against the past and its legacy in the present. But if Beuys's project sought to turn his own life into fiction, or myth, if Beuys sought to universalize Auschwitz, to suggest that "the human condition is Auschwitz,"[22] if Beuys's later projects continued to put forth the notion that the wound or trauma was universal and not historically or nationally specific, as, for example, in the annotated autobiography

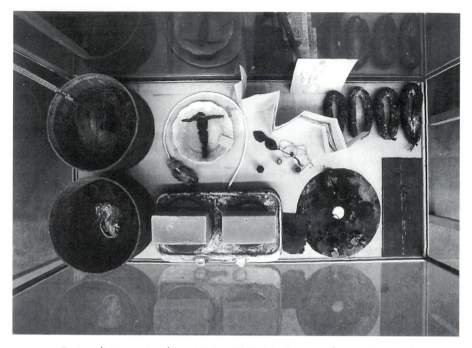

1. Joseph Beuys, *Auschwitz Vitrine*, 1956–64. Courtesy of Hessisches Landesmuseum Darmstadt. Photo: Günter Schott.

Life-Course/Work Course of 1964, or in his performative invocation of trauma and healing *Coyote*, of 1974, or the mortuary relics of *Show Your Wound*, of 1976, if Beuys resurrected the obsolete conception of the artist as savior and the artwork as auratic, all of which, as I have just said, render his work deeply problematic, I nevertheless begin with Beuys insofar as it was Beuys who helped to reintroduce the possibility for a referential, anamnetic, psychological, and political art practice in postwar Germany.

At the same time, I should point out that Beuys functions as a point of introduction rather than occupying a more central position in my study for one very simple reason. His age and, moreover, his wartime experiences not only place him generationally at one remove from Kiefer, a generational gap underscored by the fact that he was Kiefer's teacher, but perhaps even more important, his age and wartime experiences place him at one less remove from the historical trauma to which each turns in his respective aesthetic project. That is, the

belated aesthetic confrontation with traumatic national history, begun by Beuys in 1955, is essentially a belated experiencing of his own traumatic history, whereas for Kiefer and his generation of artists, authors, and filmmakers, that history can be confronted, but never reclaimed, as a primary experience. In other words, for all of the manifestations of historical reference and confrontation in Beuys's work, he remains, by virtue of his birth in 1921, a de facto member of the parental generation against whom Kiefer and his generation sought so fervently to define themselves.

It is that act of self-definition that is so central to Kiefer and his generation. It was the expressed belief and defining principle of the 68-era student rebels and their culturally engaged compatriots that postwar Germany needed to confront and acknowledge its repressed past, a past that had been shrouded in silence during their childhoods in the 1950s. For if Germany was suffering from a collective willed repression of the past, what Margarete and Alexander Mitscherlich diagnosed as an "inability to mourn," then it was in part the self-appointed task of the student generation to rouse society from this prolonged melancholic state of historical amnesia.[23]

As George Steiner wrote, the so-called *Wirtschaftswunder*, the "economic miracle" of the 1950s, was a "hollow miracle."[24] For West Germany prospered at the expense of one very crucial element, memory. A government previously marked by historical evasion evolved into one that made specific attempts to address the "historical illiteracy" of German youth growing up in a climate of taboo and repression.[25] The shift from the politics of the Adenauer restoration to that of the liberal, social democratic principles of Willy Brandt and the more radical principles of the student movement, led by Rudi Dutschke, saw its reflection in the evolving nature of public and political discourse. But perhaps more profoundly affecting than government policies or social movements were events in the cultural and public arena. It was the dramatization of *The Diary of Anne Frank* in the late 1950s that was seen to function as an important catalyst of historical memory and consciousness, if not conscience, in the postwar Federal Republic. Followed in the early 1960s by the intense media attention to the Auschwitz trials, the past came to occupy an unavoidable place in the present. And it was amid this changing social, cultural, and political

discursive field that Kiefer and other young German *Nachgeborenen* were coming of age and, in turn, that the process of historical awakening was finally begun, if not fully realized.

It is in and against this context of belated historical awakening that I intend to situate Kiefer's work. I forthrightly acknowledge that the historical paradigm I have employed for describing and contrasting two eras and generations, one that uses metaphors of silence and exposure, taboo and transgression, repression and acknowledgment, is indeed overtly binary and, as a result, lacking in nuance and subtlety. But I have chosen to use this paradigm precisely because the generation of *Nachgeborenen* saw and understood themselves in precisely such emphatically oppositional terms. The '68ers were proud and defiant in their belated confrontation with the past, their strength and solidarity owing at least in part to their self-understanding as enacting a dramatic departure from the perceived silences and evasions of the parental generation.

That Kiefer is seen as the heir apparent not only to a legacy of historical trauma but to Beuys's aesthetic and mythic legacy, setting him apart, then, from Richter, Palermo, and so on, heirs apparent to the historical avant-garde, is a history with whose own mythic dimensions I will have to contend in the course of this project. Clearly, Kiefer was Beuys's student.[26] And that history and myth are often conflated in his monumental projects is undeniable. What I would argue, briefly here and more fully in ensuing chapters, is that the problem which Kiefer's work fundamentally confronts is not, and does not claim to be, the challenges of the historical or neo-avant-garde. Rather, Kiefer's paintings confront not just the aesthetic possibilities of visual cultural practice but the theoretical and ethical possibilities of such a practice, a confrontation made particularly acute by the knowledge that history, and particularly history after Auschwitz, can be encountered, grasped, and understood only through the acknowledgment of the very inaccessibility of its original occurrence and experience. It is through Kiefer's work, then, that we come to know not really history and the past but the possibilities and impossibilities of its representation. And it is to those representations, contingent and compromised as they may be, that I will turn in the chapters which follow.

1 "THOU SHALT NOT MAKE GRAVEN IMAGES"

Adorno, Kiefer, and the Ethics of Representation

*Nach Auschwitz ein Gedicht zu
schreiben ist barbarisch.*
– Theodor Adorno

"After Auschwitz, to write a poem is barbaric."[1] So wrote Theodor
Adorno in 1949, in the penultimate sentence of "Cultural Criticism
and Society," an essay otherwise unconcerned with aesthetics. Out of
context even in its original context, later qualified and regretted,
Adorno's statement has nevertheless come to function as a moral and
aesthetic dictate for the postwar era.[2] Further, although the historically
motivated pronouncement speaks of the present, a time "after
Auschwitz," its aesthetic ethics remain deeply embedded in the past. In
other words, "after Auschwitz," Adorno may question the very propri-
ety and possibility of aesthetic representation. "After Auschwitz,"
Adorno may formulate a response to metaphysics, the micrology of
negative dialectics. "After Auschwitz," the cosmopolitan, assimilated
Adorno, born Wiesengrund, may explicitly confront the implications of
his paternal Jewish heritage in the research project on anti-Semitism.
But even more, it is in the very articulation of his proscription "after
Auschwitz" that Adorno reveals a time "before Auschwitz," an ethical
time, one shaped by the law of the hebraic father, which with his pro-
scription he comes to both evoke and instantiate. For behind Adorno's
postwar proscription lies another, namely, a biblical prohibition, the
Second Commandment, "Thou shalt not make graven images." That is

to say, it is only "after Auschwitz" that this hebraic ethics fully emerges, first in Adorno's own proscription and then in his ensuing writings.

Adorno's Jewish identity has typically been invoked to explain the messianism of his ultimately emancipatory, utopian formulations,[3] a messianism first secularized in Marxism and later displaced into the realm of aesthetics. Less central to such analyses is the ethical force of the prohibition on graven images in Adorno's writings.[4] Notably, it is in recent German writing on Adorno that the biblical prohibition has come most emphatically to the interpretive fore.

Hans-Jürgen Syberberg, better known for such controversial films as his 1978 *Hitler: A Film from Germany*, authored a book suffused with xenophobic and anti-Semitic sentiment. Written in 1990 and entitled *Vom Unglück und Glück in der Kunst in Deutschland nach dem letzten Krieg*, Syberberg's book is a nostalgia-laden plea for the aesthetic, for beauty. Syberberg attributes this loss to what he perceives as a dominance of "Jewish" aesthetics in the aftermath of the war. According to Syberberg, returning Jewish members of the Frankfurt School, with Adorno in a position of centrality, imposed their aesthetics on postwar Germany, an aesthetics that in Syberberg's eyes was an anti-aesthetics, an aesthetics that called for and existed in the absence of, or in place of, true art, that is to say, on Syberberg's account, of beauty.[5]

In contrast to Syberberg's ode to the loss of beauty and authentic German cultural identity, Gertrud Koch, the founder of the feminist film journal *Frauen und Film* and the German-Jewish cultural journal *Babylon*, affirms and in some sense celebrates what she takes to be the fundamental Jewishness of critical theory. In her 1992 book *Die Einstellung ist die Einstellung: Visuelle Konstruktionen des Judentums*, Koch sets out to demonstrate the very fundamental importance of the biblical prohibition on image making to critical theory. Koch contends that Adorno's Jewish identity, and the Jewish identity of many of the Frankfurt School members, could be seen all along in their profound ambivalence toward mimesis and their privileging of abstraction, as was evidenced for Koch most explicitly in the reception of Schönberg's opera *Moses and Aaron*.[6] Although I would not venture to make such a sweeping claim about the fundamental "Jewishness" of critical the-

ory, I am prepared to contend that "after Auschwitz," the biblical prohibition on images, what could be termed a position of iconoclasm, experienced a theoretical renaissance within postwar aesthetics.

Such examples as Dura Europas not withstanding,[7] the Second Commandment, Exodus 20:4 – "Thou shalt not make unto thee any graven image, or any likeness of any thing that is in the heaven above or that is in the earth beneath, or that is in the water under the earth" – proposes a world without images, a world in which not only God but no other thing, be it from the earth, the sea, or the sky, may be represented.[8] Further, the Second Commandment does not simply proscribe that God *should* not be portrayed. What the Second Commandment implies is that God *cannot* be portrayed. God is beyond the knowable or perceptible. God is thus unrepresentable. Unlike Adorno, whose postwar dictum is a result of history, of Auschwitz, the Second Commandment determines a representational impossibility a priori. Taken together, insofar as I am suggesting that behind, or within, Adorno's postwar proscription lies that hebraic prohibition, the intertwined dicta leave us with an aesthetic ethics of visual absence and poetic silence.

That silence has been articulated most clearly, has been given its inaudible voice, in the poetry of Paul Celan, whose work is somewhat paradoxically considered at once the catalyst for and aesthetic fulfillment of Adorno's proscription. In other words, whereas it may have been Celan's lyrical evocation of the death camps, "Fugue of Death," that occasioned Adorno's dictum, it was "Tübingen, January," that echoed its ethics of impossibility and unrepresentability. Wrote Celan:

Came, if there
came a man,
came a man to the world, today, with
the patriarchs'
light-beard: he could,
if he spoke of this
time, he
could
only babble and babble,
ever-, ever-
moremore.[9]

Adorno's language of proscription and prohibition is all the more insistent when he writes not of poetry but of painting. In *Aesthetic Theory* he states that "the Old Testament prohibition of graven images can be said to have an aesthetic aspect besides the overt theological one. The interdiction against forming an image – of something – in effect implies the proposition that such an image is impossible to form."[10] And yet at the same time, it would seem that Adorno proposes a visual alternative, a visual fulfillment of the aesthetic prohibition. Just as Adorno wrote of Celan, "Celan's poems articulate unspeakable horror by being silent,"[11] insofar as they thematize the very silence and impossibility their existence would seem to disrupt, Adorno frames the visual practice of abstraction as having "something of the old prohibition of graven images,"[12] positing painterly abstraction as a mode of aesthetic representation that avoids in its professed non-referential, nonfigurative aspect, that which Auschwitz and the Hebrew Bible expressly forbid.[13]

Adorno's invocation of what he himself terms a "taboo on sensuality"[14] is a taboo on all that is material, all that is from nature, whose antidote can be found in modernism, most particularly in the asceticism and dissonance of Schönberg. Turning again to the example of painterly abstraction, Adorno writes, "the images of the post-industrial world are images of dead anorganic matter."[15] Abstraction as aesthetic practice defies, perhaps even precludes, fetishistic, animalistic behavior. Or is it not so much the object as our spectatorial relation to that object?

As much as abstraction might allow for the dialectical possibility of representation in the absence of figuration, the fundamental import of the biblical prohibition for the Judeo-Marxist tradition is not its ethical stance on the making of images. Rather, the biblical prohibition speaks against the *worshipping* of images. In smashing Aaron's golden calf, Moses prevents the Jews from looking, from displacing their adoration from God to icon. In other words, Moses prevents the Jews from entering into a fetishistic relationship with the image. Adorno, writing against a spectatorial experience of pleasure and desire, again invokes a language of prohibition and taboo. As Adorno writes, "Perhaps the most important taboo in art is the one that prohibits an animal-like

attitude toward the object, say, a desire to devour it or otherwise to subjugate it to one's body."[16]

Thus, what Adorno formulates is ultimately less a hebraic ethics of art, or art making, than what might be termed a hebraic ethics of spectatorship. Adorno's is a spectatorship of extreme ambivalence, one founded not simply on the specificity of the object, that is, abstract or representational, but on the specificity of spectatorial attitude, on a viewing position of disinterestedness. It is a spectatorship deeply wary of fetishism. In other words, although initially Adorno's is a spectatorship that would seem to be dependent upon an anti-aesthetic, anorganic, even abstract art which would circumvent the possibility of a libidinous engagement with the object, ultimately, that responsibility is shifted from the object itself to the viewer.

That the Second Commandment functions for Adorno as a taboo on any sort of sensual or libidinous relationship with the image lays bare an aspect of the prohibition that has been explored more explicitly by such post-68 French thinkers as Jean-François Lyotard and Jean-Joseph Goux, first in Lyotard's "Jewish Oedipus"[17] and more pointedly in Goux's "Moses, Freud and the Iconoclastic Prescription."[18] On their account, to sculpt an image of God is to create a material image, a maternal image, and to encourage its sensual worship. Yet, to tear oneself away from the enticements of the senses and direct one's thoughts toward the unrepresentable God is to turn away from desire for the maternal and to rise toward the sublime father and respect his law. This is where, for Goux, the Mosaic proscription acquires its fundamental import. In Freudian terms, Mosaic law articulates the threat of castration brandished in opposition to a fundamentally incestuous desire.[19]

It is within neither the French nor the German critical tradition, however, but within an Anglo-American tradition that the Second Commandment may see its ultimate legacy. There, the full force of the libidinous nature of the spectatorial relationship is revealed in one of the foundational texts of feminist aesthetics. For Laura Mulvey's essay "Visual Pleasure and Narrative Cinema"[20] stands as a text whose fundamental iconoclasm reiterates the Mosaic no. Moreover, it positions Mulvey as another ethical voice in the postwar era. Although in many

respects specific to film, narrative film, and its manipulations of time and space, Mulvey's call for an end to visual pleasure, for an end to the pleasurable structures that arise in the conventional cinematic situation and its representation of women, namely, scopophilia, and within that narcissism, voyeurism, and fetishism, comes to sound much like Adorno's call for viewing without pleasure, viewing without fetishism. Writes Mulvey in the conclusion of her essay, "The first blow against the monolithic accumulation of traditional film conventions is to free . . . the look of the audience into dialectics and passionate detachment. There is no doubt that this destroys the satisfaction, pleasure and privilege of the 'invisible guest'" (that is, the spectator).[21]

Although it is Mulvey's mapping of the economy of the spectatorial gaze that comes to shape feminist studies of images, moving and still, for years to follow, Mulvey herself comes to qualify, though not to regret, her adamantly iconoclastic formulation, her calling for a cinema of displeasure, a "negative aesthetics of counter-cinema,"[22] one that would circumvent the fetishistic impulses of the presumptive male spectator. But if Mulvey's "Afterthoughts on 'Visual Pleasure and Narrative Cinema'"[23] is the explicit moment of renunciation of her prior iconoclastic proscription, in which she posits the possibility of a positive cinema, one with active female protagonists undaunted by the look of the camera, it is in many respects her essay "Pandora: Topographies of the Mask and Curiosity"[24] that fully articulates a spectatorial position which opposes one of voyeurism and fetishism – that is, one of intellectual curiosity. For if the fetishist becomes fixated on an object in order to avoid knowledge, in order to indulge a scopophilic impulse and avoid coming into confrontation with lack, with absence, the curious spectator, in contradistinction, seeks knowledge.

Likewise, Adorno does not simply adamantly prohibit images or advocate looking only with what Martin Jay might term "downcast eyes,"[25] Jay echoing and perhaps misprising the Lacanian pronouncement that "he who looks is always led by the painting to lay down his gaze."[26] Rather, as I have already discussed, Adorno allows the spectator to look, but to look as an ethical spectator, one who has internalized the law of the hebraic father. In other words, Adorno allows the spectator to look not merely at an object so ascetic, so stripped of the

organic, of the sensuous, of pleasure, that he or she would not be tempted to assume a libidinous relationship with that object. Rather, the presumptive spectators, hearing in their ears the Mosaic no, would already have forgone the prospect of fusion with the material image, would have forgone the pleasure of the spectatorial process, the pleasure of suspending traumatic knowledge. Instead, they would view as ethical spectators, they would accede to knowledge.

In that call for knowledge, heard in the writings of both Mulvey and Adorno, there is an acknowledgment of the fundamental importance of the image, of aesthetic representation, its ability to convey knowledge or, more pointedly, to bear witness. For if to make images or worship images is to transgress the Second Commandment, to play Aaron rather than Moses, to remain silent is to transgress the law of bearing witness, the law of Leviticus 5:1,[27] it is to perpetuate the silence in which Auschwitz was encircled and enshrouded, first in a Nazi policy of Night and Fog and then in a postwar silence of those "unable"[28] or, more accurately, unwilling, to mourn. As Adorno writes in *Negative Dialectics*, "Perennial suffering has as much right to expression as a tortured man has to scream; hence it may have been wrong to say that after Auschwitz you could no longer write poems."[29]

❖ ❖ ❖ ❖ ❖

I want to turn, in the discussion that will follow, not to poems but to paintings. In so doing, I will return, through the invocation of particular images, to the implications of Adorno's original dictum and its later qualifications, to the paradoxical logic engendered by a historical event, the Holocaust, whose very horror, exceptionality, and incomprehensibility at once forbids expression, and yet, at the same time, demands remembrance. It is as a means of further expanding and exploring the postwar legacy of the Second Commandment, then, that I turn to the work of the postwar German artist Anselm Kiefer.

From his paintings involving Aaron to those of the Iconoclastic Controversy of Byzantium to those of Sulamith and Lilith, Kiefer immerses us in the theoretical and aesthetic terrain of the biblical prohibition on image making. He does so not only through the textual

referents of his titles but through visual enactment, the contesting strategies of photography, painting, writing, and burning, aesthetically embodying the dialectic of figurality and discourse, image and word, representation and iconoclasm.

I will begin with Kiefer's *Aaron* series (1984–5) (Figs. 2 and 3), pictures that suggest as a point of interpretive departure their framing narrative, Aaron and his oppositional relation to Moses and the tenets of the Second Commandment. The pictures are not portraits of Aaron but, instead, precipitously pitched painted landscapes and works of photographic collage. Aaron, their presumptive subject, emerges pictorially only through Kiefer's use of metonymic processes, namely, the synecdochic inclusion of Aaron's staff. Rendered either in a photographic cutout or a thinly wrought leaden strip, each vaguely anthropomorphic in form, the staff, utterly dependent on the semantic field

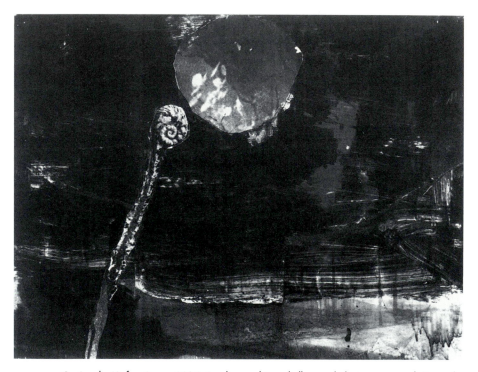

2. Anselm Kiefer, *Aaron*, 1984. Acrylic, emulsion, shellac, and photoscraps on photograph; 65 × 83 cm. Private collection. Courtesy of Marian Goodman Gallery, New York.

3. Anselm Kiefer, *Aaron*, 1984–5. Oil, acrylic, emulsion, and shellac on canvas, with lead, woodcut, and cardboard; 330 × 500 cm. Collection of Norman and Irma Braman, Miami Beach, Florida. Courtesy of Marian Goodman Gallery, New York.

determined by the title, comes to function as the marker of the biblical iconophile, represented yet not mimetically figured. Although it is Moses's staff that contains greater powers – Moses makes serpents appear, parts the Red Sea, and strikes a rock to obtain water – this staff, through Kiefer's titling, is Aaron's, and Aaron. Signifying Aaron without directly representing him in figural form, Kiefer at once engages in the practice of pictorial representation, but avoids its most idolatrous characteristics. With this picture that is not a portrait, with this landscape that verges on a painterly field of abstraction, Kiefer would seem to play both Aaron and Moses, creating a proverbial golden calf and then undermining its power as idol by resisting a traditionally figural pictorial language.

The representational paradox incarnated in his *Aaron* series has a history in two series of paintings that directly precede it. In Kiefer's *Iconoclastic Controversy* series (1977–80) (Figs. 4 and 5), German toy tanks, painted palettes, and the inscribed names of significant Byzantine iconoclasts and iconophiles do battle.[30] As in the *Aaron* paintings,

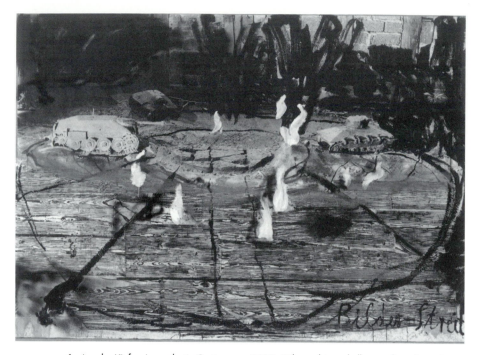

4. Anselm Kiefer, *Iconoclastic Controversy,* 1980. Oil, emulsion, shellac, and sand on photograph, mounted on canvas, with woodcut; 290 × 400 cm. Courtesy of Museum Boijmans Van Beuningen, Rotterdam.

Kiefer again thematizes aspects of the Second Commandment, but in this series, he particularizes its historical and aesthetic resonance. In situating the image in and between the epic time of the Hebrew Bible, the historical time of Byzantium, and the not so distant time of Nazi Germany and the Second World War, Kiefer historicizes the Second Commandment and the prohibition on image making and points to the political uses and abuses of both representation and iconoclasm.[31]

In the early 1980s, Kiefer created the *Margarethe* and *Sulamith* paintings. In certain respects, these paintings, even more than the *Iconoclastic Controversy* series, located themselves firmly within the historical terrain of the twentieth century. And yet, despite this anchoring, within, for example, the architectural spaces of Nazism, in this case, of Wilhelm Kreis, the images at the same time hover, like so many of Kiefer's paintings, within a mytho-poetic sphere.

5. Anselm Kiefer, *Iconoclastic Controversy*, 1977. Oil on canvas; 220 × 270 cm. Private collection. Courtesy of Marian Goodman Gallery, New York.

The *Margarethe* and *Sulamith* paintings (1981–3) appear in several different versions. Typically, the *Margarethe* paintings are composed of areas of configured straw, embedded in and loosely covering painted canvases, whose surfaces seem to comprise and magnify into intense detail the thickly encrusted surfaces of his signature landscapes. In contrast to the organic imagery of the *Margarethe* paintings, the *Sulamith* canvases evoke deeply recessional architectural spaces or built environments. The *Margarethe* and *Sulamith* canvases, in their naming and their iconography, refer quite expressly to Paul Celan's poetic evocation of the Holocaust and the death camps, "Fugue of Death."[32]

I will cite the second half of Celan's poem, in part to demonstrate the ways in which Kiefer drew so heavily on its evocative imagery and in part to suggest the ways in which Celan's use of language is in

many ways incompatible with its reductive, monumental translation in Kiefer's work:

> Black milk of daybreak we drink you at night
> we drink you at midday and morning we drink you at evening
> we drink and we drink
> a man lives in the house your goldenes Haar Margareta
> your ashenes Haar Shulamith he plays with his vipers
>
> He shouts play death more sweetly this Death is a Master from
> Deutschland
> he shouts scrape your strings darker you'll rise then as smoke to the sky
> you'll have then a grave in the clouds there you won't lie too cramped
> Black milk of daybreak we drink you at night
> we drink you at midday Death is a master from Deutschland
> we drink you at evening and morning we drink and we drink
> this Death is ein Meister aus Deutschland his eye it is blue
> he shoots you with shot made of lead shoots you level and true
> a man lives in the house your goldenes Haar Margarete
> he looses his hounds on us grants us a grave in the air
> he plays with his vipers and daydreams der Tod ist ein Meister aus
> Deutschland
>
> dein goldenes Haar Margarete
> dein ashenes Haar Sulamith[33]

As in many of Kiefer's other works, in *Margarethe* and *Sulamith*, the text overlies and literalizes the often nonliteral, nonfigurative painting, in some way fixing the metaphoric field. Kiefer's Margarethe, who is at once Celan's and Goethe's, is a blond-haired ("*strohblond*," literally, straw blond) figure of German womanhood, embodied, corporealized, and metaphorized, in straw. For the straw is at once the German landscape, in its pure materiality, and, at the same time, strands of blond hair, the conflation pictorially enacting the ideological conceit of Nazism, namely, that German identity was autochthonous, that it was rooted in and emerged from the soils.

The brilliant colors, planarity, and highly textural materiality of *Margarethe*, 1981 (Fig. 6), its insistent presence, contrast dramatically with the empty, dark, cavernous space depicted in *Sulamith*, 1983 (Fig. 7). In *Sulamith*, Kiefer represents a vaulted, brick chamber, an

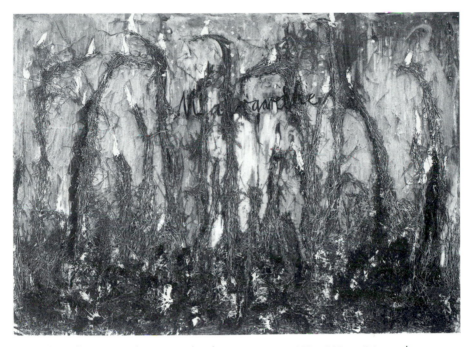

6. Anselm Kiefer, *Margarethe,* 1981. Oil and straw on canvas; 280 × 380 cm. Private collection. Courtesy of Marian Goodman Gallery, New York.

architecturally exacting rendering of Wilhelm Kreis's *Mausoleum for German War Heroes.* As is typical of Kiefer's evocation of Nazi architecture, he creates a deeply perspectival recession into the cryptlike depths of the chamber. The recession leads to a tangle of flames, whose shape and delineation evoke a menorah, an object that has been seen as transforming the commemorative potential of the space. If the suggestive candelabrum is indeed transforming the space from a mausoleum for Nazi war heroes to a memorial to Jewish victims, then it may be noted that all other fires in the chamber – torches hung in the bays of each transversal arch – are extinguished with blackened cutout.[34]

A more diffuse form of covering, a black, sooty, ashen residue, covers the upper half of the painting, out of which emerges, in the upper left corner, in small white print, the name Sulamith. Here, in linguistic inscription only, is Margarethe's other, the dark-haired woman of the Song of Songs, forever transformed by Celan's verses into an ashen symbol of the destruction of European Jewry, irrevocably absent. Placed,

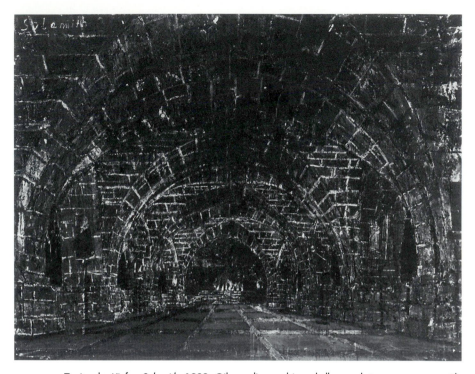

7. Anselm Kiefer, *Sulamith,* 1983. Oil, acrylic, emulsion, shellac, and straw on canvas, with woodcut; 290 × 370 cm. Private collection. Courtesy of Marian Goodman Gallery, New York.

unlike the majority of Kiefer's linguistic inscriptions, which scrawl and expand across the center of his images, in such tiny characters in the uppermost corner of the canvas, the inscription of Sulamith, even as but a sign of her own absence, is not integrally related to the pictorial space. She does not even occupy the cavernous chamber. She is consigned to the margins, the framing brick work of the outermost arch.[35]

If Sulamith remains absent, her textual lineage does not. In his evocation of Margarethe and Sulamith, Kiefer's canvases bring us back not just to their most immediate referent, Celan, as I have already discussed, but, more important, to Adorno. For whether it is apocryphal or not that Adorno's dictum was said to have been originally occasioned by his reading of Celan's "Fugue of Death," his dictum has since become explicitly linked with that poem. The relation between Celan's "Fugue of Death" and Adorno's proscription has been so firmly established within the reception histories of each that, as Sidra

DeKoven Ezrahi writes, "the two are as intertwined as a talmudic commentary and its biblical source."[36] Thus, Kiefer's series is, in the end, not only a palimpsest through which we read Celan but a palimpsest through which we read Adorno. In other words, from "Fugue of Death," through Kiefer, we return to Adorno.

Sulamith raises the question, then, of precisely how Adorno comes to function as a moral dictate for Kiefer. In Kiefer's paintings that take up the Second Commandment, metonymy is the standard representational device. With Sulamith, in contrast, metonymic substitution gives way to pure absence. Sulamith, whose name appears in the very margins of the image, outside the aching void of a Nazi architectural structure turned memorial, is nowhere represented, though one might make the claim that the ashen surface of the canvas is indeed her metonymic representation.

How does this figural absence function? Does Kiefer avoid representing the human figure in *Sulamith* because to represent, to create aesthetically, is, taking Adorno to the letter, not so much impossible as barbaric? Or does Kiefer, a non-Jewish German, invoke the Second Commandment, invoke Celan, invoke Adorno, to avoid representing, to avoid working through – by invoking these voices of moral authority – the most painful aspects of his country's traumatic history. Moreover, does Kiefer use Adorno's moral call for silence, a deeply ethical silence, to perpetuate a silence that was Germany's?

Such questions have no easy answers. It could be argued that Kiefer takes spectators into the very spaces of Nazism and engages them, with his use of monumental scale, deep perspectival recession, and densely textured, material surfaces, in the spectatorial and ideological lure of fascism, the aestheticization of politics and, in the end, the image.[37] For if such images seduce spectators, lure them in, but then remind them in their historical referent of the danger of that spectatorial dynamic, then Kiefer's paintings would seem to instantiate not just the prohibition on image making, and viewing, but its qualification. Thus, even as Kiefer's *Sulamith* indulges a certain fascination of fascism, the spectatorial lure of the material image, the worshipping of false idols, it simultaneously blocks that spectatorial relationship, ruptures that unity, insofar as it gives viewers that Žižekian unassimilable traumatic kernel that is in this case, history.[38] Even more, even as *Sulamith* thematizes and instantiates

the impossibility of representation, its incommensurability, as is emphat-
ically metaphorized in the Second Commandment by the sublime object
that is divinity, that is, the unrepresentable, Kiefer's image nevertheless
exists as visual object, as image.

As such, I would suggest that Kiefer's images, and *Sulamith* partic-
ularly, be read within and against Adorno's call for witness. In
Sulamith, if only in *Sulamith*, that biblical and historical impossibility
and silence *is* contextualized, framed as the image is not just textually
by the various levels of reference – biblical, poetic, and theoretical –
but visually, architecturally, by the hollow crypt of Kreis's Nazi mau-
soleum. The space is then rooted not just in Germany but in Germany
of the Nazi period. Through the absence that *Sulamith* then implies, if
not foregrounds, the rendered space may come to function as Kiefer's
most commemorative piece, its monumentality and determined refer-
encing of the absent Jew and the historical trauma of the Holocaust
serving to configure a pictorial space of memory akin to the memorial,
what Pierre Nora has termed a *"lieu de mémoire."*[39]

If *Sulamith* gives spectators a space of memory, albeit painterly and
two-dimensional, then his work might well be linked with the com-
memorative monuments in Germany of the 1980s that James Young
has termed *Gegen-Denkmäler* ("counter-monuments") in his study of
Holocaust memorials, *The Texture of Memory*.[40] Young views such
contemporary German "counter-monuments" as sculptural pieces that
challenge the very premise of their being-as-monuments, resisting not
just figuration but the conventions of commemorative sculpture or
site-specific installations. In this context, Young discusses Jochen and
Esther Gerz's *Monument against Fascism* for the city of Harburg,
Alfred Hrdlicka's monuments in Hamburg and Vienna, Sol Lewitt's
Black Form Dedicated to the Missing Jews, designed for the city of
Münster, and Norbert Rademacher's memorial in the Neukölln district
of Berlin. These "counter-monuments," according to Young, eschew
figuration and are characterized more by absence than presence, more
by impermanence than permanence. Young considers these "counter"
or in some cases "vanishing" monuments of the 1980s to be emblem-
atic of questions about history, memory, and representation that have
so shaped public and political discourse and practice in Germany dur-
ing that decade. As Young writes, "Ethically certain of their duty to

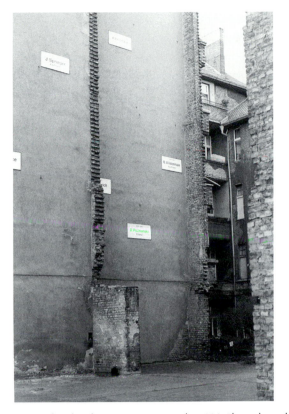

8. Christian Boltanski, *The Missing House,* Berlin 1989. Photo: the author.

remember, but aesthetically skeptical of the assumptions underpinning traditional memorial forms, a new generation of contemporary artists and monument makers in Germany is probing the limits of both their artistic media and the very notion of memorial."[41]

I would add to Young's list Christian Boltanski's *The Missing House,* a 1989 project in Berlin's formerly Jewish Scheunenviertel[42] (Fig. 8). For Boltanski's piece participates in an analogous process to Young's "counter-monuments" of marking and configuring absence, consisting as it does solely of commemorative name plaques, reminiscent of German obituary notices, mounted along the fire walls of the two buildings adjacent to the now "missing" house.[43] I might also invoke the haunting photographic projections of Shimon Attie, a project from 1992 entitled *The Writing on the Wall,* in which the prewar Jewish residents

of Berlin's Scheunenviertel experience a return, but only as an ephemeral play of light and shadow, on the crumbling facades of their former neighborhood, as, for example, in his *Almstadtstraße 43* (formerly *Grenadierstraße 7*), *Berlin, Slide Projection of Hebrew Bookstore* (1930) (Fig. 9). Or I might reference Christo's Reichstag project, which during the two weeks in June 1995 that it was "wrapped" was at once absented and yet monumentally present. Or I might describe Micha Ullman's 1996 installation beneath Berlin's Bebelplatz, formerly Opernplatz, site of the May 11, 1933 Nazi book burning. For there, beneath the infamous square and visible only through a small translucent glass window, lies a stark white room lined with empty bookshelves, the ghostly and barren *doppelgänger* of Kiefer's massive leaden book-filled shelves nearby in Berlin's newly renovated Hamburger Bahnhof. Closer to home, I would include Maya Lin's Vietnam

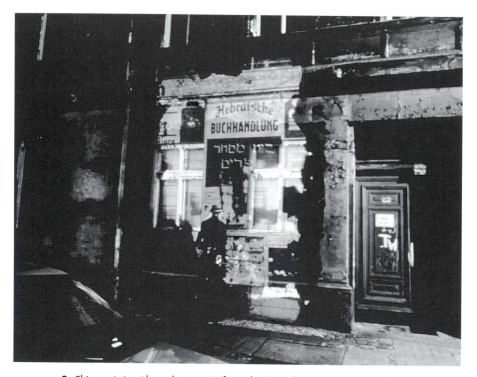

9. Shimon Attie, *Almstadtstraße 43* (formerly *Grenadierstraße 7*), *Berlin, Slide Projection of Hebrew Bookstore* (1930), from *The Writing on the Wall*, 1992–3. Courtesy of Shimon Attie.

10. Maya Lin, Vietnam Veterans Memorial, Washington, D.C., 1980–2. Photo: the author.

Veterans Memorial (Fig. 10), which commemorates the Vietnam War and its American victims with decidedly nonfigurative means, its inscribed yet abstract minimalist form figuring absence and loss.[44]

Returning, finally, to Kiefer's work, I would acknowledge that in contrast to such antimonumental "counter-monuments," *Sulamith* would seem to remain monumentally present. And yet, its powerfully monumental form ultimately acts only as a frame, as a pictorial space that configures nothing but an emptied, cavernous void. Despite its sheer size, the doubly inscribed recessional movement, in which both the tiles of the floor and the arches of the chamber help to accentuate and accelerate the visual regression to its depths, creates a dramatic perspectival illusion of space. As such, the viewer is forced into confrontation with its emptiness, an emptiness framed and made meaningful through the absent referent, Sulamith, the Jew.[45] Moreover, much like Young's "counter-monuments," Kiefer's work has come to emblematize, in the deep ambivalence of its reception, Germany's conflicted struggle with remembering and representing the past.

Before concluding, I want to examine one of Kiefer's more recent series of paintings and books. For Kiefer's conflicted relation to figural

representation, coupled with what I have posited as a hebraic ethics of
representation, is only deepened in his turn to the Jewish mysticism of
Kabbalah, esotericism known best within secular circles in the writ-
ings of Gershom Scholem.[46] The philosophical doctrines, lore, and
vocabulary of Kabbalah are virtually catalogued in such recent works
as *Lilith, The Daughters of Lilith, Lilith at the Red Sea, Breaking of
the Vessels, Sefiroth, Emanation, Zim Zum*, and *Merkabah*. But if
there is an almost uncanny affinity between Kiefer's processes of cre-
ation and the mystical processes of creation described in Kabbalah –
his use of lead, his interest in alchemy and transformation, his insis-
tent reliance on language and on the word,[47] it is the relationship of
Kabbalah to historical trauma that makes Kiefer's invocation and evo-
cation of its tenets all the more significant.

Jewish history is a history defined in part by catastrophe, from the
destruction of the Second Temple in the first century of the Common
Era to the destruction of European Jewry in the twentieth century.[48]
But it is to a particular catastrophe, the expulsion of the Jews from
Spain in 1492, that modern Kabbalah responded. In its myth of cos-
mic catastrophe as the originary moment of creation, or so Scholem
argues, modern Lurianic Kabbalah transposed historical trauma, the
expulsion of the Jews, into mythic trauma, the shattering of the mysti-
cal vessels. As such, historical trauma, historical suffering, and the
possibility of redemption could find their reflection in a mystical story
of creation, destruction, and redemption.[49]

But if it would be to the monumental canvas *Zim Zum*, or the mas-
sive sculptural installation *Breaking of the Vessels* (Fig. 11), a work at
once deeply kabbalistic in its thematizing of mystical creation and
destruction and deeply historical in its insistent reference to the events
of Kristallnacht, that I might most obviously turn as a means of situ-
ating Kiefer's aesthetic and ethical dilemmas, for the very literality of
their kabbalistic references, I want to turn instead to his 1990 book
project *The Heavenly Palaces: Merkabah*. For *The Heavenly Palaces*
is a project that could be said to narrativize and contextualize the aes-
thetic and ethical dilemma with which Kiefer's work has for so long
been preoccupied.

On page after page of this book project, Kiefer presents shadowy

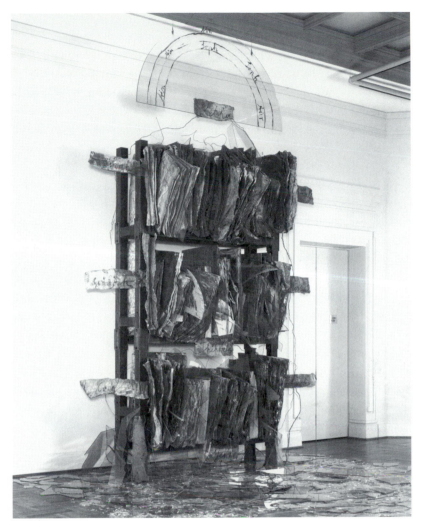

11. Anselm Kiefer, *Breaking of the Vessels*, 1990. Lead, iron, glass, copper wire, charcoal, and Aquatec; height 149 inches. Courtesy of The Saint Louis Art Museum. Purchase. Funds given by Mr. and Mrs. George Schlapp, Mrs. Francis A. Mesker; Henry L. and Natalie Edison Freund Charitable Trust, Helen and Arthur Baer Foundation, Marilyn and Sam Fox, Mark Twain Bancshares, Inc., Mrs. Eleanor J. Moore, Mr. and Mrs. John Wooten Moore, Donna and William Nussbaum, Mr. and Mrs. James E. Schneithorst, Jain and Richard Shaikewitz, Mr. and Mrs. Gary Wolff, Mr. and Mrs. Lester P. Ackerman, Jr., Hon. and Mrs. Thomas Eagleton, Alison and John Ferring, Mrs. Gail Fischmann, Mr. and Mrs. Solon Gershman, Dr. and Mrs. Gary Hansen, Mr. and Mrs. Kenneth Kranzberg, Mr. and Mrs. Gyo Obata, Warren and Jane Shapleigh, Lee and Barbara Wagman, Mr. John Weil; Contemporary Art Society, Museum Shop Fund, and Museum Purchase; Dr. and Mrs. Harold Joseph, Museum Purchase, Estate of Alice P. Francis, Fine Arts Associates, J. Lionberger Davis, Mr. and Mrs. Samuel B. Edison, Mr. and Mrs. Morton D. May, Estate of Louise H. Franciscus, Anonymous Gift, and Miss Ella M. Boedeker, in exchange 1:1991.

black and white photographic images of a cavernous interior.[50] With its vast expanse of uneven, at times rubble strewn, stone flooring, the cellar-like space is punctuated only by blocky, solid pillars and diaphanous shafts of light that stream through isolated windows. It is with and upon this image, photographed from different angles and with varying degrees of resolution, that Kiefer constructs the visual project of the book.

Save the bare elements of its structure, the room Kiefer represents photographically is entirely empty. It is devoid of objects, containing none of the ephemera of daily or past life that typically would litter its floors. The cellar does not fulfill its expected function, in which it, like the attic space, would serve as the storehouse of familial history, of shards of memory. In contrast, this cellar would seem to be a space that holds no memories.[51] It would seem to be a place emptied of a past and suffused only with the dim, raking light of the present. But if the vacant cellar space represented in the photographic book remains empty, the surface of that image is gradually filled and overtaken by matter, by the increasingly dense application of acrylic and ash to its surface. With each turn and unfolding of the massive pages of Kiefer's book, the empty cellar becomes a repository of materiality and meaning. Like a cinematic storyboard, the format of the book allows for the introduction of narrative, traditionally either condensed or absent from the pictorial arts. Each opened spread of pages functions as a coherently conceived image, and at the same time, the drive or pulsion created by the simple act of sequentially turning the pages sets the stage for a visual story to emerge from the penumbral depths of the represented cellar space.

The book cover provides the first means of entry into the embedded narrative structure (Fig. 12). Inscribed upon the page in Kiefer's typically looping cursive handwriting, atop the photographic base and a field of acrylic paint and ash, are the German words *Die Himmelspaläste* ("the heavenly palaces") and the Hebrew word *Merkaba* (literally, "chariot"). The words *Die Himmelspaläste* scroll across the top center of the cover page. Below them, skeins of vertically oriented white paint, labeled with the numbers one through seven, seem to emanate from the cracks in the stone floor of the photographic image. Below them, scrawled across the bottom center of the page, is the word *Merkaba*.

12. Anselm Kiefer, *The Heavenly Palaces: Merkabah,* 1990, cover. Ashes and acrylic on photographs, mounted on board; 100.8 × 71 × 8 cm. Courtesy of the Busch-Reisinger Museum/Harvard University Art Museums. Purchase in honor of Arend Oetker through the generosity of a group of Friends of the Busch-Reisinger Museum.

If it is the visual referent that initially locates the work in the present, in the ruined chambers of the artist's studio space, it is the textual referent that takes the work out of its state of perpetual present and into a past, into the mystical world of Kabbalah. Unlike so many of Kiefer's projects, in which a dark, cavernous architectural space serves as the staging ground for an artistic exploration of the collected histories, memories, and mythologies of the German nation, especially the phenomena of Nazism and German nationalism, this space, like its painterly antecedent, *Sulamith,* evokes a different historical and

mythic tradition. Inhabiting this cellar space, inscribed and affixed upon the photographic image, alluded to and perhaps even embodied in its aesthetic strategies, is the ghostly presence of the mystical traditions of Judaism.

Within the mysticism of early formations of Kabbalah, in stark contrast to the notion of an imageless and invisible God so energetically maintained by Jewish tradition, there is a conception that knows the projection of this God as a mystical figure, anthropomorphized. In several different respects, it would seem that, like the anthropomorphized God, the invisible is made visible, albeit it only briefly, upon the pages of Kiefer's *The Heavenly Palaces*, a work that would seem to "illustrate" this mystical world of Kabbalah and the *Hekhalot*, the celestial regions of the mystical world through which the mystic seeker travels before arriving at the throne of God. Shifted into a visual terrain, on both a formal and iconographic level, Kiefer's project presents a tale of artistic and divine creation, a tale of emergent figuration and a return to abstraction. It is precisely at that moment of creation, of figurative emergence, of inchoate matter given over to form, that the dramatic moment of reading/viewing takes place.

On a formal level, this mystical and artistic process of making the invisible visible is carried out in two media. First, the photographic image itself comes into focus and resolution. In the first several pages of the book, the cellar space takes on an increasing clarity and legibility – the spatial orientation of the image resolves itself, and the tonal contrasts become sharper. Significantly, it is immediately following the photographic image of greatest clarity that the photographic image is consumed by painted and applied matter. It is out of this material that a figural representation emerges. There, loosely rendered in sketchy, gestural black paint against an indeterminate photographic base, is the head of a woman, from whose opened mouth emanates a field of white paint and ash.

On the following set of pages, the loosely rendered, painted figure is concretized and transformed into photographic form (Fig. 13). Kiefer presents a nude woman shot from the torso up, hands clasped behind her head, mouth opened in a scream of either ecstasy or horror. A mixture of paint and ash emerges from her gaping mouth, materially

13. Anselm Kiefer, *The Heavenly Palaces: Merkabah*, 1990, page 6. Ashes and acrylic on photographs, mounted on board; 100.8 × 71 × 8 cm. Courtesy of the Busch-Reisinger Museum/Harvard University Art Museums. Purchase in honor of Arend Oetker through the generosity of a group of Friends of the Busch-Reisinger Museum.

forming in her inaudible articulation the visual basis for the narrative
resolution of the book itself. The emanations slowly leave their
inchoate state and take shape on the following page opening in the
form of numbered skeins, repeating the formal rhythm of the cover
page and reinforcing the manifest kabbalistic presence in the work. In
the final page sets that follow, the substance disperses once again into
arrested flows of matter, completing the tale of form and matter, figu-
ration and abstraction.

The woman in *The Heavenly Palaces* appears, albeit briefly, not as
a metonymic trace, as is so typical of Kiefer's work, but as a figural
representation. As such, she may represent a concretized amalgam of
the mythical Jewish figures that appear in other Kiefer works. The
linkage to other works is first established spatially. The exact space in
which Kiefer conceives this project is used as well in his contempora-
neous book project *Lilith* (Fig. 14). And Lilith herself emerges, albeit
only in metonymic form, in such massive contemporaneous works as
Lilith at the Red Sea (Fig. 15).

As Scholem explains, within Merkabah mysticism, to which this
project so manifestly alludes, Solomon's beloved in the Song of Songs
is the feminine mystical presence.[52] The embodied female presence in
Kiefer's book is thus a manifestation of that presence, at once
Sulamith, a recurrent figure in Kiefer's work since the early eighties,
and her dark side, Lilith.[53] She is the embodiment of mystic and
mythic figures of Jewish womanhood, emerging upon and then disap-
pearing from the encrusted pages of Kiefer's book. Further, if her
source is not, or is not only early Kabbalah, but later Lurianic Kab-
balah, she may embody aspects of cosmic creation and catastrophe,
but she is first and foremost the product of, the transposition of, his-
torical catastrophe and trauma, a history of catastrophe that now ends
not with the expulsion of the Jews from Spain but with genocide.

Moving from the specificity of Kiefer's *The Heavenly Palaces:
Merkabah* and its relation to kabbalistic theories of creation and
returning to the more general case of Kiefer's biblically and kabbalis-
tically inspired works, I want to raise the question of how the figure of
the dark-haired Jewish woman, in all her various pictorial and the-
matic incarnations, and, even more generally, the Jew, function.

14. Anselm Kiefer, *Lilith*, 1990, pages 4–5. Acrylic and ashes on original photographs, mounted on cardboard; 102 × 71 × 8 cm. Private collection. Courtesy of Marian Goodman Gallery, New York.

Inscribed with the names Lilith, Sulamith, and Aaron, and titled with the words "Sefiroth," "Zim Zum," and "Daath," it would seem that on a very basic level Kiefer's work suggests a memorializing impulse, an anamnetic impulse, an impulse to reintroduce, if not into the visual, at least into the linguistic and acoustic, landscape of postwar Germany, the absent other, the Jew, signified in the foreign sounds of the Hebrew language. For it could be argued that the migration of the Hebrew language is a marker not only of the absent Jewish culture that once was Germany's but of the absent reader, the Jew, the reader of Hebrew. These to many spectators indecipherable, literally illegible

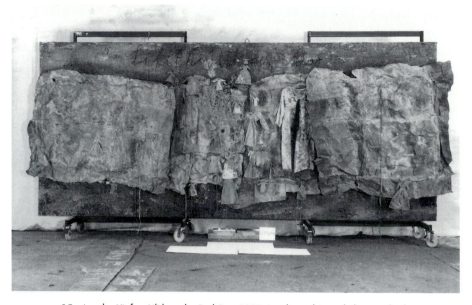

15. Anselm Kiefer, *Lilith at the Red Sea,* 1990. Lead, emulsion, clothes, and ash on canvas; 280 × 625, Sammlung Marx, Berlin. Courtesy of Heiner Bastian Fine Art, Berlin.

inscriptions, signify words that are unassimilable and yet persistent, a past that will not pass away, the unassimilable kernel, the trauma that is twentieth-century German history.

Thus, obscure or irretrievable as the reference to Jewish mysticism may be, as inaccessible as the textual and religious tradition may be to a contemporary audience, particularly a contemporary German audience, it performs the task of making the absent once again present. The invisible is made visible. A Jewish mystical and intellectual past and tradition emerge out of the shadowy chambers of the cellar space, even as the narrative trajectory of the project is one that ultimately returns to abstraction, to the realm of the invisible, forgoing the possibilities of figural representation. Moreover, despite this conclusion in an absence of figuration, the book project itself, nevertheless, leaves behind a concretized trace of a Jewish past. In it, that past is re-presented and preserved in the present.

But what if Kiefer's turn to Kabbalah demonstrates less a certain aesthetic or philosophical sympathy with Kabbalah or an anamnetic

impulse, than, instead, and more portentously, a postwar manifesta-
tion of German Orientalism, that is, a fascination with the other, made
exotic by the very fact of its virtual absence from contemporary Ger-
man society? In other words, what does it mean for a postwar German
artist to turn to Jewish sources, to make not only Kabbalah but, as is
the case in many of Kiefer's other projects, the Hebrew Bible, the
poetry of Paul Celan, and the writings of Walter Benjamin the ostensi-
ble focus of his work?

For it is important to consider what it means that the Federal
Republic was a place where, from a prewar German Jewish population
of 500,000, only 30,000 Jews came to live after the war, rendering the
Jew a virtually invisible component of that postwar political body.[54] I
would suggest that like the Oranienburgerstraße and its environs in
the former East Berlin, once the prewar neighborhood of Berlin's poor,
Eastern European Jewish immigrants and now a neighborhood of
teeming nightlife in which the Jewish past is made manifest as a cul-
tural attraction, or the ever burgeoning popularity of Hebrew classes
and synagogue services with Berlin's non-Jewish citizens, Kiefer's
turning to Jewish subjects, be they from Jewish mysticism, the Hebrew
Bible, or from intellectual history, evidences a similar attention to and
resurrection of Germany's now missing other, the Jew.[55]

Thus, perhaps despite the act of naming, of inscribing, or even in
The Heavenly Palaces, the concretized if ephemeral representation of
the female form, in Kiefer's avoidance of human figuration, in his con-
tingent yet persistent iconoclasm, his work may tend less toward
memorialization or remembrance than toward mystification. In Kiefer's
work with Jewish subjects, this process of mystification is only under-
scored by his choice of protagonists, all of whom derive not from his-
tory, as is the case in *Ways of Worldly Wisdom* (Fig. 16), in which
Kiefer brings together such renowned German literary, philosophical,
and historical figures as Kleist and Hölderlin, Kant and Heidegger, and
Hermann and Bismarck, but from a literary and mythic sphere. Fur-
ther, when Kiefer does represent the human figure, which he did almost
exclusively in works from the 1970s, as in the aforementioned *Ways of
Worldly Wisdom* and his self-portraits, which I will discuss in the fol-
lowing chapter, there is a concreteness to the representation, a return to

16. Anselm Kiefer, *Ways of Worldly Wisdom*, 1980. Woodcut, additions in acrylic and shellac on canvas; 344.8 × 528.3 cm. Restricted gift of Mr. and Mrs. Noel Rothman, Mr. and Mrs. Douglas Cohen, Mr. and Mrs. Thomas Dittmer, Mr. and Mrs. Ralph Goldenberg, Mr. and Mrs. Lewis Manilow, and Mr. and Mrs. Joseph R. Shapiro; Wirt D. Walker Fund, 1988.112. Photo: © 1997, The Art Institute of Chicago. All rights reserved.

mimetic conventions of portraiture, one that does not give way to the aesthetic or ethical constraints of either abstraction or iconoclasm.

❖ ❖ ❖ ❖ ❖

In closing, I would like to suggest that no matter how fundamentally the epistemological and moral claims of representation have been undermined – by history, by secularized notions of sublimity, by ethical constraints on the image – that Kiefer's images ultimately instantiate rather than undo this foundational representational paradox. That is, his works are visual counterparts to Adorno's aesthetics and, moreover, Adorno's negative dialectics, even as their very being-as-art departs radically from what Adorno may have envisioned as the necessarily autonomous, utopian possibilities of art. For in their very being,

Kiefer's images point to the social role that representation can perform. That Kiefer, however asymptotically and problematically, deals with questions of representation, that he deals with history, that he deals with Germany's other, the Jew, that he deals with the legacy of the past and its place in the present, affords his work a place and a weight in the present, no matter how irretrievably absent its lost subject is.

To create, to continue to give voice to that which was silenced, to those who were silenced, affords Kiefer's work this position. In his essay "Commitment," Adorno reiterates his position articulated in *Negative Dialectics*. It is a stance that constitutes not a reconciliation, but the dialectical intertwining of a hebraic ethics of unrepresentability and a hebraic ethics of bearing witness, one I fundamentally see enacted in the work of Kiefer. Writes Adorno, "the abundance of real suffering tolerates no forgetting . . . [it] demands the continued existence of art [even as] it prohibits it. It is now virtually in art alone that suffering can still find its own voice, consolation, without immediately being betrayed by it."[56]

Until we have a world without suffering, until we have a world without injustice, until we have a world in which ethical law is so internalized as to preclude the necessity of images standing as either visualized taboos against or witnesses to past, present, and even future wrongs, we cannot maintain a position of unqualified iconoclasm. Both Adorno and Mulvey, two foundational voices of iconoclasm in the postwar era, come to recognize this. Each asserts the fundamental importance of the image, even as they decry the danger represented by its continued existence. And Kiefer, for all his iconoclasm, literally and figuratively, continues to make pictures.

2 OUR FATHERS, OURSELVES

Icarus, Kiefer, and the Burdens of History

> Father, don't you see I'm burning?
> – Sigmund Freud

Despite my invocation of Freud, I want to begin with a passage from Susan Neiman's memoir *Slow Fire: Jewish Notes from Berlin*, an evocative rendering of her experiences, as a philosopher and a Jew, in Berlin during the 1980s. Neiman writes:

Dieter said the current renaissance in German painting is due to the postwar preoccupation with the Nazi era. A conflict between fathers and sons which can only be resolved through art.[1]

The passage presents a provocative thesis about contemporary German painting, proposing both its impetus and its thematics. Of course, the first portion of Dieter's diagnostic description may seem unduly causal, suggesting history and its legacy as the catalyst for recent German painting. And the second portion may seem profoundly clichéd, both in its reassertion of an overblown notion of the transformative and curative powers of "Art" and in its reinscription of the highly gendered, Bloomian notion of an oedipal "anxiety of influence" driving aesthetic production.

Causality, hyperbole, and masculinist assumptions notwithstanding, I would argue that Dieter's statement is more accurate and penetrating than we might initially deem it. For in his invocation of the past and the oedipal drama, he engages more than facile explanations and tired clichés. He calls attention to the way in which a largely theoretical dynamic at once shaped and saw its reflection in cultural practice. Although perhaps not enacting quite so dramatically the Bloomian

battle "between strong equals, between father and son as mighty opposites, Laius and Oedipus at the crossroads,"[2] the antiauthoritarian revolt of 1968 – a revolt quite pointedly addressed to the generation responsible for Nazism – witnessed a dramatic confrontation between sons and fathers, bringing this charged oedipal dynamic to the social and cultural fore.

Despite marked liberalization and democratization in the late 1960s, the generational conflict that engendered such changes and their cultural reflections was largely played out between men. From a male-dominated student movement interrogation of the *Vaterstaat* ("the fathers' state")[3] to the explosion of so-called *Vaterliteratur* ("literature about fathers")[4] to such theoretical explorations of the fascist unconscious and German masculine identity as Klaus Theweleit's *Male Fantasies,*[5] the father, his historical legacy, and, concomitantly, German male subjectivity became the personal and cultural preoccupation of a generation of sons. Significantly, this highly conventional, oedipal dynamic was only mirrored and amplified in the visual arts, where the so-called return to figuration produced not simply representation in the aftermath of internationalist postwar abstraction but a resurrection of nationally coded painterly idioms coupled with a specific reassertion of the human figure.

It is abundantly clear that neo-expressionism, as it took shape and cohered as a practice and perceived movement, was an almost exclusively male domain.[6] The question remains, why? Did its very aesthetic project preclude the participation of women?[7] Was its redeployment of massive scale, its rediscovery and recapitulation of earlier modes of figural representation, namely, German expressionism and romanticism, its foregrounding of painterly signifiers of mastery, or its thematic reassertion of the "heroic" artist/creator in some way simply formally, conceptually, thematically, or ideologically incompatible with the artistic projects of women artists in the post-68 era?[8] Or, and this question may be seen as inextricably linked to the preceding questions, was the very nature of the historical project of neo-expressionism somehow confined and circumscribed by an insistently oedipal logic? Whatever the causal or circumstantial reasons for its formal characteristics and thematic preoccupations, we are left with a body of work produced by

male artists that is typically concerned with the pictorial negotiation of identity.

It is my contention that the work of Anselm Kiefer most embodies this postwar painterly exploration of identity. In other words, it is Kiefer more than any other postwar German painter who grapples not only with the aesthetic question of what it means to paint but with the ontological question of what it means to paint as a German, and to live as a German, in postwar, post-Holocaust Germany.

Returning specifically to the framework established in Dieter's thesis and considering Kiefer's singular prominence and renown, I would suggest that his work may be read as emblematic of the "current renaissance in German painting" and symptomatic of the "postwar preoccupation with the Nazi era." Kiefer's work, as wide-ranging as its subjects may be, organizes itself most consistently around issues of German history, myth, and identity, issues inextricably linked, in the aftermath of the Second World War, to Nazism and its legacy. More pointedly, the thematics of Kiefer's work, as they take shape around the question of subjectivity, indicate the labors of a son, toiling against the legacy of a historically tainted father, or paternal signifier. Precisely how that filial subjectivity is constructed, figured, and negotiated in Kiefer's work, its qualities of commonality and uniqueness, will be the focus of the ensuing discussion. And that discussion will take shape around the question of self-representation, what might even be called self-portraiture, a project that sees a persistent, if untraditional, enactment in Kiefer's work. For the body, the painted and photographic self-image of the artist, will eventually be made to disappear entirely in Kiefer's work. But this disappearance of the body is not synonymous with the disappearance of self-representation. Instead, the artistic body re-emerges, symbolically embodied upon the canvas, insistently present.

It is with Alexander Mitscherlich's "diagnosis" of a "society without the father"[9] that I will begin to construct a theoretical framework for conceptualizing a trajectory of German masculine subjectivity. According to Mitscherlich, the father's absence or impotence is as much a function of industrial obsolescence as it is of historical tainting and discrediting.[10] In many ways, Mitscherlich's work is quite radical in that it finds changes within societal authoritarian structures so substantive

that the oedipal drama is effectively undermined. But ultimately, Mitscherlich's model does not adequately account for the social formations it claims to describe. For, weak as their social and familial functions may have been in the aftermath of German fascism, as social and cultural activity will attest, German fathers loom large in the postwar era, albeit as negative imagoes. Discredited by their past, supplanted by American surrogate authority figures, the generation of German fathers, nevertheless, still continued to exercise an enduring hold on the generation of children, on the *Nachgeborenen* ("those born after").[11]

Before turning specifically to the case of Kiefer, I want to look briefly at some early works by his neo-expressionist colleague Georg Baselitz. I do this in part for historical, or art-historical, reasons. Namely, Baselitz's work was the first postwar figurative painting to negotiate identity within this particular historical legacy and its oedipal dynamic. Further, it is useful to establish the shared artistic tradition and cultural moment out of which their work emerges. Although the paintings of Markus Lüpertz, Jörg Immendorff, and later A. R. Penck are deeply, if not equally significant, Baselitz provides an exemplary and originary moment in the history of neo-expressionism and of postwar German painterly negotiations of subjectivity. And finally, in order to comprehend the singularity of Kiefer's eventual project, it must be set against that of his compatriots. And so I turn to Baselitz.

Disheveled, in a state of decay, frozen in place, exhibiting a manifest lack of potency, such are Baselitz's *Heroes/New Types* (Fig. 17). Perhaps belated visual enactments of *Trümmerliteratur* ("rubble literature"), replete with its topoi of ruins, physical and physic,[12] Baselitz's paintings and prints of the mid-1960s repetitively put forth the figure of the hulking male form, poised precariously against a backdrop of devastated landscapes. With their flaccid genitals often exposed, the flies of their baggy fatigues hanging open, these "heroes" are more the antithesis of heroism.[13] They are heroes devoid of their traditional powers and attributes. They are men shattered by war.

Part of an extensive series of works in which the war-torn Saxonian countryside of Baselitz's youth is not only populated by these weary figures but strewn with biomorphic lumps, clusters of semiorganic material and dismembered body parts, they systematically and resoundingly articulate a breakdown of the heroic imago of the German male body.

17. Georg Baselitz, *Heroes/New Types,* 1966. Oil on canvas; 162 × 130 cm. Courtesy of Galerie Michael Werner, Cologne and New York.

This breakdown is further heightened by the very ways in which these teetering, disjointed figures are rendered – the application of paint is hurried, gestural, and thickly applied, further fracturing any sense of a bounded, unified human figure. The men, like the landscapes in which

they stand, appear in a state of decay and disintegration. These tired figures, coupled with their jagged rendering and their ruinous surroundings, visually bespeak a masculinity called into question, literally, a masculinity in ruins.

Despite the weaknesses in Mitscherlich's thesis, I would still suggest that Baselitz's prints and paintings from the mid-1960s be read as imaging this crisis of identity, screened through these absent, lost, or discredited fathers. One image from 1965, replete with the signature amorphous lumps of organic detritus, is entitled *Picture for the Fathers* (Fig. 18). If painted "for the fathers," Baselitz's titling does not help to secure the identity of all the hulking yet impotent men in his early work, some of whom even carry palettes. Are they the fathers, artistic or otherwise, depicted in a state of homecoming and

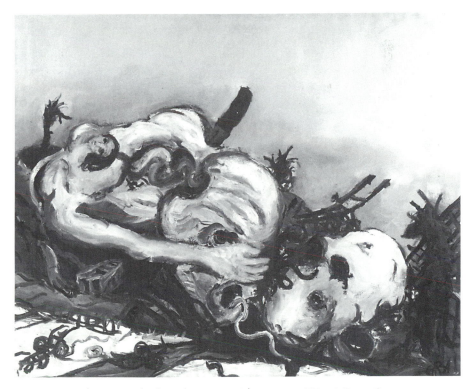

18. Georg Baselitz, *Picture for the Fathers*, 1965. Oil on canvas; 130 × 162 cm. Courtesy of Galerie Michael Werner, Cologne and New York.

impotence? Or are they the sons, Baselitz's generation, self-portraits of sorts of the "fatherless" generation to which he belongs?

The ambiguity of the dedication is, if not resolved, lessened by considering the work in question in relation to the group of images from this period, which would seem to secure the paternal identity of the figures. For the desiccated landscapes and ruinous architectural fragments in which the men appear suggest that their "place" – temporal and spatial – is indeed the bombed-out topography of Germany at the end of the war. Accordingly, even if these weary figures are not the literal, or biological, fathers, they are paternally indexed figures. Further, they signal in their depicted impotence a vision of defeated masculinity, recalling Mitscherlich's thesis and throwing the foundations of the oedipal narrative, if not into chaos, then into question.[14] What these images depict, then, is a moment of identity at a crossroads, a moment when identity – personal, cultural, and national – was so called into question that cultural products must necessarily be seen as symptomatic, if not emblematic, of this moment of crisis.[15]

Before turning once and for all to Kiefer, I should mention that Baselitz's work quickly moved toward more assured and pointed assertions of artistic authority, masculinity, and German identity. In other words, Baselitz as painterly and German son negotiated his personal, national, and masculine identity, pictorially and publicly, in quite conventional ways. He came to assume the once discredited, but now reinstated paternal role and artistic role, not only in his later painting but in his public persona.[16] In Baselitz's work, the oedipal narrative is restored intact, despite its historical compromising. Kiefer's work, in contrast, tells a very different story about the painterly negotiations of a subject position.

I will begin my discussion of Kiefer's work by referring to a 1970 painting entitled *Heroic Symbols*, from a series bearing that name.[17] On a larger-than-life scale, Kiefer represented himself with his arm raised in a Hitler salute, his rigid, erect body cloaked in a stiff overcoat. Put simply, Kiefer represented himself as a Nazi.[18]

Kiefer posing in the guise of a Nazi is by no means unique to this series of paintings, as is demonstrated in both photographs and watercolors from his contemporaneous book project, bearing the same title, *Heroic Symbols* of 1969 (Figs. 19 and 20). But the 1970 paintings create a markedly different effect than the book images. For one, the

19. Anselm Kiefer, *Heroic Symbols,* 1969, page 9. Watercolor on paper, graphite, original and magazine photographs, postcards, and linen strips, mounted on cardboard; 65 × 50 × 8.5 cm, 46 pages. Private collection. Courtesy of Marian Goodman Gallery, New York.

20. Anselm Kiefer, *Heroic Symbols,* 1969, page 15. Watercolor on paper, graphite, original and magazine photographs, postcards, and linen strips, mounted on cardboard; 65 × 50 × 8.5 cm, 46 pages. Private collection. Courtesy of Marian Goodman Gallery, New York.

early painting series introduces the factor of scale, one that Kiefer will exploit to great end in his ensuing artistic production, its sheer monumentality lending a weight and presence to the image that the early books simply could not convey. And, in its assertion of the human figure on a massive scale, rendered in oil with an expressionistic brushwork and palette, the series places Kiefer, if only for that brief moment, firmly within the painterly movement of neo-expressionism.

In his 1975 project *Occupations*, Kiefer reorganized and recontextualized photographs from his early books, placing them within a seventeen-page spread commissioned by and published in the Cologne art journal *interfunktionen*, then edited by the art historian Benjamin Buchloh. In the series, which derives its title *Occupations* from the longer title affixed to the first page, "During the summer and fall of 1969, I occupied Switzerland, France and Italy: a couple of photos," Kiefer used the 1969 photographs in which he had dressed himself up as a Nazi and then posed in either the private realm of his apartment or in the public realm of historically significant sites.

In one of the images, typical of the series in that it is black and white, grainy, muddy, and somewhat amateurish, we are presented with a centered figure in riding boots and jodhpurs, his arm raised in a Nazi salute, positioning himself before a monument to imperial greatness (Fig. 21). His pose at once echoes that of the mounted horseman of that earlier empire and recalls the rigid salute of a more recent "empire." Or does it? If Kiefer can be said to flaunt the tabooed signs of Nazism – the salute, the regalia, the dreams of territorial expansionism – then he does so in a way that makes his iconoclastic gesture seem silly, slightly preposterous. In the series, the figure of the artist is often a bit disheveled and unkempt. He does not actually wear a Nazi uniform, but instead riding pants that merely mimic its form. And his figure is often dwarfed by its surroundings.

In these images, Kiefer is very much the son, and not simply in relation to the historical legacy with which he grapples. There is something childish, or childlike, in the masquerading "dress-up" games enacted in Kiefer's first book projects. And that sense of child's play is carried into his later books and paintings, with his insistent reliance on toys and models as a means of restaging historical and mythic

21. Anselm Kiefer, *Occupations,* published in *Interfunktionen,* Cologne, 1975, photo 9. Courtesy of Marian Goodman Gallery, New York.

scenes within the space of his studio.[19] As early as 1975, in both paintings and book projects related to Hitler's misguided and never-used plan to invade England by sea, Operation Sea Lion, Kiefer began using toys to "stage" the photographic backdrops for his work. He continued to use this technique throughout the 1980s, in such projects as the *Iconoclastic Controversy* series and *The Golden Fleece*.[20]

The playfulness, irony, or patent absurdity of *Occupations* has done little to soften the intense polarization of response it has generated. Typically, the series of images has been read as either an unrepentant reassertion of fascism or as a means of coming to terms with the past. It is clear why the former would emerge as an immediate reaction. Without the proper framing (and what *is* the proper framing?),[21] what is represented is simply a German dressed up as a Nazi, making a Hitler salute, a German artist playing at being a Nazi, occupying (to play on the title, *Occupations*) that subject position. And to play at being a Nazi, particularly in Germany in 1969 – a place where to this day it is ostensibly illegal to make the Nazi salute – is a provocative and confrontational gesture. That the photographs were shot either in his apartment or in Switzerland, France, or Italy underscores the point that their staging could not take place within the public sphere in Germany. When the collection of photographs was ultimately exhibited in a public forum in 1975, on the pages of *interfunktionen*, they were found so offensive that their publication led to a boycott of the journal.[22] More egregious than violating taboo, they could have been perceived as actually breaking the law.

As a means of emphatically expressing just how controversial Kiefer's repeated invocation of the Nazi salute would have been, I want to juxtapose his painterly and photographic self-representations with the contemporaneous public gesture of Willy Brandt, captured and disseminated worldwide by journalistic photographers (Fig. 22). For in December 1970, while Kiefer was touring Western Europe and posing in mock Nazi regalia, Brandt, initiating a political policy toward Germany's neighbors in the East, *Ostpolitik*, went on a diplomatic trip to Poland, the first such trip by a West German chancellor. While in Warsaw, Brandt knelt, with hands clasped and head bowed, before Nathan Rappaport's memorial to the victims and freedom

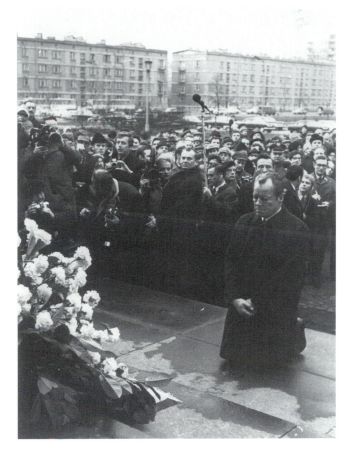

22. Willy Brandt kneeling before the Warsaw Ghetto Memorial, December 7, 1970. Photo: UPI/Bettmann.

fighters of the Warsaw Ghetto, Brandt's solemn and deferential posture a powerful testimony to the enormity of the legacy of the past and its losses. As the first West German head of state to assume such responsibility before such markers of loss and destruction, Brandt established a moral paradigm for his fellow citizens, a model that has seen its legacy in the speeches, gestures, and moral authority of Richard von Weizsäcker and its cooptation and corruption in the acts of Helmut Kohl, as, for example, at Bitburg.

Of course, in some ways Kiefer's posture in these early works *was* a

posture, an iconoclastic means of confronting the past and its legacy, by showing the persistent "presence" or legacy of fascism in present-day Germany. That I can now interpret these images, or at least frame a discussion of these images as acts of performative masquerade, may seem anachronistic or inappropriate. Similarly, that I can talk about these early works or his later paintings as Kiefer's attempts to "come to terms with past" or his attempts to perform "the work of mourning" may seem like a facile application of Freud via Mitscherlich. The mere fact of their emergence at a moment when German society was so preoccupied with the issue of the past is not enough to justify such readings. Nor is the intriguing fact that critics and art historians began to talk about Kiefer's work in these terms enough. But, that their operations and thematic preoccupations converge so persuasively with these theoretical models does open up a space for analyzing their interrelationship.

The very title of the series, *Occupations*, provides a way into such an analysis. "Occupations," in German *Besetzungen*, shares the military connotations of the English word. But in German, it is the word as well for the psychoanalytic concept of the amount of psychic energy invested in a given object. The Freudian term *Besetzung* translates into English as "cathexis," a concept that plays an enormous role not just in describing emotional and psychic attachments, but in the theorization of loss, trauma, and mourning.[23] Thus the title *Occupations* would suggest that Kiefer's act of dress up is not just one of masquerade – an act of role playing, costuming, theatricality, and surface – but one imbued with deeper psychological dimensions. As Kiefer himself stated: "I do not identify with Nero or Hitler, but I have to reenact what they did just a little bit in order to understand the madness. That is why I make these attempts to become a fascist."[24] I will address the Nero painting shortly. Presently, I want to point out how these early "attempts to become a fascist" are precisely such an act of repetitive "identification" with the paternal imago and, further, that it is this process of identification which consistently informs and dominates Kiefer's work.

In these early works by Kiefer, his own embodied subjectivity was absolutely central. He introduced a figure, a self-representation, who was iconoclastic, irreverent, and provocative. He took up the paternal

23. Anselm Kiefer, *For Genet,* 1969, pages 14–15. Watercolor on paper, graphite, original photographs, women's hair, and linen strips, mounted on cardboard; 69 × 50 × 8 cm, 24 pages. Private collection. Courtesy of Marian Goodman Gallery, New York.

legacy and the role of the father as a means of negotiating his own identity in relation to history. But Kiefer's operations of subjective identification were more complex than they might appear. Kiefer also assumed a subject position that thoroughly undermined the hypermasculine subjectivity of the Nazi. Put simply, he wore dresses.

As is demonstrated in the book project *For Genet* (Fig. 23), made in 1969 alongside *Heroic Symbols* and used as a partial source for *Occupations*,[25] Kiefer introduced a second subject position while still maintaining the first. In *For Genet,* subjectivity oscillated between two poles. One was the position of the Nazi, the other, the cross-dresser. For in this second role, Kiefer wore not his Nazi regalia but a simple white nightdress, and at other points, a dark, embroidered dress. In invoking the figure of Jean Genet, a more ambiguous and ill-defined subjectivity emerges. For not only does the invocation of Genet introduce homosexuality, the repressed subtext of the "fascist unconscious," it introduces the issue of Genet's own ambivalence vis-à-vis Hitler and the Third Reich.[26] The presumed binarism established between these two subject

positions, Nazism and homosexuality, is not as stable or as fixed as it might appear. In the ensuing collapse and breakdown of German masculine subjectivity evidenced in *For Genet*, what gets configured is less a simply binarized, schizophrenic subject position, oscillating between two poles, than one that implodes upon itself.[27] That it is the figure of the Nazi who looms everywhere in *For Genet* – even the feminized figure gives the Hitler salute – would suggest that perhaps it is Nazism itself, its history and legacy, which is the unassimilable kernel which makes impossible anything but a fragmented, schizophrenic, destabilized, finally, implosive identity.[28]

The *Occupations* series presents an interesting way of resolving, distilling, or repressing the thematic content of the earlier books. For the later photographic series deals only with the subject position of the Nazi, losing or sacrificing the ambiguity, duality, and embeddedness of the *For Genet* project, from which this series was in part culled. Nazism becomes the position of subjectivity against which Kiefer must negotiate his own. In other words, Nazism frames his identity. And, I would argue, Nazism continues to "frame" his identity, even when he stops masquerading as a Nazi, even when he stops literally cloaking himself, bodily, in its material signifiers.

Significantly, in his monumental painted work that followed these photographic and painterly self-portraits, although Kiefer the embodied subject disappeared, neither the frame – Nazism – nor the act of self-portraiture – Kiefer representing himself – followed suit. In other words, although these paintings moved away from the theatricality and externality of the act of masquerade, Kiefer as artistic and subjective agent remained amazingly visible. Further, with their almost obsessive engagement with a painterly world of symbols and referents Germanic, from myths of the Nibelungen to Wagnerian libretti to Nazi architecture and battle plans, Nazism was the thematic frame for his images. Moreover, this framing was literalized in that he used these Germanic spaces, either deeply recessional architectural spaces or vast landscapes, pressed to the very edges of the picture frame, as the space of ontological exploration.

Let me begin to trace the way in which Kiefer's work furthered the exploration of subjectivity. As I have already suggested, during the 1970s, Kiefer came to evacuate himself as embodied subject from the

24. Anselm Kiefer, *Nero Paints,* 1974. Oil on canvas; 220 × 300 cm. On loan to the Staatsgalerie moderner Kunst, Munich. Collection Prinz Franz von Bayern, Munich. Photo: Staatsgalerie, moderne Kunst München.

canvases. The self-representation, exteriority, and theatricality of masquerade shifted to the interiority of symbolic configurations. That symbolic configuration was the artist's palette.[29] As is demonstrated in *Nero Paints* of 1974 (Fig. 24), a palette armed with flaming brushes and inscribed across a precipitously pitched landscape, ignites a small Russian village, its national identity indicated by what might be read as a church with an onion dome. The flaming Russian village and the almost cauterized looking surface[30] alludes quite evocatively to the scorched earth campaigns of the Nazi military in the East.

As in Kiefer's earlier poses before monuments to imperial greatness, leaders and empires are conflated into an amalgam of authoritarian subjectivity. To be sure, Nero was in many respects an impotent son himself, the last in the line of the Julio-Claudian empire. But as ineffectual as Nero ultimately was, Nero, like Hitler, like the German soldiers of the scorched earth campaigns, represent subject positions that

Kiefer feels he must occupy and enact in order to understand "the madness." They are subject positions with which he "identifies," despite his claims to the contrary. *Nero Paints* is a transitional painting in his pictorial articulation of identity because Kiefer at once identifies with and is enframed by evocations of empire and Nazism. His identity is still merged with that of the historically tainted paternal signifier, even if displaced into the symbolic realm as well. In *Nero Paints*, he wears that history much as he wore Nazi regalia.

In the years that followed, the attributes and deployment of the palette underwent a process of significant transformation. By 1977, when Kiefer painted *Palette on a Rope* (Fig. 25), the palette of Kiefer/Nero had lost the power not just to create but to imperil and destroy. Instead, the palette itself was in danger of destruction, sus-

25. Anselm Kiefer, *Palette on a Rope*, 1977. Oil, emulsion, shellac on canvas; 130 × 160 cm. Private collection. Courtesy of Marian Goodman Gallery, New York.

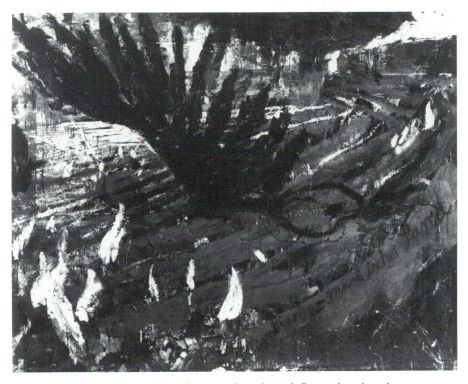

26. Anselm Kiefer, *Icarus – March Sand,* 1981. Oil, emulsion, shellac, and sand on photograph, mounted on canvas; 290 × 360 cm. Private collection. Courtesy of Marian Goodman Gallery, New York.

pended as it was by two flaming skeins of paint. In 1981, the palette was given a set of wings and emerged in its ultimate and recurring incarnation as Icarus, the doomed son. In *Icarus – March Sand* (Fig. 26), poised against the Prussian landscape of the Brandenburger Heide, the flying palette that is Icarus and Kiefer succumbed not to a mythical sun above but, rather, to a historical fire beneath.

Kiefer's implementation of the myth of Icarus and Daedalus literalizes filial thematics, thus not only evoking but depicting a son literally weighed down by his identity and doomed, as in the case of Icarus, to death. By representing Icarus as palette, Kiefer inserts himself, as son and artist, into his work. Moreover, he inscribes himself as a victim, victim of the historical legacy, of the paternal legacy, against which he has tried so hard to articulate and negotiate his own identity.[31]

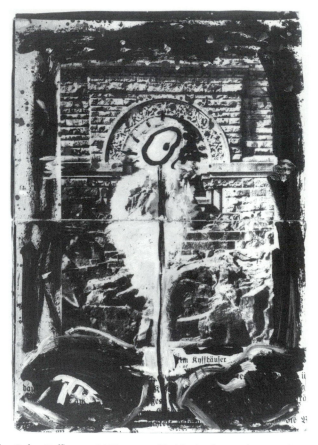

27. Anselm Kiefer, *Kyffhäuser*, 1980, pages 28–29. Acrylic, emulsion, and watercolor on original photographs, mounted on cardboard; 60 × 42 × 8 cm. Francesco Clemente Collection, New York. Courtesy of Marian Goodman Gallery, New York.

This thematic falling, this succumbing to the fires and forces of a paternally indexed history, this symbolic movement toward a subject position of victimhood is cemented in his book project *Kyffhäuser* of 1980–1 (Figs. 27 and 28). The palette, inscribed for the first time against an architectural backdrop, enframed by the architectural spaces of Nazism, is given a very particular identity. In the overpainted, photographic images of the project, the "Unknown Soldier" is replaced, textually and iconographically, with the "Unknown Painter." *Soldat* is crossed out and changed to *Maler*, and the form of

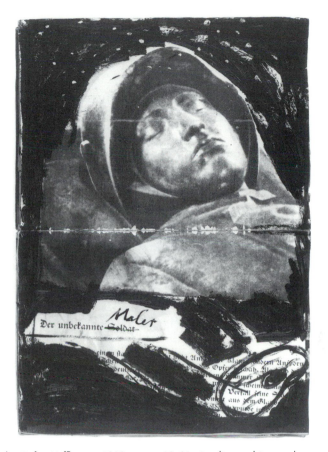

28. Anselm Kiefer, *Kyffhäuser,* 1980, pages 30–31. Acrylic, emulsion, and watercolor on original photographs, mounted on cardboard; 60 × 42 × 8 cm. Francesco Clemente Collection, New York. Courtesy of Marian Goodman Gallery, New York.

the palette emerges as the signified victim. Kiefer no longer constructs himself as the mythic victim Icarus. Instead, he constructs himself as a victim of history, the war-dead, the unknown soldiers of the Third Reich. And yet, Kiefer was not and is not a victim of the historical past. If anything, he is heir to a tainted historical legacy.[32]

Kiefer's ensuing series *To the Unknown Painter* (Fig. 29), which features the palette, mounted upon a pedestal and enshrined within the deeply recessional spaces of Speer's Mosaic Room of the Reich's Chancellery, becomes a memorial to Kiefer's own sense of victimhood,

his painterly response to his own sense of a threatened, eroded, or untenable identity. Rendered both with the grandeur of large-scale oil and the intimacy of watercolor, the painter is not "unknown." He is Anselm Kiefer.[33]

In these emptied interiors of Nazi architecture in which Kiefer configures his own victimhood, Kiefer constructs a commemorative, or memorializing, space. But in that the self-reflexive act of mourning takes the place of mourning for historical victims, these spaces present another sort of commemorative architecture. They become at once shrines to Kiefer's own sense of victimhood and the visualization of a space for preserving that which cannot, or will not, be mourned. For the inability to mourn, the inability to deal with traumatic memory, forces within the ego the construction of a place for the repressed or forgotten memory. It is the space of internalization, the space within the ego set up for the lost object, for its burial or entombment. It is a place that might be envisioned, given these psychological operations of repression, of submersion, as a crypt.[34]

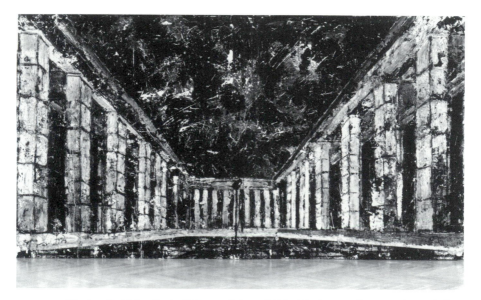

29. Anselm Kiefer, *To the Unknown Painter,* 1983. Oil, Aquatec, latex, emulsion, shellac, and straw on canvas; 208 × 381 cm. Collection of Celine and Heiner Bastian, Berlin. Courtesy of Heiner Bastian Fine Art, Berlin.

I would argue that Kiefer's insistently dark, somber, windowless chambers, his deeply elegiac evocations of Nazi architectural structures, are those psychic spaces of repressed memory. And in his assumption of the subject position of the victim, Kiefer effectively emerges pictorially in the very space of psychic entombment, of repression. What emerges from these spaces then is less repressed historical memory — the catastrophic history inflicted by the Nazis upon millions of their victims — than the scene of its repression.

The trauma of the historical catastrophe that was Nazism is configured, walled off and walled in, by the very concretized structures of Nazism itself. In other words, the walls of the crypt — the form that frames, defines, and confines the space of repressed memory — embody the repressed memory itself. The repressed memory is so traumatic that even in its revealed state it "encrypts" itself, it walls itself off, leaving memory as inaccessible and as remote as before. The psychic space of the crypt, the visual space of the Nazi interior in Kiefer's paintings, is then a space which preserves that which cannot yet, or, without the suspension of the oedipal structure, ever, be mourned. In that space, the figure of the artist emerges, as palette, but still unable to configure the traumatic kernel that is the repressed history, memory, and guilt of his country. Instead, Kiefer, in the form of the palette, places himself in the darkness of this psychic tomb. He becomes a victimized dweller in this temporal and spatial netherworld that is at once his traumatic history and his deferred and inherited psychic trauma.

To be a German and to image or imagine oneself as victim is a deeply problematic position, one whose moral and ethical complexities are crystallized in the memorialization of war victims at Bitburg, and in more recent remembrances of the victims of Stalingrad or Dresden. To separate victims and perpetrators of Nazi terror is one matter. To take on the task of working through by pictorially enacting victimization is another. Rather than manifest an experience of guilt associated with a history of *victimizing* and domination, Kiefer problematically assumes the subject position of victim — a victim of a burdensome historical legacy, a deferred trauma and the loss of the ability to be unselfconsciously German.

If that subject position of victimhood is most emphatically allegorized in the enshrined and encrypted palette paintings, I would suggest that the thematic inscription of artist as victim has been, and continues to be, a recurrent thematic in Kiefer's work. That is to say, the winged palette is perpetuated, transformed, and aggrandized in Kiefer's sculptural works and paintings of arrested flight, ranging from the 1984–6 painting *The Order of Angels*, its encrusted canvas mounted by a tilting, leaden propeller, to such sculptural works as the impossibly leaden airplanes of *Poppy and Memory* (Fig. 30), *Melancholia*, and *Jason* of 1989 and *Voyage au bout de la nuit* and *Elisabeth* of 1990.

But perhaps even more significant, from the very earliest of moments in his career there exists a small but haunting watercolor that most clearly and emphatically thematizes and visualizes the artist as victim. If it is characteristic of the peculiar temporality of trauma

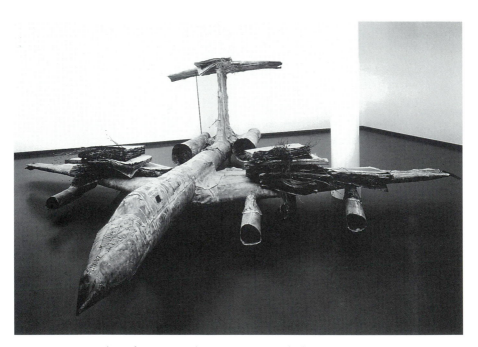

30. Anselm Kiefer, *Poppy and Memory,* 1989. Lead, glass, poppies; 2.5 × 6 × 6 m. Sammlung Marx, Berlin. Courtesy of Heiner Bastian Fine Art, Berlin.

that the past asserts itself upon the present with a willful and unpredictable rhythm, it is perhaps not surprising that at the earliest moment of its emergence, the traumatic past would appear most vividly, only to be cloaked and disguised in its later appearances. In 1970, Kiefer produced a delicately rendered watercolor entitled *Winter Landscape* (Fig. 31). Although the watercolor has never been linked to Celan's "Fugue of Death," which I discussed at some length in the prior chapter, I would suggest that its watery evocation of a disembodied head, a head at once resting in a sea of dark, billowing clouds and spilling blood upon a desolate, snow-covered German landscape, gives us its subject, with a figurality and presence that uncannily reproduces both the content and tone of Celan's poem. The head, ringed by dark clouds and ashen hair, visualizes not simply Celan's refrains "black milk of daybreak" and "you'll rise then as smoke to the sky, you'll have then a grave in the clouds there you won't lie too cramped," but, in the end, Sulamith, Celan's figure for Jewish womanhood and victimhood.

If that coincidence of subject were not enough, suggesting that at the very outset of his career Kiefer produced work that took on the legacy of the Holocaust, as figured in Celan's poem, a further point may render this early watercolor even more uncannily unsettling. For the watercolor may indeed be a self-portrait.[35]

Clearly, the years 1969–71, into which the watercolor falls, were a moment in Kiefer's career when he occupied himself to a great degree with the form of the photographic and painterly self-portrait. That the beheaded figure hovering above the blood-stained landscape may be Kiefer, and, moreover, may constitute an early and portentous conflation of the artist with the quintessential Jewish victim, not only further secures the thematic significance of the Icarus/palette paintings and sculptures but opens up the possibility that even Kiefer's 1983 *Sulamith* may be linked to this series of symbolic self-portraits, where the tangle of flames thought to be a menorah may, in fact, also resonate as the flames by which Icarus, in his doomed flight, and Kiefer, in his historically compromised artistic project, were and are engulfed.

Returning, in conclusion, to the historically specific oedipal logic that inscribed itself within, or perhaps even produced, a great deal of

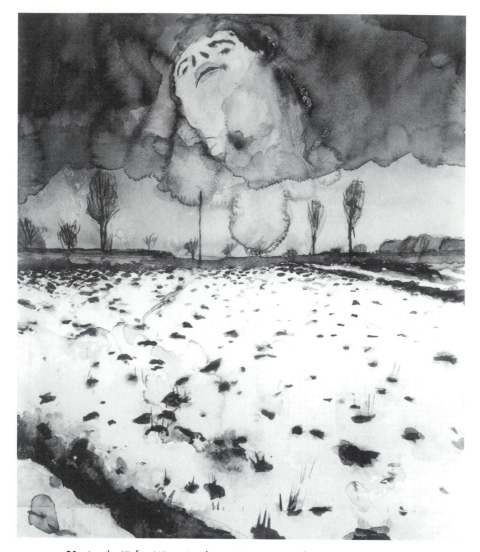

31. Anselm Kiefer, *Winter Landscape,* 1970. Watercolor on paper; 43 × 36 cm. Courtesy of the Metropolitan Museum of Art, New York. All rights reserved. The Metropolitan Museum of Art.

postwar German culture, we see the questions remain as to how to come to terms with Kiefer's visual articulation of a subject position. Why should a discredited father, or paternal signifier, a tainted history, produce such a thematic of victimization? Or, as Eric Santner asks in his study of postwar German film, *Stranded Objects:* "If, as

Lacan and others have suggested, all mourning must pass through the instance of the paternal signifier, be performed, at some level, in the Name-of-the-Father, how might this be done when it is the fathers who have littered the path with so many dangerous splinters and shards?"[36]

The phrasing of Santner's question at once demands an answer and yet suggests that the question can be answered only in the negative. It suggests that given the particular historical circumstances, mourning cannot happen. And yet, given the historical circumstances, it must. As such, the desire for and yet the impossibility of an authentic act of mourning has close structural and moral parallels to another postwar paradox, that engendered by Adorno's later qualified dictum on the impossibility of (aesthetic) representation after the Holocaust. That is, the very horror, exceptionality, and incomprehensibility of the Holocaust that would demand its remembrance at the same time forbids its expression.

In the preceding chapter, I have discussed how Kiefer produces work that moves from biblical stories of Moses and Aaron to the Iconoclastic Controversy to Paul Celan's "Fugue of Death" to Kabbalah. It is work that effectively, in its aesthetic self-definition between the fields of figuration and abstraction, thematizes and instantiates both Adorno's dictum and, moreover, its qualification. For in the very act of being, it foregrounds the importance of image making, while at the same time, it insistently thematizes its impossibility. Similarly, just as the enormity of history would demand an act of mourning, the very enormity of the trauma would seem to preclude the possibility of that mourning ever taking place.

But perhaps the structural parallel should be brought no further. For just as the Mitscherlichs's *The Inability to Mourn*[37] framed less an inability than an unwillingness to mourn – a work predicated on the assumption that it is the loss of Hitler as ego ideal, not the loss of the Jews, which must be mourned – it would seem that Kiefer's work presents us with a similar proposition. Despite a persistent reception history since the mid-1980s that has framed Kiefer's work as performing the work of mourning, it would seem that the only work of mourning performed is self-reflexive. Kiefer's work immerses itself in the history and historical legacy of Nazism and, at the same time, its thematics

bespeak the impossibility of continued paternal identification. Thus, ironically and (perhaps) inappropriately, it can articulate that impossibility only as a loss, a loss in which his own ego, his own identity, as son, as painter, as German, is impoverished.

In these images, then, it would seem that Kiefer commits the undignified act of conflating his own sense of loss with that of history's, and Germany's, original victims. In the end, what is carried out, if only belatedly and symbolically, is that very work of mourning which the Mitscherlichs prescribed, the grappling with the loss of a paternally indexed ego ideal.[38] But we do not see the work of mourning projected beyond the narrow confines of Kiefer's own impoverished sense of identity. Whether historically inevitable or individually determined, the mourner becomes melancholic,[39] and the possibility for a positive or future identity is consumed by the repetitive operations of an artist unable, or unwilling, to configure the traumatic kernel which is the repressed history and memory that is his father's, his country's, and his own.

3 THE SONS OF LILITH

Mourning and Melancholia, Trauma and Painting

It is certain that the cloak of silence in which, for political reasons, Nazism was enshrouded after 1945 has made it impossible to ask what will come of it in the minds, the hearts, the bodies of the Germans. Something had to come of it, and one wondered with some trepidation in what shape the repressed past would emerge at the other side of the tunnel: as what myth, what history, what wound?

– Michel Foucault

What is the relation between traumatic historical memory and painting? Can painting mourn, perform the work of mourning, or is it melancholic, a petrified object, an allegorical fragment, a ruin, whose meaning, whose resolution, is necessarily deferred in an endless chain of signification? In Kiefer's oeuvre, the possibility of painting, the category of painting, even as it persists, is always already inscribed within a metaphorics of impossibility, where no painting, no aesthetic object will ever be commensurate with or appropriate to the trauma that it takes as its grounding subject. In that respect, it would seem that Kiefer's painting, Kiefer's aesthetic project, is necessarily melancholic, for it bespeaks in its ossified, at times even charred, and ruinous surfaces and constructions the inevitable failure of its presumptive project. Further, if Kiefer's works themselves appear as already ruinous, so too do their thematic inscriptions give way to the

figuration of a subjectivity in ruins, in which the authorial subject is literally consumed by a deferred confrontation with history and its legacy, reduced to the inward-looking gaze of mourning's other, melancholia.

And yet, as inward looking as that melancholic gaze may be, Kiefer continues to produce art, enacting less the paralytic state of the clinical melancholic than the unbounded creative achievements of the humanist artist-genius. In fact, it may be from the very position of the *humanist* melancholic, not the Freudian or Mitscherlichian melancholic, that Kiefer defines his artistic production. To be sure, the psychoanalytic concept of melancholia, or blocked mourning, as articulated by Freud in 1917 and as taken up by the Mitscherlichs in 1967 to describe or explain what they saw to be the cultural and creative lacunae of a postwar German nation "unable," or perhaps more accurately, unwilling, to mourn, constructs melancholia as a crippling state of psychological torpor. However, it would seem that Kiefer, for all of his rootedness in the historical specificity of the twentieth century, comes to enact strategically in his work a conception of melancholia that transcends, if not negates, its twentieth-century psychoanalytic inscriptions and embodies instead that privileged state within a humanist, or modernist, conception of the artist, that state which is the very site of, or condition for, creativity and genius.[1] Or does he? What, in fact, do Kiefer's works do? Do his works figure and configure melancholia and, moreover, melancholically? Is there what might termed a quite complicated, if not conflicted, semiotics of mourning, melancholy, and trauma operative in his work?

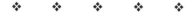

As a point of departure, I would like to make the observation that it is in the mid-eighties, in the aftermath of the *To the Unknown Painter* series and Kiefer's thematic inscription of his own melancholy subject position, that Kiefer's paintings become self-proclaimed melancholy objects. Let me begin my discussion by way of example. If the inadequacy and impossibility of art is most emphatically imaged in Kiefer's *Fallen Pictures* of 1986 (Fig. 32), in which a lead-backed photo-

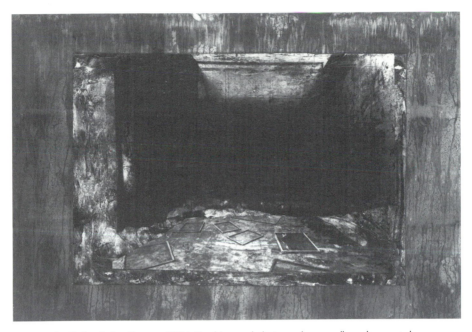

32. Anselm Kiefer, *Fallen Pictures,* 1986. Emulsion and photograph on cardboard, mounted on lead; 102 × 141 cm. Collection of Mr. and Mrs. David Pincus, Wynnewood, Pennsylvania. Courtesy of Marian Goodman Gallery, New York.

graphic image reveals an abandoned room strewn with empty picture frames, more forthrightly iconoclastic than any of the works that explicitly reference the iconoclastic proscription, Kiefer's melancholic art objects that ensue come to articulate their ostensibly melancholic identities with semantic force and clarity. That is, works like *Saturn Time,* the *Lilith* series, *Melancholia,* and *Black Gall,* all of which emerged after the palette/painter series, bespeak in their very titling, if not their iconography and material identities, their melancholic dispositions.[2] Most obviously, the titular invocations of Saturn, Lilith, melancholia, and black gall locate the semantic field of each work within a discourse of melancholia. But if their respective titling would seem to locate the semantic field anywhere in and between humanist, kabbalistic, and psychoanalytic constructions of melancholia, it is the pictorial and material iconography which shifts that semantic field more decisively, if only superficially, into a humanist past.

This semiotics of humanist melancholy is most emphatically, literally, at work in Kiefer's image *Melancholia* of 1988 (Fig. 33). A massive work of photographic collage, the composition is built upon a ground of acid-treated lead. Much like the image *Fallen Pictures*, in this photographic image Kiefer presents a studio space strewn with stacked canvases, empty frames, and empty exhibition vitrines. But if the photograph would seem to recapitulate the scene of ruin and aesthetic abandonment figured in *Fallen Pictures*, it is an additional sign that situates this image, at least initially, within the humanist legacy of melancholia. For affixed in the center of Kiefer's massive photograph is a geometric form, a polyhedron. The polyhedron, which appears as well as a figure in the painting *Black Gall* and as a three-dimensional object atop the wings of Kiefer's airplane project *Melancholia*, both of

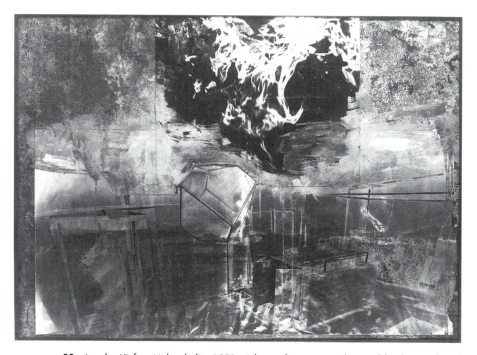

33. Anselm Kiefer, *Melancholia*, 1988. Ash on photos on acid-treated lead in a glazed steel frame; 170 × 230 cm. Private collection. Courtesy of Marian Goodman Gallery, New York.

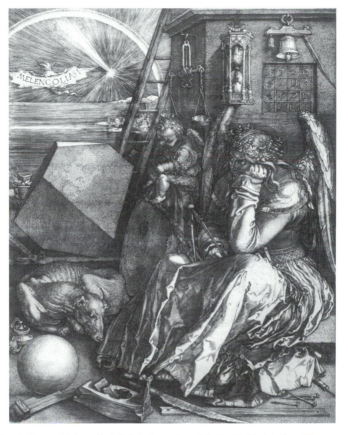

34. Albrecht Dürer, *Melencolia I*, 1514. Engraving; 9 1/2 × 7 5/16 inches. Courtesy of the Philadelphia Museum of Art: The Lisa Norris Elkins Fund.

1989, is a direct quotation of the polyhedron in Albrecht Dürer's engraving *Melencolia I* (Fig. 34).

In the classic art-historical reading of Dürer's engraving, that is, in the writings of Erwin Panofsky, Raymond Klibansky, and Fritz Saxl, Dürer's rendering of melancholia is interpreted as representing a triad of Saturn, Melancholy, and Geometry, of scholastic activity and melancholic inactivity fused into one symbolic figure. This fusing, for them, is "an act equal to the merging of two different worlds of thought and feeling – he (Dürer) endowed one with a soul, the other with a mind. He was bold enough to bring down the timeless knowledge and method

of a liberal art into the sphere of human striving and failure, bold enough, too, to raise the animal heaviness of a 'sad, earthy' temperament to the height of a struggle with intellectual problems."[3] In this struggle between the ideals of rationality and the opposing forces of irrationality figured in Dürer's engraving – one that ultimately rejects the medieval understanding of melancholia as an unattractive and undesirable state and replaces it with an understanding of melancholia as the temperament of genius – there nonetheless lingers the image of the melancholic, even when he assumes the mantle of artistic genius, as a figure who will yearn for but never quite achieve the heights of his ambition.[4]

That Kiefer's polyhedron is pictorially overwhelmed by an immense, looming cloud of fire is doubly significant. In thematic terms, the flaming form distinguishes Kiefer's *Melancholia* from Dürer's *Melencolia I* in significant ways. For in Kiefer's work, it is not the rays of the sun, of reason that rise above the polyhedron, bathing it in a glow of enlightened illumination, but, instead, the fires of history and postenlightenment doubt and skepticism that threaten to consume the polyhedron and its attendant humanist subjectivity. However, rather than underscore the ways in which the semiotics of *Melancholia* repeat Kiefer's prior inscriptions of the artist self as melancholy genius, a grounded Icarus who strives for the unattainable, I want to turn to the ways in which that fire signals not, or not only, a melancholic subjectivity but an aesthetic practice that is at essence deeply melancholic.

For if Kiefer creates images *of* fire, in the painterly flames that emanate from Nero's palette or from the tips of Margarethe's straw-based hair, he also creates images *with* fire. One might, in fact, point to the very moment when Kiefer starts burning, charring, or "cauterizing" his surfaces. It is in 1975 that he starts destroying as a process of creating, starts creating works as wounded beings, as ruins, inflicting upon his work the masochistic and self-destructive impulse of the melancholic. It is in 1975, at the very same moment that the exteriority of performative masquerade gives way to the interiority of symbolic embodiment, that melancholia starts to inform his aesthetic practice. That is, it is not only artistic subjectivity that is forever

scarred by history and its legacy but, on my account of Kiefer's paint-
ing, the aesthetic object too that is wounded and disfigured, if not
entirely destroyed.

From the outset of his career, Kiefer's works have thematized and
visualized the concrete trace of historical wounding. Beginning in the
delicate watercolor of 1970, *Winter Landscape* (Fig. 31), the unnamed
victims of Germany's history, personified in one beheaded figure, be it
Kiefer, Sulamith, or some nameless amalgam of the two, drip blood
upon a snow-covered field. Perhaps culminating in the monumental
painting *Varus*, of 1976 (Fig. 35), an image commemorating, or at
least referencing, the founding historical battle of the German nation,
waged between the troops of the Germanic leader Arminius (Hermann)
and the Roman soldier Quintilius Varus, history leaves an eternal pat-
tern of blood stains on the Teutoburg Forest floor. In each picture,

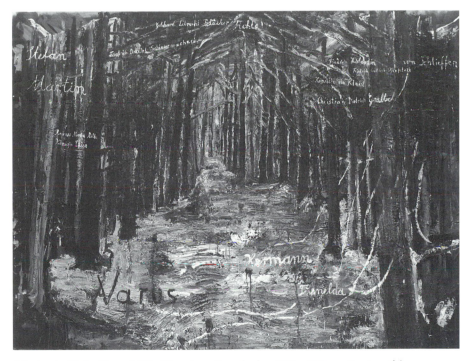

35. Anselm Kiefer, *Varus*, 1976. Oil and acrylic on burlap; 220 × 270 cm. Courtesy of the
Stedelijk Van Abbemuseum, Eindhoven, The Netherlands.

history metaphorically inscribes its losses in the form of blood upon the German soil, *Blut* upon the German *Boden*.[5]

But if Kiefer continued to trace the militaristic triumphs and tragedies of German history, from Hermann to Hitler, it was only in the 1975 project *Cauterization of the Rural District of Buchen* (Fig. 36), that Kiefer literalized that history of destruction by carbonizing, or burning, a series of canvases and then binding them together in the form of a book. If the contemporaneous reference of the Buchen project was to the environmental danger of benzine stored in a military installation[6] and another, art historical, to the aesthetic project of Lucio Fontana, to the very literal destruction of painting, its historical references were at once to the scorched earth military campaigns carried out by Hitler's armies in the East, to the book burning, looting, destruction, and killing of Kristallnacht, and perhaps even to another forest of beech trees, Buchenwald, and, in turn, the fires of the crematoria. In the *Buchen* project, if only in the *Buchen* project, the wounds that first saw their semiotic inscription in the iconography of Kiefer's painterly surfaces (i.e., the spatters of red paint or watercolor as blood), came to subsume the canvas, here transformed into a book, turning the entire object not simply into a sign of wounding, but a literal and concretized wound, a petrified object engulfed by the fires of history and artistic creation.[7]

Although future Kiefer projects never fully gave themselves over to the thorough charring witnessed in the Buchen project, ash did become an integral material component of Kiefer's densely textural aesthetic surfaces. Furthermore, by the 1980s, when lead became a standard element in Kiefer's work, that process of burning, of using fire, produced not the material trace of destruction (i.e., ashen residue) but, instead, the concretized trace of its transformative possibilities. That lead emerges in this period as either figurative presence or aesthetic ground suggests an aesthetic investment in a material semiotics of melancholy. For lead, that base material of alchemical transformation, is also, and perhaps most notably, the attribute of Saturn. And leadenness, as conceived in the postwar present, takes on the metaphorical capacity to describe if not the psychic state of melancholia, then the constricted and repressed social state of melan-

36. Anselm Kiefer, *Cauterization of the Rural District of Buchen,* 1975, pages 60–1. Fragments of original photographs with ferous oxide and linseed oil (oil on burlap); 61 × 42 × 8 cm; 74 pages. Private collection. Courtesy of Marian Goodman Gallery, New York.

cholia, as described by the Mitscherlichs. In the aftermath of the Mitscherlichs's work, that leadenness becomes quite literally the postwar present of the *die bleierne Zeit,* ("the leaden time"), as it is evoked and thematized so powerfully in Margarethe von Trotta's 1981 film of that title (although I should note that metaphor is absent from its English-language version, *Marianne and Julianne*).

Further, the lead in Kiefer's work, made malleable and fluid only in its molten form, is a material element that encodes within its very being its transformation through fire. Thus, the leaden elements of Kiefer's work appear only after they have been subjected to the extreme heat of a fire. If the original meaning of trauma, or "wound," was an injury of the body and only later, and most centrally in Freud, came to be understood as a wounding of the psyche, or mind, it is Kiefer's work that underscores the doubleness, the restiveness, of its

meaning. For as much as Kiefer's surfaces bear the trace of a physical wounding, as much as they embody physical woundedness, their insistently referenced context of post-Holocaust Germany situates that wound in a psychic sphere as well. Further, whereas the physical wound heals, leaving perhaps only a trace as scar tissue, the psychic wound may never heal. And Kiefer's paintings, frozen as they are in time, will never heal. They are trapped in a perpetual present, they remain concretized as an always open wound.

It is in this creation of the painting, of the pictorial surface, as wound, and in this aesthetic enactment of transformation, that Kiefer may be seen to most closely follow in the tradition of his teacher, Joseph Beuys. But it is less their shared interest in alchemy, in processes of transformation, that I want to discuss, than their shared interest in the wound, in the physical manifestation of trauma. As early as 1960, Joseph Beuys gave his audiences an aesthetic object contextualized as wound. Beuys's *Bathtub*, a re-presentation of a tub from the era of his childhood, appears not as a pristine porcelain piece that might be seen to reenact the iconoclastic gesture of Duchamp's 1917 ready-made, but, instead, as a battered and vulnerable object, held together with strips of bandage.

In the individual mythology of Beuys, typified by a fusing of fact and fiction, Beuys's 1921 birth in Krefeld is transformed into a symbolic birth in "Kleve," or Cleves, a place that suggests in its relation to the doubly inscribed word "cleave" an action of adhering and splitting, a state of unity and division, a moment of continuity and rupture. As Beuys wrote of this piece, and his birth, in his *Life Course/Work Course*, 1964, the *1921 Cleves: Exhibition of a wound drawn together with plaster*, represented "the wound or trauma experienced by every person as they came into contact with the hard material conditions of the world through birth."[8] That trauma of birth, the trauma of cleavage and separation, was reimagined by Beuys in his story of his traumatic crash in the Crimea in 1943, his near-death experience and eventual rescue at the hands of the Tartars, who wrapped his frozen body in fat and felt.[9] And that formative, if mythic, experience became the foundational event in an artistic career at least in part defined by a shamanistic belief in the powers of transformation and healing, in the therapeutic powers of art and artist in society.

It is with a brief discussion of two Beuys projects, *Coyote* of 1974 and *Show Your Wound* of 1976, that I would like to conclude my treatment of Joseph Beuys. For in these two works, the former, a performance piece in which Beuys was carried on a stretcher into a gallery space in New York in which he cohabitated with a coyote, and the latter, conceived after a severe illness and consisting of an underground pedestrian passage in Munich, filled with pieces of mortuary equipment and dissection tables from a pathology lab, Beuys dealt explicitly with trauma and its wounds, both physical and psychic. Significantly, neither piece dealt with a trauma that was uniquely, if at all, German. *Show Your Wound* recapitulated the attention to Beuys's personal suffering, initiated at the moment of his birth and repeated in his moment of rebirth in the Crimea, whereas *Coyote*, alternately titled *I Like America and America Likes Me*, was a performance that referenced America's own repressed history of trauma and guilt, that involving Native Americans, rather than Germany's and his own.

If the emphatically imperative *Show Your Wound* suggests a call for an end to repression, a call to lay bare and to bear the visible signs of one's traumatic past,[10] it signals more directly an invitation to self-memorialization, an invitation to take up an emphatically melancholic subject position, one that Kiefer assumed as well in his *To the Unknown Painter* series. But unlike Beuys, who saw his role and work as shamanistic and therapeutic,[11] Kiefer has never explicitly contextualized or described his work in such terms. It is in their reception, the history of which I will discuss in the ensuing chapter, that such therapeutic ends have been ascribed to Kiefer's aesthetic project. If anything, in their instantiation and thematization of art, and artist, as wounded and victimized by the burdens of history, they may bear a more direct resemblance, at least on a thematic level, to the paintings of Jörg Immendorff, where that wounding and trauma are explicitly situated in the context of the postwar present. In such works as *Seam*, of 1981 (Fig. 37), Immendorff symbolizes a divided Germany, a Germany cleaved in two, the Brandenburg Gate, that sign of division, rendered as a scar, a red and bleeding wound, etched upon the surface of a frozen, five-pointed star.

If German painting after Auschwitz, if German painting in a divided Germany, exists only as concretized or thematized wound,

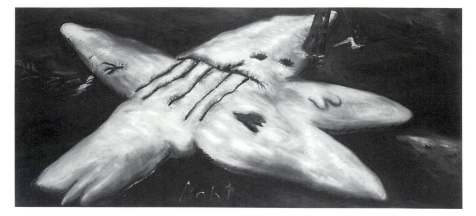

37. Jörg Immendorff, *Seam*, 1981. Oil on canvas; 180 × 400 cm. Courtesy of Galerie Michael Werner, Cologne and New York.

that woundedness is only underscored in the deeply elegiac tone that accompanies Kiefer's monumental work. In its evocations of incipient ruins and cryptlike spaces, in its reliance on processes of destruction, encrustation, and sedimentation, and in its quite literal participation in a natural process of dissolution and decay, Kiefer's work bespeaks an aesthetics that is deeply melancholic.

In his metaphorical movement into the depths of the German psyche, in his progression from the rendering of attic spaces, as in *Nothung* (Fig. 38) to the rendering of insistently dark, somber, windowless, monumental chambers, Kiefer departs from a German vernacular architecture of the pitched roof and moves into the historically specific architecture of Nazism, an architecture to which the filmmaker Peter Cohen refers, in his 1992 film of the same title, as "the architecture of doom." These architecturally exacting spaces painstakingly communicate the physical detail of their Nazi sources and suggest in the material accretion that overwhelms their surfaces a future present as ruin, an enactment of their very future projected by Hitler and his architects. Built as monumental ruins, Kiefer's paintings encode and begin this unfulfilled material destiny, layering oil paint, straw, ash, emulsion, shellac, and other materials over their photographic bases. His technique creates a painterly surface with a dense

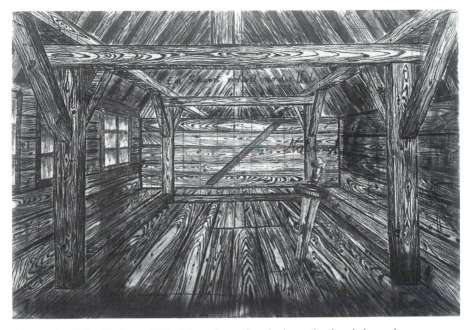

38. Anselm Kiefer, *Nothung,* 1973. Oil on charcoal on burlap with oil and charcoal on cardboard; 300 × 432 cm. Courtesy Museum Boijmans Van Beuningen, Rotterdam.

materiality, one that, given the fragility of the materials employed, already hovers on the brink of disintegration and decay, an aesthetic as steeped in the Romantic fascination for the ruin as in the aspirations of the Thousand Year Reich.

❖ ❖ ❖ ❖ ❖

The ruin, the quintessential allegorical object, is the Benjaminian object that becomes so under the gaze of melancholy. The ruined object is lifeless, empty of immanent meaning, and enlivened with meaning, with significance only by the allegorist, through whose necessarily palimpsestic process other objects may be seen, other works may be read, and, perhaps in the end, history may be witnessed, confronted, if only through the acknowledgment of its ultimate inaccessibility.[12] Within the ruinous architecture and upon the scorched landscapes that

so define and characterize Kiefer's output, within and upon the deadened traces and representations of sites of historical trauma, the allegorical, if not the allegorist, emerges. That is, the deadened objects, inanimate, absent of all but imbued meaning that populate Benjamin's theorization of allegory, may come to find their most powerful and acute visualization in Kiefer's work – his landscapes, for example, uncannily embodying the allegorical conception of "history as a petrified, primordial landscape."[13]

Yet, as uncannily easy as the fit may seem between Kiefer's paintings and Benjamin's theory of allegory, Kiefer, despite his own invocations of Benjamin in his titles, presenting himself and his work as "the angel of history,"[14] may not ultimately be the historical repetition or reincarnation of the angelic Klee figure who inspires Benjamin's theses of history. Kiefer's works, despite their dialectical operations, their signifying practices, their elegiac tone, and their thematic preoccupations, may not be the insistently melancholic works they proclaim themselves to be. For as petrified and ossified as his ruinous pictorial surfaces may appear, as leaden and frozen in place as his massive sculptural works may seem, as nostalgic, melancholic, and elegiac as his work, in both its materiality and thematics may be, as much as time, the very cornerstone of the work of mourning, would seem to disappear from the very frozenness, the very stillness of the material object, Kiefer's works are nevertheless the site for, and were once the site of, movement and inscription and function as, as Benjamin writes of the *Trauerspiel* ("the *mourning* play"), "the transposition of the originally temporal data into a figurative spatial form."[15]

Moreover, beyond the implied movement that once brought into being his and any work of art, that Kiefer's works lead into the crypt, the architectural spaces of the tainted past, the recesses of collective memory that could be seen to haunt and animate his work, may suggest a different but equally compelling metaphor for describing Kiefer's aesthetic project of historical remembrance, its anamnetic function, that of archeology. For Kiefer may be seen to dig through layers of memory, literal and metaphoric, if only potentially to be overwhelmed, much as his surfaces ultimately are, by the very past that he uncovers. That is, even as Kiefer's work enacts materially and

thematically, the melancholy impulses of repetition, entombment, burial, and repression. considered more broadly, his work may be seen to enact the activity of the archeologist – or, to change metaphors, the analyst, whose job it is not simply to uncover but to facilitate the analysand's retrieval of buried memories. That work of excavation, a psychoanalytic and archeological project, is in part what is manifestly at work in Kiefer's project.

Pursuing this archeological/analytic metaphor further, I might well turn, albeit briefly, to two films that narrativize such archeological operations of memory and, more specifically, historical memory. Alexander Kluge's 1977 film *The Patriot* presents Hannelore Hoger in the role of a frustrated secondary school history teacher. Infuriated by the totalizing, and often obfuscating narratives of conventional historical practice, she is determined to present to her students a history of the marginal, the forgotten, and the repressed. Literally digging up and uncovering history, she embarks at night upon archeological expeditions to supplement the inadequacies of current historical teaching. Michael Verhoeven's 1989 film *The Nasty Girl* turns the actual story of a German historian from the Bavarian town of Passau into a filmic narrative. Starring Lena Stolze, Verhoeven's film presents the young woman as a heroic figure in the quest for the repressed history of her town during the war. She digs not through the earth but through suppressed archival material, material that will indict the supposedly innocent clergy and elders of her town for their documented involvement in the Third Reich.[16]

Kluge's "patriot" and Verhoeven's "nasty girl" come to prefigure, or echo, the actions of a collective of students and academics, led by the historian Reinhard Rürup, who "rediscovered" and excavated an important, yet "forgotten," historical site within Berlin, who dug not just through the rhetorical ground cover of a postwar Berlin defined by the exigencies of Cold War politics and, later, the *Historikerstreit*, but through the very ground, the actual earth covering history itself. Known as the Prinz-Albrecht-Gelände, during the war the site came to be occupied by the Reich security main office, the Gestapo, and the SS. In addition to serving as a center of Nazi bureaucratic operations, the site functioned as a prison in which brutal methods of torture were

used during interrogations. Although the site was partially destroyed
during the air raids of 1945, it was not until 1962, following several
earlier sweeps, that the remaining rubble and debris were completely
leveled. In the 1970s, precipitated by urban planning discussions, but
in response to the urging of a concerned group of citizens who feared
that the historical meaning of the site might disappear from memory,
the building of a memorial for the site was proposed for the 750th
anniversary of Berlin in 1987.

Despite architectural competitions for the site in the eighties and
nineties, no permanent memorial has yet been built. Instead, in what
is still considered a "temporary" plan, a portion of the site remains
excavated, revealing the foundations, border walls, and cellars of the
Gestapo prison. In this subterranean space, one that in many ways
indulges an aesthetics of the ruin, the participating collective of stu-
dents and historians installed a historical exhibition documenting both
the history of the site and its place within the history of the Third
Reich.[17] Situated on a ravaged stretch of land before what was, until
1989, the site of the Berlin Wall, the so-called Topography of Terror,
as a potential site for memory, engages many of the same issues exem-
plified in Kiefer's *Sulamith*, namely, whether a historical site reflective
of a history of the perpetrators, be it the ruinous underground cham-
bers of the Gestapo headquarters or Kiefer's aesthetic evocation of
Kreis's memorial to German soldiers, can ever be transformed into a
site of, or a catalyst for, historical memory and commemoration.

If these films and historical projects suggest the relation of Kiefer's
work to archeology, its processes and its metaphors, his work never-
theless distinguishes itself from such projects of historical recovery
and reclamation.

For ultimately, Kiefer's work is not performing such a uniquely
archeological task. Although his work has been received as "archeo-
logical,"[18] as work seen to dig and sift through the layers of German
history and reveal its buried secrets, I would suggest that in the end,
his work, and working methods, may enact an archeological process
in reverse, a process of layering, of sedimentation, of repeated cover-
ing and burial of shards. To be sure, Kiefer does confront, through his
pictorial semiotics, a past that, during his own childhood, had been

taboo or repressed. But despite his "unearthing" of history, the over-arching impulse of his work, the aesthetic strategies he comes to employ, operate in ways quite contrary to an archeological impulse. For the densely layered surfaces of Kiefer's landscapes and architectural interiors and their complex inscriptions of subjectivity suggest less retrieval than a degree of burial or, to use the terminology of Abraham and Torok, not only of exhuming but of entombing.[19] In other words, that Kiefer's works embody in their materiality and thematics the dialectical impulse of uncovering and covering, remembering and forgetting, renders their aesthetic and thematic operations more complex than those of the posited archeologist or allegorist and may suggest a dialectical wedding of the two. Perhaps, in the end, Kiefer's work is that of an allegorical archeologist or an archeological allegorist, whose paintings, be they tragic, melancholic, or ethical, become so precisely because of their relation to their historical subject, which is catastrophic.

Whether Kiefer is an archeologist or an allegorist, whether, in turn Kiefer performs the work of mourning or the repetitive operations of melancholia in his studio, whether, for that matter, I perform the work of mourning or fall into melancholia in writing about Kiefer's project, whether individual members of a German audience perform the work of mourning or suffer from a blocked state of melancholia when brought face to face with, for example, *Sulamith*, whether the work of mourning is indeed possible when faced with the enormity of historical trauma, hinges, at least in part, less on Kiefer's painting than on our conception of mourning and melancholia.

It should be acknowledged that the Freudian conception of mourning, the clinical conception of mourning, is in many ways a profoundly tragic and pessimistic one. Mourning, much like its presumptive other, melancholia, is a continual process of repetition, of remembering, repeating, and working through. Thus, the possibility of triumphantly completing the work of mourning, *Trauerarbeit*, of "mastering the past," as the composite word so popular in postwar Germany, *Vergangenheitsbewältigung*, would suggest, is a resolution that perhaps always remains unattainable, in a state of perpetual deferral.[20]

That Kiefer's repeated attempts to figure, or to figure in the aftermath of a traumatic historical legacy, to produce objects that testify to the very challenge of that precarious historical position, that Kiefer's aesthetic achievement ultimately depends on, rather than being inhibited by a certain impossibility of representation, or even a failure to represent, may, in fact, be the source of their aesthetic, if not their ethical and historical power. And insofar as Kiefer's project is deeply invested in an anamnetic process, a process of memory, perhaps it constitutes in this very endeavor an act of mourning, or at least of remembrance. In other words, despite the burdens, the limitations, and the thematics of Kiefer's work, for more than a quarter of a century Kiefer has produced a prodigious body of aesthetic work, work that attests to the power and persistence of historical memory. The melancholic painter continues to work and to produce, and, if not to mourn, at least to confront, through acts of repetition, the deferred and traumatic memory that is the history of his nation. And, in turn, his audiences are repeatedly challenged by the very same anamnetic task.

❖ ❖ ❖ ❖ ❖

I will turn in the following chapter to a history of Kiefer's reception, to the question of how these paintings were seen to function, how critical spectators came to both interpret and judge them. But here, in conclusion, I want to move away from the exclusive context of postwar German culture and society and toward a consideration of post-Holocaust, if not postmodern, aesthetics. For we might in fact muse on the state of cultural affairs in the present, a present *after* the Holocaust, after modernism, a postindustrial present, a cultural present in which we might all be seen as mourners, if not melancholics, wandering about as disoriented and decentered beings through the postwar, posthumanist, post-Holocaust landscape, a landscape, in some sense, of ruin.

This aesthetic moment has been investigated by Yve-Alain Bois in his article "Painting: The Task of Mourning." Rather than simply accept the gloomy and apocalyptic assertions of a cultural and philosophical community whose rhetoric is pervaded by a metaphorics of

loss and impoverishment, Bois looks to painting, specifically postwar abstract painting, to test whether, in fact, the death of painting occurred, and perhaps occurred in the very originary moments of abstraction – and if so, whether the painting that followed in its aftermath constituted acts of mourning, or instead, the hysterical repetitions endemic to melancholia, to an inability or unwillingness to acknowledge loss.[21]

If Bois looks to the surfaces of Robert Ryman, and to the theoretical lessons of game theory, that intersection of the mathematical and the political, for a "solution" to the problem of modernist painting, for a way out of the ontological conundrum of painting's continued existence in the aftermath of its presumed death, my account, in this chapter and more broadly, has tacitly questioned the hermeticism of Bois's rigorously formalist, or structuralist, account by looking to the work of Anselm Kiefer as a very different exemplar of postwar aesthetic practice. In Kiefer's work that very same ontological conundrum is situated firmly, and necessarily, in the particularity of its historical present. For there, the question of the death of painting, painting as mourning, painting as melancholic repetition, painting as trauma, painting as wound, moves beyond the insularity of the modernist paradigm and opens out onto the field of history, where, if Kiefer is indeed melancholic, he is so not simply because the historical project of modernist painting has played itself out, nor because he was born under the proverbial sign of Saturn, but, as I will explain more fully, because he, as a son of history, was born under the sign of Lilith, of historical catastrophe, and thus works, if not mourns, forever in her shadow.

A contemporaneous paradigm for Kiefer's artistic enactment of melancholic artistic subjectivity may be found in Julia Kristeva's *Black Sun: Depression and Melancholia*.[22] There, Kristeva presents a theorization and cultural application of melancholia that situates the psychoanalytic, or clinical, concept within a broader humanist tradition. For Kristeva, melancholia is not simply an act of denial. Nor is it simply an inability or an unwillingness to acknowledge or process loss.[23] Instead, melancholia, following Lacan, is a detachment from the symbolic, from the field of representation, an act of denial, but

this time, importantly, a denial not just of loss but of representation itself. In that respect, on Kristeva's account, the impossibly and necessarily thwarted operations of melancholia correspond to the striving for union with the Lacanian real, with the mother and with death. Kristeva's melancholic is one who perpetually tries to come to terms with the loss of that thing, Lacan's *das Ding*, which perpetually defies the possibility of signification. The sadness of Kristeva's melancholic is "the most archaic expression of an unsymbolizable, unnamable narcissistic wound."[24] Where I depart from Kristeva's reading of Lacan, as I have argued in Chapter 2, drawing on the work of Slavoj Žižek and Kaja Silverman, is in terms of the nature of the loss. For the traumatic loss, that unsymbolizable wound inscribed within post-Holocaust subjectivity, is of another order. It is not the loss of the mother, even if it may be predicated on the experience of that loss. That loss, that trauma, is the unassimilable trauma that is history, the catastrophic history of the Holocaust and the Second World War. And its losses, if indeed they can be registered in words alone, are the losses, first and foremost, of Nazism's victims. Given their enormity, these losses are as well, as work ranging from the Mitscherlichs's to Kiefer's attests, the loss of ego ideals, those tainted and disavowed paternal signifiers, and with that, the loss of an ability to unselfconsciously articulate and embody a German identity. As I have claimed, it is the catastrophic losses of history that are insistently present, if only as absence, in the work of Anselm Kiefer. These are the losses, the traumas, that at once impoverish Kiefer's identity as a postwar German subject, but at the same time enrich his art.

In an inversion of Adorno's postwar proscription, his prohibition of poetry, it is with the metaphor of poetry, and, in turn, its metaphors that Kristeva finds a way of imagining, and imaging, if only in language, the unsymbolizable and the unnameable. For Kristeva, the poetic metaphor is not originally hers but that of the nineteenth-century French poet Gérard de Nerval, whose work takes us back to that originary moment of at once the modern and the postmodern, romanticism. For it was Nerval, a poet of a quintessentially melancholic disposition, whose quest for his necessarily irretrievable origins led him to contemplate the unsymbolizable and the unnameable. And

it is in his poetry, particularly "El Desdichado," 1853, the "disinher-
ited," that we see enacted this ontological quest for origins and find the
metaphor of the "black sun," a metaphor that suggests for Kristeva
"an insistence without presence, a light without representation."[25] If
that "black sun" might lead, if only retrospectively and admittedly,
anachronistically, to Celan's poetic leitmotif "black milk of daybreak,"
and in a chain of signification, to the smoke of the crematoria that
turned every dawn at Auschwitz into darkness, to the "grave in the
clouds," and to the ashen hair of Sulamith, to the biblical Sulamith, to
Kiefer's Sulamith, it might just as well lead to Lilith, the kabbablistic
Lilith, Sulamith's dark other. For Lilith is not only the mistress of
darkness in her personification as the killer of newborn children and as
evil temptrix.[26] Lilith is also, in Kabbalah influenced by astrology, the
mother of melancholy, the kabbalistic Saturn, a female Saturn, and
"all those of a melancholy disposition are her sons."[27] Moreover, Ger-
shom Scholem's reading of Kabbalah asserts Kabbalah's relation to
catastrophe, to historical catastrophe,[28] in whose aftermath Lilith
stands as both mystical personification and aesthetic progenitor. In
other words, if Saturn may be seen to have "released his children from
history,"[29] to have set artistic creation in an ahistorical flight from real-
ity, it is Lilith who grounds her children, her sons, in history, for all of
her identity as a mythic and mythical figure. Lilith, unlike Saturn,
embodies a melancholia that is insistently of and in history.

Kiefer, then, might be said to have been born not simply under the
metaphorical sign of Saturn, father of melancholia, but under the sign
of Lilith, the aegis of Lilith, mother of melancholia, a melancholia
always inscribed in a history of catastrophe. Created in the aftermath of
historical trauma, Kiefer's work, like Lilith, like Scholem's Kabbalah,
historicizes melancholia, that humanist construction of the melancholy
artist, but this time in the postwar, post-Holocaust present.[30]

As such, Kiefer's works do not only signify but embody the para-
doxes and impossibilities of the historical epoch they take as their
subject and object. Like Benjamin's conception of allegory, Kiefer
gives us an aesthetic object that defies the unity of the modernist
symbol. Kiefer's are objects whose historical referent necessarily rup-
tures the image, wounds the image, shatters the fusion of meaning

that the symbol, or the self-identical, autonomous modernist object would claim to embody. Kiefer's postmodern project moves toward the necessarily compromised recovery of a repressed history, be it the repressed history of modernity, of modern Germany (Hitler, the Holocaust, barbarism, totalitarianism), or the repressed history of modernism, of modernist painting (referentiality, figuration, aura). And in this postmodern aesthetic project, whose temporality swings wildly between the past and the present, between the romantic and the postmodern, between history and its inevitably inadequate representation, Kiefer gives us representation, but representation as ruin, whose significance will be realized, albeit never completely, in the spectatorial relationship through which it constitutes itself, repetitively and yet always anew, as art.

4 KIEFER

A Painter from Germany

> I have come to see myself only as they
> see me. I peer into the dark pit of their
> souls and there, deep down, I see the
> image that I have built up. I shudder,
> but I cannot take my eyes off it.
> Almighty Zeus, who am I? Am I
> anything more than the dread that
> others have of me?
>
> – King Aegisthus, Jean-Paul Sartre,
> *The Flies*

If art is one of the cultural spaces in which the negotiations of identity
are at once enacted and, in its viewing, witnessed, art criticism is
another place for such inscription and reflection, as the methodologies
of reception history and reception aesthetics can attest.[1] Before turning
to the discursive field of art criticism, however, and with that the criti-
cal reception of Kiefer's work more specifically, I want to begin with a
political incident, something that might be seen as a performance piece
of sorts, and its journalistic representation. I do so not only because I
witnessed this incident in Berlin but because it was in reading about it
in the days that followed that I came to realize something quite signifi-
cant about postwar Germany and its self-representations.

On the London BBC on Sunday night, November 8, 1992, just
hours after a demonstration for peace and tolerance took place and
was disrupted in Berlin, the following was reported: "During a
demonstration today against anti-foreign activity, German Chancellor
Kohl and President von Weizsäcker were pelted with eggs and stones
by extremists."[2] And so this reporting appeared in the Berlin
Tagesspiegel two days later in an article that referred not only to the

BBC but to daily papers and news programs from the United States, France, Poland, Scandinavia, and Israel. The *Tagesspiegel* article aimed to capture less the event than precisely how foreign journalists and correspondents had characterized and described the demonstration and its violent interruption. Citing a range of vivid descriptions of rampaging extremists and egg-splattered German officials forced to cower behind the plastic shields of riot-control police, the *Tagesspiegel* article suggested that international coverage had tended to focus only on the violence and aggression that disrupted the civic event, overshadowing and obscuring the otherwise peaceful tenor of the demonstration as a whole.

Buttressed by quotes from foreign minister Klaus Kinkel, the editorial opinion expressed in the *Tagesspiegel* article was that such reporting presented Germany in a rather unfavorable light to foreign readers, listeners, or viewers. And, more important, such reporting was seen by the *Tagesspiegel* as neither representative nor fair. Rather, the expressed editorial sentiment was that owing to the unruly, disruptive, riot-inciting behavior of some egg-throwing "extremists," the outside world saw, following a summer and fall of ever-escalating anti-foreigner violence throughout German cities and towns, yet another example of ugly lawlessness in Germany. In other words, the provocative actions of a small group of extremists tainted the overall picture of a demonstration in which 300,000 peaceful participants marched from points in East and West Berlin to express their belief in tolerance and basic inalienable human rights.

This mode of reporting on the perception and reception of Germany abroad, a sort of journalistic polling or gathering of international opinion, is both a distinctive and recurrent practice in the German media.[3] And it is significant because it is a strategy that demonstrates an immense concern for how Germany is "represented" abroad.[4] In the case of the disrupted demonstration, much to Germany's dismay and embarrassment, the behavior of a few renegade extremists not only obscured the actions of many good Germans but compromised West Germany's postwar image as a tolerant country committed to its constitutional democracy.

The "Deutschland-Bild," the "image of Germany," or its sense of its

image in an international arena, already buffeted by a resurgence of neo-Nazi activity against refugees, foreigners, and places of Jewish memory, had with the disrupted demonstration suffered yet another blow. Of course, unlike the preceding acts of violence, which were the work of neo-Nazis, the November 8 disruption was staged by left-wing, anarchist extremists, so-called redskins, a distinction that was lost in most of the initial coverage – in part, perhaps, for its emergence out of the very term "skinhead." The identification of the "extremists" as "redskins" rather than as neo-Nazis rapidly became an issue in the German press, which then turned its attention not to the issues at stake in the protest but to the mismanagement of the police, who were being accused of not heading off and controlling this left-wing violence.

Rioting skinheads, whatever their particular political affiliation, all look like skinheads.[5] The distinction, however, is significant. The anarchists claimed their actions were a form of protest against the hypocrisy of a demonstration sponsored by the conservative government (CDU/CSU), which, despite its participation in the demonstration, was pursuing the revision of a basic constitutional right to asylum (Grundgesetz [Article] 16).[6] But to the press, whatever the particularities of the disruption or the identities of the protesters, what remained significant were the images left behind, images of rampaging, out-of-control German youths, skinheads, attacking the symbolic figurehead of postwar German tolerance, President Richard von Weizsäcker. Thus, despite the political motivations behind the anarchists' actions, their behavior was conflated with and subsumed into a growing list of ever more violent actions staged by right-wing skinheads, namely, those directed against foreigners in Germany.

As it has perhaps by now become clear, I began this chapter with the disrupted demonstration and its journalistic coverage because I believe that domestic coverage, that domestic reception, to be both symptomatic and emblematic of mechanisms and patterns of identity formation in postwar German society. Further, that the actions of the "redskins," the anarchist skinheads, could all too easily raise the specter of neo-Nazism and, with that, National Socialism reveals the enduring presence of that past's legacy in postwar Germany's present. That the German press should not only cover the disruption of the

demonstration but also report on its coverage abroad reveals a particular sensitivity in postwar Germany to external perceptions. Seeing itself reflected in the eyes of the outside world, Germany was faced with an image of itself living not so much in the shadows but with a thriving legacy of its past. And it is the forces exercised by the legacy of this past, combined with this constant awareness of an external gaze, that prove central to the postwar reconstitution, reconception, and rearticulation of identity in Germany.

As I will argue in this chapter, such a concern for how Germany is perceived and represented abroad does not remain confined to the purely political arena. Be it images *of* Germans disseminated abroad on television screens or images *by* Germans shown abroad in museums, galleries, and movie theaters, great attention is devoted within Germany to the issue of their international reception. For the images disseminated in this virtual globalization of culture and the media, whether by satellite, the art market, or film distributors, quite literally represent, or stand in for, Germany abroad. In this sense, objects of visual culture – paintings, photographs, sculpture, and film – come to function not just as cultural exports but as cultural emissaries or ambassadors, as a form of visual proxy.

Moreover, when those images produced and sent out for international consumption do not easily conform to the image, or self-image, that Germany wants to present to that international community of spectators, when those images or representations, regardless of their politics or motivations, like the rioting extremists, raise the ugly specter of the German past, their reception at home comes to reflect, reveal, and perhaps even magnify the conflictedness of a fundamentally troubled subject position of postwar German identity. For it is in such a metaphorical mirror held up before Germany by the international community, be that mirror image truthful or distorting, that Germany sees itself reflected, as it continues to negotiate the path toward the constitution of a new identity within its reunified national boundaries.

Jürgen Habermas has suggested a "solution" to the "German Question" of identity, a political and ontological question made all the more pressing in the aftermath of reunification, positing what he terms a

"post-conventional identity." Habermas's ideal of identity is one that can be conceived at a level of moral and political development which makes possible a universalistic orientation, taking identity beyond the narrow perspective of a national identity.[7] If the demonstration in its ethos expressed a civic display of the very characteristics that would compose Habermas's "post-conventional identity," the rioting skinheads expressed its very opposite, their disruptive presence and actions triggering associations with the extreme manifestations of a racially determined nationalism that culminated in National Socialism.

These two poles of identity, which can be recharacterized, as Eric Santner has done on a more abstract and theoretical level, as "the maddening binary opposition: schizophrenic dissolution of identity/narcissistic respecularization of identity,"[8] and which, as I argue in Chapter 2, are negotiated in Kiefer's aesthetic self-representations, are ultimately simply that, two poles, two extremes, devoid of dialectic. The question I would raise, one that will expand the undialectical nature of Santner's opposition, is how and if Germany can reconstitute its identity in the public or private sphere without feeling trapped within the confines of this ontological conundrum. And it is thus less to Kiefer's work than to its reception that I will turn in pursuit of that perhaps unrealizable goal and, in turn, that perhaps unattainable answer.

❖ ❖ ❖ ❖ ❖

Anselm Kiefer creates work that makes its German audience profoundly uncomfortable. Although he has been hailed by many American critics as the greatest German artist of the postwar era,[9] his reception in his own land has been far less gracious and enthusiastic. Kiefer's work, particularly his early work, steeped in the signifiers of German history, myth, and national identity and typically rendered on a monumental scale, has led to his appellation and condemnation as a reactionary, and at times, even a neofascist. As such, his work was initially received in Germany less as a visual enactment of the liberal left conception of *Vergangenheitsbewältigung*, "a coming to terms with the past," than as a resurrection in bombastic form of the darkest moments of Germany's

past. It has been only in recent years that Kiefer's work has been more widely accepted in Germany, albeit somewhat grudgingly. The German acceptance of Kiefer was to a degree symbolized by a retrospective of his recent work in Berlin in 1991, which was, significantly, only the second such major exhibition on German soil since the start of his career more than a quarter of a century ago.[10]

The reasons for this shift within the German critical discourse surrounding Kiefer, an evolution from outright rejection to guarded, at times even resentful, acceptance, are as complex as they are varied. My intention in this chapter is to examine the volatile discourse constituting Kiefer's German reception and situate and interpret that discursive field in and against the broader context of a postwar German negotiation of identity. In order to do so, I will isolate particular moments in his reception history, framed at one end by his international debut and German condemnation at the Venice Biennale in 1980 and at the other by the German response to his apotheosis in America following the American retrospective in 1987–8; and I will situate this reception within its broader critical and cultural context.

I should explain that I have chosen to center my analysis on the German context not simply because it is there that his work has generated the most charged, volatile, and consistently negative or, at best, ambivalent criticism. Rather, I have chosen the German context because it is only there, within a set of national boundaries, that the discursive field of criticism emerges out of a context shared with the work itself, that context being a society forging some kind of identity in the face of a traumatic national history. Criticism, like the cultural objects it takes as its subject, is thoroughly embedded within the political, social, and cultural fabric of postwar Germany. And although it is a fabric composed of many threads and colored by diverse political imperatives, it is nonetheless one that is woven together under a shared legacy, the problematic legacy of the Nazi past.

❖ ❖ ❖ ❖ ❖

Before investigating Kiefer's actual reception, however, I want to reflect on why Kiefer, and the neo-expressionists with whom he came

to be critically associated, were not and generally have not been taken up by the German liberal left, whose defiant confrontation with the past and continued engagement with the project of *Vergangenheitsbewältigung* would seem to see its visual enactment in the insistently historical paintings of Kiefer, if not of his peers. For if conservative cultural and political forces worked toward a normalization of the Nazi past, a stance that would clearly discourage the emphatic cultural assertion of Germany's Nazi past, it would seem that the left would, at least in principle, support, and even applaud, the work of Kiefer. And yet, Kiefer's work was almost universally reviled in Germany for almost two decades.

I would suggest that the reasons for this rejection stem from the Marxist-Leninist foundations of the liberal left as it re-emerged in the mid-to late 1960s. Within the Marxist orthodoxy that came to define the aesthetic ideology of the German left,[11] high art was expressly anathema, nothing more than an elite object for the cultural consumption of the bourgeois. Moreover, expressionism, the presumed, if inaccurate, stylistic camp in which Kiefer's work was situated, already subjected to interrogation and critique in prewar debates,[12] was then fundamentally tinged with and tainted by its historical uses and abuses under fascism. If one looks to the aesthetic paradigm developing among the left in the 1960s, as it can be reconstructed from the major left-oriented cultural journals of the period, for example, *Argument*, *kursbuch*, and *Tendenzen*, there is a manifest preoccupation with the return of figuration. But the form of figuration that is valorized is critical realism, the precedent for which was established in the 1920s by the artists of the *Neue Sachlichkeit*, in whose ranks could be found George Grosz, John Heartfield, and Otto Dix.[13]

Significantly, such politically engaged journals were joined by the cultural establishment of the museum in their support for a critical practice of realism. This support began with the exhibiting of English and American Pop Art in the early 1960s, an art form that provided German artists with a source of realism free from association with either Nazi or East German propaganda and that possessed a certain critical capacity.[14] As Andreas Huyssen wrote, by the mid-1960s, when "the student movement broadened its criticism of the university system

to include attacks on West German society, politics and institutions in general, a wave of pop enthusiasm swept the Federal Republic . . . pop in its broadest sense became amalgamated with the public and political activities of the anti-authoritarian New Left."[15] And by the later 1960s and into the 1970s, the museum establishment helped to entrench the place of critical realism even more deeply in current aesthetic debates by mounting a spate of exhibitions of realism from the 1920s.[16]

Such exhibitions of realism not only served to point out similarities and continuities between present practices of critical realism and their Weimar antecedents. More important, they were instrumental in helping critics to draw distinctions between the work of contemporary artists producing a form of "critical realism" – groups such as the "Junge Realisten" in Düsseldorf, "Real" in Wiesbaden, and the "West-Berlin Realisten" of the Secession Großgörschen 35, many of whose work exhibited a certain formal resemblance to *Neue Sachlichkeit* – and contemporary artists who worked in a far more "expressionistic," "elite," "high-art" mode, namely, the Berlin artists Baselitz and Lüpertz, whose work earned them the appellation *Pathetische Realisten*. Even artists like Beuys, whose advocacy of social dissent and radical democracy would seem to ally him with the politics of the liberal left, remained peripheral to, if not entirely disdained by, those cultural circles.[17]

The legacy of that critique and cultural ideology can be seen in the present in the work of Benjamin Buchloh and, to a different extent, in that of O. K. Werckmeister. Buchloh, still beholden to the utopian premise, and promise, of the historical avant-garde, sees the aesthetic atavism and regressions of Kiefer's work as fundamentally incompatible with the project of the neo–avant-garde. Although Buchloh's abhorrence of the neo-expressionists, with whom Kiefer is invariably grouped, emerges in many of his articles on postwar German art, his most sustained critique appeared in 1981, in his article "Figures of Authority, Ciphers of Regression: Notes on the Return of Representation in European Painting."[18] Buchloh's subject was not simply the "return" of representation witnessed in European painting in the 1970s – of figuration, expressionism, woodcut, and so forth, but the particular stylistic and ideological character of that return in so-called neo-expressionism, both German and Italian. Finding in its stylistic

tendencies and figurative returns an alarming parallel to the regressive and recuperative returns of the post-First World War *"rappel à l'ordre,"* the conservative return to stylistic conventions and values of classicism.[19] Buchloh diagnosed the contemporary return of figuration as fundamentally authoritarian, an aesthetic encoding of the conservatism and political oppression of the *Tendenzwende,* the "change in tendency" that followed the brief flowering of cultural revolution and political liberalism under Willy Brandt. It is significant, for my discussion which will follow, that Buchloh's art historical critique was in part impelled by the international rise to prominence of neo-expressionism at the 1980 Venice Biennale.

Where Buchloh sees political authoritarianism and aesthetic regression in Kiefer's art, Werckmeister sees the potential for its cooptation and complicity, directing his critique less at Kiefer's work than at the art market and institutions in which it is inextricably enmeshed, seeing the erosion of any potential for radical democracy through the machinations of state apparatuses of power, as is most emphatically demonstrated for Werckmeister in the Berlin retrospective in 1991. As Werckmeister argues in an article following that retrospective exhibition, rather than promote historical self-awareness or political self-expression in the political sphere, the cultural establishment promotes only a culture of political disenfranchisement, whether concerning, quite specifically, the question of nuclear rearmament or, more broadly, the conservative normalization of German history, be it at Bitburg or in the academic and public debates of the mid-1980s that came to be known as the *Historikerstreit,* the "historians' controversy."[20]

❖ ❖ ❖ ❖ ❖

If the preceding paragraphs give some sense of the critical and scholarly context out of which Kiefer's work and reception evolved, I want to turn now to the event that placed Kiefer for the first time in an expressly international arena. In June 1980, the opening of the Venice Biennale unleashed a storm of controversy, at the center of which was Klaus Gallwitz's German Pavilion and the work of two artists from the Federal Republic of Germany, Georg Baselitz and Anselm Kiefer.[21] It

would seem that everything in and about the exhibit was cause for horror, alarm, and criticism. Decried as "fascistic," "teutonic," "bombastic," and simply "embarrassing," what was intended as an introduction and celebration of the work of two of Germany's young artists in an international arena became instead an occasion for their mockery and condemnation. Significantly, from the outset the most persistent, polemical, and scathing criticism surrounding the exhibition was penned by German critics. In reviews and articles throughout West Germany, from the solidly conservative daily paper the *Frankfurter Allgemeine Zeitung* to the centrist/liberal weekly newspaper *Die Zeit* to the leftist daily the *Frankfurter Rundschau*, there was a remarkable unanimity of opinion.[22]

As selected by Gallwitz, the director of the Städel Museum in Frankfurt and one of the staunch and early supporters of so-called neo-expressionism, the German Pavilion quite simply represented the work of two of its central practitioners.[23] Despite the uproar over their selection, and the artistic and critical climate I have sketched for the 1960s, the choice for the German Pavilion did conform for all intents and purposes with the basic conceptual schema of the 1980 Biennale, which was captured with the phrase "Art in the '70s." Clearly, the pluralism of styles characteristic of art in the 1970s could suggest the possibility of other inclusions. But one such artistic current in West Germany and elsewhere during the 1970s was undeniably the growing predominance of neo-expressionism, or, more aptly, the return of a painterly and figurative aesthetic practice.[24]

The German Pavilion was composed of three rooms. The first housed, most notably, a roughly hewn wooden sculpture by Baselitz, surrounded by his painting. The two flanking rooms contained a collection of paintings and books by Kiefer.[25] But if it was Baselitz's sculpture that initially seemed to rile the critics, because it was, after all, the first and most prominent object the visitor saw upon entering the pavilion, it was Kiefer's work that provoked a more sustained and detailed critique and, in turn, generated a rhetoric and a body of criticism that would have a resonant and enduring legacy.

Baselitz's seated, wood figure, *Model for a Sculpture*, 1980 (Fig. 39), was almost universally condemned by German critics.[26] More than any-

39. Georg Baselitz, *Model for a Sculpture,* 1980. Linden wood painted with red and black tempera, 178 × 147 × 244 cm. Courtesy Galerie Michael Werner, Cologne and New York.

thing else, it was the gesture of the sculpture, its stiffly raised right arm, an inescapable referent to the Nazi salute, that most profoundly incensed the critics – it would seem for the sheer blatancy of the allusion. Replete with what could even be perceived as a signature Hitler mustache, the sculpture raised the specter of Nazism and was seen as an affront, an outrage, and an embarrassment. Simply to demonstrate the level of outrage and furor Baselitz's sculpture generated, I cite the response of the art critic for the *Frankfurter Allgemeine Zeitung,* Werner Spies. In an article entitled "An Overdose of Teutonicness," Spies decried the fact that the visitor to the German Pavilion was greeted with a gesture that "was equated immediately with a German, [i.e., Hitler] salute."[27] The outrageousness of the sculptural gesture was underscored for Spies only by the fact that "the black-white-red coloring further suggests the idea of German imperialism."[28] Significantly, Spies's review also manifests a deep concern for the perceived role of the non-German visitor to the

German Pavilion, expressing a marked anxiety for how "a number of visitors (primarily non-German)" might react.[29]

As such, Baselitz's sculpture, which "greeted" the German Pavilion visitor with its "Hitlergruß," set the tone, or was feared to set the tone, for the spectators, particularly the non-German spectators, of the entire pavilion. For after leaving the first room, the Biennale spectator was then enveloped in Kiefer's emphatically Germanic works from the 1970s. These works delved into myths of the Nibelungen, Wagnerian scenarios, German intellectual history, and nationalistic militarism, all rendered on a scale and with a palette that was seen to bespeak a nascent, or renascent and potent, German national identity, replete with all its ghosts.

Although there were isolated German critics who supported Gallwitz's Biennale selection,[30] typically, the German media spared neither Gallwitz, Baselitz, nor Kiefer their invective. Soon after the opening of the Biennale, a "culture report" was aired on ARD, a major German television network. Its hosts expressed their dismay that Anselm Kiefer was chosen to represent Germany in the Biennale. Their critique not only assailed Gallwitz for his poor judgment in selecting Kiefer for the German Pavilion. It went on to label and assail Kiefer for being a "new reactionary":

Anselm Kiefer: He represents the state of art in the Federal Republic at the Biennale. This selection is a huge misunderstanding. The museum director Klaus Gallwitz believes that he has discovered a "Neuen Wilden," as the expressive contemporary painters have been called. But Anselm Kiefer is not a "Neuer Wilder." He is at best a new reactionary.[31]

The "new reactionary" did not fare much better in the journalistic engagements with his work. In the *Frankfurter Rundschau*, after attacking both Gallwitz's judgment and Baselitz's sculpture, noting, as Spies had, its "Hitlergruß," the critic Peter Iden reserved his more detailed and impassioned critique for the work of Anselm Kiefer:

What comes in the flanking rooms is even worse: Anselm Kiefer takes the opportunity to present for viewing his ideologically confused, thematically overloaded painting: The alleged analysis of German traditions in these huge pictorial spaces is a technically lamentable, coloristically helpless and compo-

sitionally pathetic, bombastic "painting," and exposes itself as being in dangerous proximity to glorifying German megalomania.[32]

In its elision of the boundaries between formal and thematic aspects of Kiefer's work, the review leaves the reader unsure whether Kiefer's greater offense was *what* he painted, his supposed engagement with "German traditions," or *how* he painted, his use of "technically lamentable," "coloristically helpless," and "compositionally pathetic," "bombastic" technique to render his canvases.

In perhaps the most sophisticated and extensive of this spate of reviews that appeared in the German press that June, Petra Kipphoff, the art critic for *Die Zeit*, also took on the Pavilion and its selected array of objects.[33] Recapitulating the established critical litany, Kipphoff condemned both Kiefer and Baselitz for what she took to be the message of their work, the rekindling and perpetuating of Nazi ideology, writing of their work that "fear, brutality and injury are cited, not in order to denounce them, but in order to celebratorially perpetuate them."[34]

Referring then to the "Anstößigen," the "offenses" of his work, Kipphoff went on to deplore not only Kiefer's thematics but his painterly technique. Her attention to technique, to the actual process that went into constructing his massive, densely layered canvases, marked a departure from the majority of the early Kiefer criticism, which focused on formal characteristics solely for their stylistic affinities and references, while ignoring their role as a visual record of the very process of artistic production. To Kipphoff, Kiefer enacted in his studio a painterly game of "irrationality and brutality."[35] In response to Kiefer's use of fire in his artistic process, his incorporation of layers of burned matter and ash onto the surface, Kipphoff described Kiefer's technique as "his game of extermination/destruction in the studio."[36] Although Kipphoff's language at once identified and described Kiefer's destructive yet ultimately sedimentary process of layering, effacing, and further layering his canvases, at the same time it charged that process with all of the historical resonances implicit in the term "extermination."

Perhaps most central, or salient, in Kipphoff's article is the attention she relished upon the presumptive, if not imagined, international spectator. For it is the critical phantasm of the international spectator,

the gaze of the specifically non-German body of viewers who are thought to sit in continuous contemplation and judgment of postwar German society and culture, that comes to ground Kipphoff's critique. Although Spies invoked as well the phantasmatic presence of the non-German spectator, Kipphoff specified the identity of the posited spectator, suggesting the possibility that the viewer may have been a victim of fascism. Wrote Kipphoff, "the entire Kiefer-esque thematic and the applied theatricality must be simply unbearable for the many who were nearly exterminated by such German megalomania."[37] In Kipphoff's indirect but implied reference to the Jews and other victims of German "megalomania," she introduced what was to become a significant aspect in Kiefer's ensuing reception, the presumed non-German, and, more pointedly, Jewish spectator.

In short, within just a few days of the Biennale's opening, Kiefer's work was resoundingly concretized in the Federal Republic as fascistic, reactionary, and profoundly unsettling, if not simply embarrassing.[38] In part, Kiefer's German reception suffered from the perception that he was reasserting, rather than working through, the shameful chapters of German history and national identity. And in this perceived reassertion, his reception suffered from the recurrent postwar German impulse to normalize that past, to lay the ghosts of Nazi Germany once and for all to rest. But even more, Kiefer's Biennale reception suffered from the fear of what his work might suggest about the Federal Republic in such a prominent international cultural forum. For the *"Deutschlandbild,"* the "image of Germany," offered up in Kiefer's paintings was not the desired self-projection or self-representation of the Federal Republic and its constitutional democracy.

It would seem that the Biennale functioned as an arena for Germans, in this case, German art critics, to prove their vigilance about potentially disturbing signs of a renascent German past. As Charles Mark Werner Haxthausen suggested, "After Kiefer's international debut at the 1980 Biennale, German critics – as if eager to reassure the rest of the world – made him the *Prügelknabe*, the whipping boy, of the art press."[39] I would remove the "as if" from Haxthausen's statement. It was precisely for the reason that Haxthausen suggests that the

German reception was so resoundingly negative. German critics were quick to show, through their vociferous condemnation, that the presumed fascist impulses seen in Kiefer's work were indeed atavistic, a thing of the past that was not to be tolerated in the present.

That the German critics responded to Kiefer's work with a level of vigilance verging on the hysterical, denouncing its unrepentant Germanness at every turn, suggests the degree to which postwar German identity was formed, not simply in and against the legacy of fascism but in and against the presumptive gazes of the international community. For it is interesting to reflect on how postwar identity was from the start an imported and imposed, rather than an indigenous and a desired, construction. That is, much as German urban and economic infrastructures were rebuilt with the economic support of the Marshall plan, so too was German national identity reconstructed through the agency of the Allies, with de-Nazification and re-education programs established as part of a patently purposeful agenda to reshape a German identity that had been thoroughly tainted by Nazism.[40]

It is of fundamental importance in this political, economic, and psychic rebuilding of postwar Germany that all of the reforms came not from within the body politic but from without. Thus, it was the nations of the Allied forces, with America in a central and powerful role, that initially took on the task of reshaping German society and identity. Given this powerful presence and role of an external authority, coupled with the lacuna of paternal authority I discussed in Chapter 2, it would seem that the Allies, particularly the Americans, came to stand in for that absent, or tainted, paternal function, in whose eyes the Federal Republic came to see a reflected version of the self.[41]

For the actions of the German critics do not so much confirm the Lacanian notion of identity as that which is formed through the gaze of the Other, the notion that a sense of self-identity is formed through an answering of the question, "Why am I what you are saying that I am?"[42] Rather, it would seem that the German critics took this process one step further and constituted identity through a specular process of identity formation based not so much on what the Other actually said they were but on what they assumed or feared the Other was thinking they were. That Kiefer's work raised the fear that on

some level Germans were and still could be perceived as Nazis meant
that on some level Germans feared this perceived identity within.

❖ ❖ ❖ ❖ ❖

Before proceeding with the next stage of Kiefer's reception history, I
want to make a digression of sorts into another incident of reception
history. For if Kiefer's art was perceived to be fascistic, then it might
be useful to compare the reception of his putatively fascistic and
unrepentantly German painting with the roughly contemporaneous
reception of the art of the Third Reich. It is an interesting point of
comparison that several years after the Biennale debacle, in 1986, a
controversy erupted when the prominent and powerful art collector
Peter Ludwig expressed his desire to exhibit Nazi art in the space of
the contemporary museum.[43] Although Ludwig's initial plan was to
exhibit two postwar sculptures, busts of himself and his wife, that
had been executed by the former Nazi sculptor Arno Breker, his
ambitions expanded to include the exhibition of Nazi art as a general
category.

Ludwig's claim, much like the claims of the conservative historians
of the *Historikerstreit*, or the politicians at Bitburg, was that it was
time to "normalize" art that had been produced during the Third
Reich. In a clever adoption of the language of the left, Ludwig accused
German art museums of suppressing the past. As he argued in an
interview published in *Der Spiegel:*

I consider it narrowness of vision to want to wipe out twelve years of German
history. There was also wonderful music during that time. Naturally, there
was literature during the Third Reich. It is an absurd idea, that on January
30, 1933, visual art ended. But our museums act as if this were so.[44]

Ludwig's plans were met with anger, outrage, and a voice of protest. A
public letter, bearing the title "Keine Nazi-Kunst in unsere Museen,"
was circulated on September 6, 1986 and signed by a number of
prominent artists, curators, and academics. It argued the following:

With intimidation, terror and crimes, Nazi-art forced its way into the muse-
ums in the time of Hitler. The most important artists of our century were per-

secuted, forbidden to work, killed and forced into exile, so that a submissive state-art of third-class works could promulgate the ideological commands of the dictator. Nazi-art of artistic quality is not known to us, as has become clear time and again in several exhibitions in recent years. The German museums, therefore, want to continue what they have done in their work for art in the last 40 years: they will set standards. Art also has to do with ethics. Therefore, we appeal once again to the public: Nazi-art does not belong in our museums.[45]

Among those signing the petition were not only the artists Jochen Gerz, Hans Haacke, Gerhard Richter, and Wolf Vostell but Anselm Kiefer, accused only six years before of making Nazi art for the present.

Following the furor elicited by his polemical remarks, Ludwig soon qualified his earlier statement, making a distinction between so-called Nazi art and art simply produced during the Third Reich. As Ludwig claimed, this time invoking a language of taboo and prohibition:

I never supported the idea that Nazi-art be shown, but that art from the years 1933 to 1945, art that arose in Germany, also art that was exhibited at that time, should not be covered by a general taboo, nor with a practically enforced exhibition-prohibition. I don't want a glorification of Nazi-art, but I want to see that art from the time 1933 to 1945 is no longer excluded from every objective discussion.[46]

Ultimately, Ludwig's defense offers nothing more than a plea to normalize and relativize the art of the Third Reich. That Nazi art should be recognized as a document of the aestheticization of politics that occurred during the Third Reich is a point well worth considering, particularly in relation to debates about what should be included in museums of German history.[47] Furthermore, the fascination that such art, or aesthetics, did and might still have on the viewer is a vital historical and ethical question.[48]

But those were not the sorts of questions being asked by Ludwig. Nor were these the kinds of questions being asked by the early critics of Kiefer's work. Further, it is important to recognize the historical and ethical distinctions between Ludwig's plan, which sought to normalize fascist art through the unmediated exhibition of such work as art, and Kiefer's work, which, whatever its complex and irretrievable intentions may have been, was nevertheless a mediated encounter

with an iconography and aesthetics of German nationalism, and with that, of Nazism.

❖ ❖ ❖ ❖ ❖

Despite the intensity of the German critical condemnation of Kiefer's work, it was nevertheless the Biennale that paved the way for Kiefer's imminent international success. Previously relatively unknown in the international artistic community, in the aftermath of the Biennale, Kiefer's work was suddenly acquired and exhibited with great enthusiasm. Where the Germans were quick to see and condemn the fascistic overtones and implications of Kiefer's work, non-Germans, particularly Americans, found in his work a courageous effort to come to terms with the German past.[49] Among others, the gallery owners Ileana Sonnabend, Mary Boone, and Marian Goodman all date their "epiphany" regarding Kiefer and the neo-expressionists to the 1980 Venice Biennale,[50] a moment that in the German context, in contrast, came to signify the critical nadir of their artistic careers.

Whether American gallery owners, collectors, and critics were responding to the presumed historical and ethical ambitions of painters like Kiefer, whom they saw as aesthetically confronting the German past, or saw instead in the neo-expressionists, with their crude figuration, large scale, strong color, and loose handling of paint, a European counterpart to the so-called New Wave painting that had swept the New York art scene, is subject to debate. What is clear is that after 1980, Kiefer's career in America and elsewhere (France, the Netherlands, and Israel) rose to heights that German critics never dared imagine, or perhaps more appropriately, never would have wanted to think imaginable. Moreover, with the American acceptance of Kiefer and his compatriots came a gradual readjustment of German critical positions.

I should point out, before moving on to that critical reassessment, that the *Frankfurter Rundschau* remained an anchored voice of dissent in the shifting tides of the Kiefer reception, repeating and rephrasing the accusations that had surrounded his work at the Biennale. In an article entitled "Frescos for a Future Reich?" Hanno Reuther went on to dub Kiefer "the court painter for the newly con-

servative Bonn government" and charged that Kiefer was "a virtuoso of crude mixes, a composter of German ideology, myth-recycling his specialty."[51] Reuther's critique in many ways anticipating Werckmeister's later evaluation of Kiefer's work.

The continued and consistent indictments on the part of the *Frankfurter Rundschau* notwithstanding, the reversal in German critical opinion was indeed marked. In one of the first critical reappraisals of Kiefer's work and its implications, Christian Herchenröder, the critic for the *Handelsblatt*, came to see Kiefer's iconographic tendencies as a historically important endeavor. Looking back at such early watercolors as *Every Man Stands beneath His Own Dome of Heaven*, 1970 (Fig. 40), which, like Kiefer's earliest book projects, contained a small, green-clad figure with its arm extended in a Nazi salute, Herchenröder asserted that such pictorial motifs manifested "surely not a pro-fascist attitude, but rather a fascination with a phenomenon that we believed conquered long ago."[52] Herchenröder, with neither the doubt nor distrust of his predecessors, emphatically read the saluting figure as an unambiguous and laudable exploration of the "phenomenon" of fascism.

One month after Herchenröder's article, Kipphoff, who had been one of the most vociferous voices in the Biennale lambasting of Kiefer, joined in the reappraisal of Kiefer's work. Although Kipphoff sought to explore the ways in which both Kiefer and Baselitz dealt pictorially with what she termed the "German dilemma," that is, on her account, the problematic of articulating a German cultural identity in the aftermath of fascism, she began this task by undertaking a reassessment of Kiefer's and Baselitz's German reception history. Focusing her attention primarily on the criticism generated by the Biennale, Kipphoff looked back on the condemnation and highly charged rhetoric (to which she herself had been party) with a newly tempered and broadened vision, referring to its writers as the *"eiligen Kritiker,"* the "hasty critics"[53] – critics who had been too quick to scorn and dismiss the work of Kiefer and Baselitz.

Kipphoff concluded her summation of the critical positions in 1980 by claiming that the Biennale-inspired controversy was now *"fast vergessen,"* "almost forgotten," a point the carefully reconstructed history of her article would itself seem to contradict. Kipphoff went on to assert that Kiefer was no longer, nor, in fact, had ever been, a fascist,

40. Anselm Kiefer, *Every Man Stands Beneath His Own Dome of Heaven*, 1970. Water-color and pencil on paper; 40 × 48 cm. Courtesy of The Metropolitan Museum of Art, New York. All rights reserved. The Metropolitan Museum of Art.

a Nazi ideologue, or an atavistic romantic, but that he was instead a postwar German struggling with the difficult legacy of his country's and his forefathers' Nazi past. Wrote Kipphoff, "that he is 'one born after,' that is Kiefer's theme."[54] More broadly, Kipphoff asserted that the work of Kiefer and Baselitz, in its exploration not only of the art historical legacies of German culture (e.g., expressionism and romanticism) but of German history (namely, of fascism, but in Kiefer's case, reaching back to the very origins of the German nation in his *Hermann* [Arminius] and *Varus* paintings), was, in the end "the process of their search for identity."[55]

Just why was it that an artist who was first greeted with the appellations Nazi ideologue and fascist, an artist once seen as "a darkly

atavistic neo-Romantic, enamored of taboo national myths and images, steeped in a mode of feeling that had been irretrievably tainted by Nazi culture,"[56] was reborn on the pages of the German press as a *"Nachgeborener,"* "one born after"? Why was Kiefer no longer a reactionary, dangerously and irresponsibly playing with a tabooed nationalist past but, instead, an artist with a historical and moral mission, whose very identity and artistic work derived from his birth in Germany in the last moments of the war, a member of that generation left to work through its legacy?

On a very basic level, the simple fact of Kiefer's acceptance abroad, the blossoming of his career after the presumed debacle of the Venice Biennale, contributed greatly to his German reappraisal. If the international community saw in his work less the artistic assertion of fascist ideology that German critics feared present and hastened to condemn, and more, the laudable attempt to work through and come to terms with the problematic legacy of Germany's Nazi past, then perhaps German critics had been hasty in their judgment. In other words, if the international community saw and registered in this representative of German culture not so much a dangerous ideologue but, instead, a painter with a moral and historical mission, perhaps Kiefer's work was to be valued rather than decried.[57]

As important as the stamp of approval of an international art community may have been, I would suggest that other forces were at work as well. Kiefer's work had emerged on the international arena at a moment in German cultural history when the question of the German past was undergoing a renewed public reevaluation. The catalyst for this historical consciousness was the American TV miniseries *Holocaust*, whose broadcast in Germany was seen to have played an enormous, and to some extent, unprecedented role in causing Germans to confront their past.[58] However, as much as the drama spurred a certain renewed historical consciousness, it also prompted a debate on the aesthetic, ideological, and moral implications of the NBC miniseries and its dramatization and narrativization of history.[59] As such, the broadcasting of the drama not only elicited a demand for historical remembrance but a debate about history and its possibilities for representation.[60]

Precisely because Kiefer emerged on the international arena and

became the subject of much German critical attention in the aftermath of *Holocaust*, a moment not only of renewed engagement with the past but one of extreme sensitivity to the forms such engagement might take, I would suggest that Kiefer's work was less celebrated by German critics for the simple fact of its engagement with the past than condemned for the forms this engagement took. For his work at the Biennale dealt almost exclusively with the phenomenon of German nationalism, in its manifestations ranging from the militaristic to the cultural, and appeared at a moment in Germany that could be characterized by a heightened sensitivity to representations of the past.

In the aftermath of the Biennale, and the German broadcasting of *Holocaust*, Kiefer's work underwent a significant thematic shift. For the first time, after a decade of dealing with themes almost exclusively Germanic, Kiefer took on the issue of the Holocaust and the Jew. In his series of paintings from the early 1980s, the *Margarethe* and *Sulamith* series, Kiefer delved for the first time into the exploration not simply of the German, the perpetrator, and the history and myth that accompanied that identity, but of the Jew. The relationship between the two – the TV film and Kiefer's painting series – is only deepened if we think of the structure of those paintings, the juxtaposition of archetypal German and Jewish womanhood, and compare that with the structure of Greene's novel-turned-television series, *Holocaust*. For, much like Kiefer's more manifest point of reference, Celan's "Fugue of Death," the dramatic structure of the film derived from the opposition of the German and the Jewish, this time through the evocation of two "archetypal" families, whose matriarchs in many ways defined their respective familial identities. That Kiefer finally moved away from themes purely Germanic and engaged with the particular issue of the Holocaust, and more specifically, the Germans and the Jews, certainly came at an opportune time. German society was primed for an engagement with its history, and the *Margarethe* and *Sulamith* canvases allowed German audiences in the 1980s to participate in yet another dimension of *Trauerarbeit*, the work of mourning.[61]

As the eighties progressed, Kiefer further broadened his general thematic preoccupations, moving beyond the almost strictly German context of national myth and history and toward a more universal set

of thematics, ranging from the biblical themes he had first touched on in the 1970s to Mesopotamian and Babylonian myth to kabbalistic tales and theories of creation. Although Kiefer's work continued to explore the notion of identity and of historical catastrophe, his broadening of thematics may have also made his work less threatening to its German audiences, while at the same time, of course, strengthening its appeal abroad. As his work moved away from the purely German context and toward one that was legible as universal, it no longer asserted national identity with such an emphatic clarity, at least on an explicit iconographic level.

With this move to putatively more universal themes during the 1980s, the early legitimation of Kiefer's work by such American gallerists as Sonnabend, Boone, and Goodman shifted to outright celebration. By 1987, Kiefer was honored with a retrospective exhibition in the United States. Although the 1987–8 traveling exhibition granted to Kiefer an even greater status in American critical circles, his success was not a cause for celebration in Germany. Instead, it ushered in yet another chapter in the history of Kiefer's German reception. It would seem that his American success, signaled not only by the retrospective exhibition but by the soaring prices of his work and its increased prominence in American collections, was greeted in Germany with both derision and alarm.

As early as 1984, when the critical reevaluation of Kiefer's work was under way in Germany, Hanno Reuther of the *Frankfurter Rundschau*, already a voice of dissent, wrote that Kiefer's rise to success had occurred not in Germany but in America, implying with the phrase *"amerikanisch gemacht"* ("Americanized," if not "American-made") to describe Kiefer's success, that this was further reason to dislike and disdain Kiefer's work.[62] Reuther's 1984 assertion was in effect confirmed when in 1987 the Kiefer retrospective opened in Chicago. And it was in response to this show, and to the critical honors bestowed upon Kiefer in its wake, that German critics started to analyze and interpret the American character of Kiefer's success.

In 1987, Jürgen Hohmeyer, a critic for *Der Spiegel*, surveyed Kiefer's career in light of the American retrospective and isolated certain noticeable patterns in the collecting of his work. What Hohmeyer

found was that Germans comprised less than one third of the world's collectors of his work. He wrote:

The international resonance of Kiefer stands in sensational disproportion to the reservation at home. In the list of 37 public collections between Eindhoven and Minneapolis, between London and Sydney, of the owners of Kiefer's work, the Germans do not even comprise one third.[63]

Another critic from 1987, Richard Beuth, writing for *Die Welt*, not only provided further material for the claim of undue foreign interest in Kiefer's work but also implied, without ever articulating what precisely he meant, that this disparity in collecting patterns was of great significance. Beuth wrote:

That one finds his most important works more often in a foreign than in a German museum (with the exception of the Staatsgalerie Stuttgart) is very meaningful. That this first comprehensive Kiefer retrospective must take place so far away from Germany, that speaks volumes.[64]

The question that is intimated but not answered in Beuth's article is precisely *why* these collecting patterns seem so portentous.

Taken together, it would seem that the significance of those collecting patterns lay not simply in the disproportionate support of international collectors, but, returning to the initial assertion of the *Frankfurter Rundschau* critic, in the "Americanness" of Kiefer's triumph, as was emphatically emblematized for the German critics in the triumphant 1987–8 retrospective exhibition.[65] Not long after the critical recognition or identification of a certain Americanness in Kiefer's triumph came a more particular assertion. In 1989, Kipphoff once again added her voice to the critical field, asserting a very particular tendency in the collecting of Kiefer's work. She wrote:

That [the works of] Anselm Kiefer are today as desired in Jerusalem as in New York or LA and that a good half of them can be found in the possession of Jewish collectors does not at all reduce their ambivalent thematic but instead confirms their ambiguous fascination.[66]

It is thus that "America," repeated like an incantation in the liturgy of the Kiefer reception, is given a more precise meaning. America becomes synonymous with "the Jews." As Andreas Huyssen would

write of the period, "the spectre of the 'Jewish-American collector' and the made-in-America reputation still haunts the critics and serves as a loaded cipher for their continuing discomfort with the artist's work."[67]

The perceived and intimated specter of the Jew was articulated as well by Kiefer in one of the very few interviews he granted to the press. In a 1990 interview with *art:Das Kunstmagazin*, in regard to the notion that in America, Kiefer is considered "Our Kiefer," a reference to the Peter Schjeldahl article of that very title, the interviewers asked Kiefer how that reputation helped to form his image of America. In response, Kiefer stated that "95 percent of all American collectors who own my work are Jews. That is surely only one aspect of America, but a very important one."[68]

But was that Americanness and, in turn, Jewishness, perceived as good or bad? If in the aftermath of the Biennale German critics were able to relax their stance on Kiefer and praise certain historical dimensions of his work in light of an international and, particularly, American interest in his work, it would seem that in the aftermath of the retrospective, a symbol of Kiefer's extraordinary American success, critics bristled at what might be seen as the recurrent inability of Germany to be in control of its own cultural destiny. For even more than in the 1950s and 1960s, it would seem that in the art world of the 1980s America was perceived as overly engaged in the process of determining the political, social, and cultural shape of postwar German society. More specifically, that it was the Jews (set up as a monolithic and powerful block) who were perceived, for better or for worse, as in some way shaping and determining Kiefer's career, brings up the troubling specter of German ideology past.

What *does* it mean that "the Jews" may or may not constitute a significant portion of the collectors of Kiefer's work, but that the *belief* in their role as such should so shape, or be believed to shape, the German reception of and attitudes about Kiefer? I would suggest that the condemnation of Kiefer, followed by the grudging reassessment and acceptance of his work, all carried out under the specter of his meteoric success in America and the role of the powerful "Jewish-American collector," can be sorted out only by examining the persistent role of anti-semitism in the Federal Republic.

Attitudes toward Jews were of critical importance in the evolution of postwar German political culture.[69] If an unreflective philo-Semitism was functionalized and instrumentalized as a means of morally legitimating the Federal Republic, particularly under Adenauer, anti-Semitism lived on as proof of an "unmastered" legacy of the past. That Kiefer's work, within the space of little more than a few years, could inspire charges of his being a neofascistic ideologue, and then of his being a pawn of sorts of a presumed Jewish-American culture bloc, demonstrates not only the ambivalence of the image of the Jew in the Federal Republic but just how active the myths and realities of the past were and still are in the Germany of the present.

How different is that critical assertion of Jewish control from the tendentious and neo-conservative writings of Hans-Jürgen Syberberg, whose 1990 diatribe *Vom Unglück und Glück der Kunst in Deutschland nach dem letzten Krieg* (invoked in Chapter 1) not only accuses the Frankfurt School, and in his eyes, implicitly the Jews, for setting the stage for aesthetics in the postwar period but speaks of a U.S.-Israeli axis of cultural power? Writes Syberberg, "it could be said for postwar Europe, that the heart of Europe beats in Israel."[70]

Although clearly none of the German critics made such patently and manifestly anti-Semitic assertions and may, in fact, have been exhibiting a certain philo-Semitism in pointing toward, as a form of legitimation, the observable Jewish interest in Kiefer's work, that the specter of the Jew nevertheless hovered around German critics' often ambivalent accounts of Kiefer's American rise to fame renders that writing deeply troubling. Much like Kiefer's work, its reception can also be seen as engaged in an ongoing struggle with the legacy of the past.

As I have suggested at many points in my study, Kiefer's work emerged at a moment in postwar German history when conflicting impulses regarding the past and its place in the present were shaping its cultural, social, and political landscape. Kiefer's reception, then, should be seen as at once embedded in and reflective of this context. In an attempt to chart the course of Kiefer's reception in Germany, I have isolated certain key moments in that history and pointed toward the possible explanations and implications of that volatile history.

First, there was a general fear and vigilance about signs of

renascent or lingering Nazism. Germany, ever wary of its image in an international arena, was quick to condemn any hints of a "return of the repressed." Much like the rioting neo-Nazis whose actions continue to plague Germany, or, perhaps more appropriately, the left-wing anarchists and their misperceived actions, that Kiefer's darkly atavistic work, filled with referents Germanic, could raise the specter of fascism and the Third Reich, that it could raise truths about certain legacies of a none-too-distant past, that it could compromise the image that Germany so wanted to maintain of itself as a thoroughly transformed society, committed to its constitutional democracy, was motivation enough for its dismissal.

That Kiefer was nevertheless accepted, and even celebrated, abroad, particularly in America and Israel, called for a critical reassessment of that early condemnation. But as much as Kiefer's critical acceptance abroad opened up a space for German critics to reverse their critical positions and laud Kiefer's work as historically, if not aesthetically, important, this acceptance also opened up a space for a more troubling development in Kiefer's German reception. For although on some level his American acceptance seemed to vindicate Kiefer and his work, somehow granting his ambiguous work a stamp of approval, it also raised the specter of undue American influence, tinged with anti-Semitic allusions to a Jewish cabal of powerful art collectors. Further, we must not ignore Kiefer's own agency in shaping his reception, particularly if we think of his own turning to Jewish thematics during the 1980s and 1990s.

What the final chapter, or chapters, in Kiefer's reception history will be cannot yet be the subject of my study. That Kiefer has left Germany, and that he continues to turn to cultural traditions other than his own, most recently delving into the myths of Hindu culture, of "all the Indias of the world," points toward his own desire to extricate his work from its German context and situate it instead within that Habermasian category of "post-conventional identity." Whether that identity will ever fully be achieved, by Kiefer, by his critics, or by his painting, can be answered only from a yet to be determined critical and interpretive position in the future.

NOTES

INTRODUCTION

1. Theodor Adorno, "Cultural Criticism and Society" (1949), *Prisms*, Samuel and Sherry Weber, trans. (London: Neville Spearman, 1967), p. 34.

2. Of course, one might look to Azade Seyhan's excellent book *Representation and Its Discontents: The Critical Legacy of German Romanticism* (Berkeley: University of California Press, 1992), which argues that as much as German romantic thought was historically specific in its radical challenge to the traditional claims of representation, the epistemic shift it engendered reached beyond the intellectual and political boundaries of late-eighteenth-century revolution and idealism and paved the way not only for Nietzsche but for the current generation of deconstructionist thinkers – Jacques Derrida, Richard Rorty, Hayden White, Michel Foucault, and Dominick LaCapra among them.

3. Fredric Jameson, *The Political Unconscious: Narrative as Socially Symbolic Act* (Ithaca: Cornell University Press, 1981), p. 102.

4. See as well Saul Friedländer, *History and Psychoanalysis* (1975), Susan Suleiman, trans. (New York: Holmes and Meier, 1978).

5. Alexander and Margarete Mitscherlich, *The Inability to Mourn: Principles of Collective Behavior* (1967), Beverley R. Placzek, trans. (New York: Grove Press, 1975).

6. See, for example, such foundational poststructuralist texts as Roland Barthes, "The Death of the Author" (1968), *Image-Music-Text*, Stephen Heath, trans. (New York: Noonday Press, 1977), pp. 142–8; and Michel Foucault, "What Is an Author?" (1969) *Language, Counter-Memory, Practice: Selected Essays and Interviews*, Donald F. Bouchard, ed. and introduction, Donald Bouchard and Sherry Simon, trans. (Ithaca: Cornell University Press, 1977), pp. 113–38.

7. Andreas Huyssen, "Anselm Kiefer: The Terror of History, the Temptation of Myth," *October* 48 (Spring 1991), pp. 85–101, and "Kiefer in Berlin"

October 62 (Fall 1992), pp. 25–45. There is, of course, also Mark Rosenthal's substantial essay and generously illustrated catalogue, *Anselm Kiefer* (Chicago and Philadelphia: Art Institute of Chicago and Philadelphia Museum of Art, 1987).

8. The direction of his Richter project is suggested by his recent, excellent article on Richter, "Divided Memory and Post-Traditional Identity: Gerhard Richter's Work of Mourning," *October* 75 (Winter 1996), pp. 61–82. I would point as well to such a recent work as Irit Rogoff's "The Aesthetics of Post-History: A German Perspective," in *Vision and Textuality*, Stephen Melville and Bill Readings, eds. (Durham, N.C.: Duke University Press, 1995), pp. 115–46, which situates aspects of the work of Jörg Immendorff, Joseph Beuys, and Jochen and Esther Gerz within debates on history and collective memory. Important as well is James Young's work on monuments, *The Texture of Memory: Holocaust Memorials and Meaning* (New Haven: Yale University Press, 1993).

9. Beginning with the German Pavilion at the 1980 Venice Biennale, several key exhibitions helped to put forth the notion of the emergence of a figurative, expressionistic artistic movement. I would point to the following group exhibitions: *Heftige Malerei*, Berlin, 1980; *A New Spirit in Painting*, London, 1981; *Documenta*, Kassel, 1982; *Zeitgeist*, Berlin, 1983; *Expressions: New Art from Germany*, St. Louis, 1983; *Berlin Art 1961–1987*, New York, 1987; *Refigured Painting: The German Image 1960–1988*, New York, 1989.

10. Siegfried Kracauer, *From Caligari to Hitler: A Psychological History of the German Film* (Princeton: Princeton University Press, 1947).

11. Anton Kaes, *From Hitler to Heimat: The Return of History as Film* (Cambridge, Mass., and London: Harvard University Press, 1989).

12. As Kracauer writes, and I cite the passage in its entirety, "We have learned in school the story of the Gorgon Medusa whose face, with its huge teeth and protruding tongue, was so horrible that the sheer sight of it turned men and beasts into stone. When Athena instigated Perseus to slay the monster, she therefore warned him never to look at the face itself but only at its mirror reflection in the polished shield she had given him. Following her advice, Perseus cut off Medusa's head with a sickle, which Hermes had contributed to his equipment. The moral of the myth is, of course, that we do not, and cannot, see actual horrors because they paralyze us with blinding fear; and that we shall know what they look like only by watching images of them which reproduce their true appearance. These images have nothing in common with the artist's imaginative rendering of an unseen dread but are in the nature of mirror reflections. Now of all the existing media the cinema alone holds up a mirror to nature.

Hence our dependence on it for the reflection of happenings which would petrify us were we to encounter them in real life. The film screen is Athena's polished shield." Siegfried Kracauer, *The Theory of Film: The Redemption of Physical Reality* (New York: Oxford University Press, 1960), p. 305.

13. See, for example, in addition to Kaes, such studies as Richard W. McCormick, *Politics of the Self: Feminism and the Postmodern in West German Literature and Film* (Princeton: Princeton University Press, 1991); and Eric L. Santner, *Stranded Objects: Mourning, Memory, and Film in Postwar Germany* (Ithaca and London: Cornell University Press, 1990).

14. Of course, a great deal of scholarship has set out to redress the interpretive limitations of the Greenbergian, or formalist, paradigm, ranging from Marxism, feminism, psychoanalysis, structuralism, and semiotics to poststructuralism. One might look back to the influential words of Greenberg in his essay "Abstract and Representational" (May 1954), in John O'Brian, ed., *The Collected Essays* (Chicago: University of Chicago Press, 1986), in which Greenberg writes, "That the *Divine Comedy* has an allegorical and analogical meaning as well as a literal one does not make it necessarily a more effective work of literature than the *Iliad*, in which we fail to discuss more than a literal meaning. Similarly, the explicit comment on a historical event offered by Picasso's *Guernica* does not make it necessarily a better work than an utterly 'non-objective' painting by Mondrian that says nothing explicitly about anything" (p. 187). One might look as well to the criticism of Michael Fried, as articulated in *Three American Painters: Kenneth Noland, Jules Olitski, Frank Stella* (Cambridge, Mass.: Fogg Art Museum, 1965), in which Fried writes, "Criticism concerned with aspects of the situation in which it was made other than its formal context can add significantly to our understanding of the artist's achievement. But, criticism of this kind has shown itself largely unable to make convincing discriminations of value among the works of a particular artist, and in this century it often happens that those paintings that are most full of explicit human content can be faulted on formal grounds – Picasso's *Guernica* is perhaps the most conspicuous example – in comparison with others virtually devoid of such content" (p. 5). Or, "it is one of the prime, if tacit, convictions of modernist painting – a conviction matured out of painful experience, individual and collective – that only an art of constant formal self-criticism can bear or embody or communicate more than trivial meaning" (p. 25).

15. See, for example, Barbara Straka, ed. *Interferenzen = Kunst aus Westberlin 1960–1990* (Berlin: Verlag Dirk Nishen, 1991); and Christos M. Joachimides, Norman Rosenthal, and Wieland Schmied, eds., *German Art*

in the 20th Century: Painting and Sculpture 1905–1985 (Munich: Prestel Verlag, 1985). One might look specifically to the painting of Werner Heldt, whose postwar work continues to express his pictorial attachment to the neighborhoods of Berlin.

16. Here I make reference to Yule Heibel's study of abstraction and its constitutive discursive fields, *Reconstructing the Subject: Modernist Painting in Western Germany, 1945–1950* (Princeton: Princeton University Press, 1995), which is as much an analysis of the state of German subjectivity as it is of postwar abstraction. Heibel argues that although different kinds of abstract painting were produced in West Germany, the public and the critics suppressed affective, expressive dimensions in art, as is typified in the reception of the work of Ernst Wilhelm Nay, because such dimensions contradicted society's attempts to relocate a secure, postwar *Menschenbild*, an "image of man." Heibel argues that this image was formed in the Federal Republic in relation both to the National Socialist's bankrupt bid to determine man and to the postwar division into "occident" and "the East," and that Western Germany's bid to rejoin "the occident" restricted painting's expressive potential, since this came to be associated with Nazism and totalitarianism, including Soviet-style communism.

17. Jost Hermand, "Modernism Restored: West German Painting in the 1950s," Giddy Martin, trans., *New German Critique* 32 (Spring/Summer 1984), pp. 23–41. In relation to this "restoration" of modernism, one might look as well to the history of exhibitions in postwar Germany, both American sponsored and German initiated, that, by the late fifties, reinforced abstraction as the dominant painterly idiom. For an analysis of this history, see David Elliott, "Absent Guests: Art, Truth and Paradox in the Art of the German Democratic Republic," in *The Divided Heritage: Themes and Problems in German Modernism*, Irit Rogoff, ed. (Cambridge and New York: Cambridge University Press, 1991), pp. 32–3; and Dieter Westecker, *Documenta-Dokumente: 1955–1968: 4 internationale Austellungen moderner Kunst* (Kassel: Wenderoth, 1992).

18. The text from the speech was printed in *Die Zeit* (May 10, 1985), pp. 20–1. It was cited and translated in Joseph Thompson, "Blasphemy on Our Side: Fates of the Figure in Postwar German Painting," in *Refigured Painting: The German Image: 1960–88*, Thomas Krens, Michael Govan, and Joseph Thompson, eds. (New York and Munich: Guggenheim and Prestel Verlag, 1989), pp. 30–1. Grass's speech not only provides a characterization of the cultural climate in a divided postwar Germany. It underscores the fundamental importance to the formation of postwar German aesthetics of the so-called *Darmstädter Gespräche*, a series of debates, or conversations, between the proponents of figuration and those of abstraction. It was in the aftermath of these debates that abstraction

moved to the foreground of critical discourse and artistic practice. For a more detailed account of the proceedings, see H. G. Evers, *Darmstädter Gespräche: Das Menschenbild in unserer Zeit* (Darmstadt: Neue Darmstädter Verlaganstalt, 1951); and Hermann Glaser, *Kultur der Bundesrepublik Deutschland: Zwischen Grundgesetz und großer Koalition 1949–1967* (Munich: Carl Hanser Verlag, 1986), pp. 69–75. Moreover, Grass's identification of abstraction as an art for "external consumption" is a diagnosis I will explore in depth in Chapter 4, when I turn to Kiefer's reception, particularly once it moves into an international arena.

19. One might think of the naming and conceptual basis for *Gruppe Zero* as an example of the metaphorical and political value of abstraction in the immediate postwar era. A statement by Otto Peine, one of the founding members of its German branch, along with Heinz Mack and Günter Uecker, is quite telling. Wrote Peine: "The title ZERO was the result of months of search and was finally found more or less by chance. From the beginning we looked upon the term not as an expression of nihilism – or a fad-like gag, but as a word indicating a zone of silence and of pure possibilities for a new beginning as at the count-down when rockets take off – zero is the incommensurable zone in which the old state turns into new." Peine's statement, published originally in Germany in 1958 and 1961, and then in *The Times Literary Supplement* (September 3, 1964), is reprinted in *Zero*, Howard Beckman, trans. (Cambridge, Mass.: MIT Press, 1973), p. xxiii.

20. That this shift would not fully occur until the 1960s, whether we look to such aesthetically divergent examples as Baselitz's antiheroic figurative paintings of soldiers from the early 1960s, Richter's 1965 *Uncle Rudi*, or Kiefer's 1969 book projects, is in part, in terms of its belatedness, the very subject of my study.

21. For a discussion of the personal mythology founding Beuys's work, see, for example, Benjamin H. D. Buchloh, Rosalind Krauss, and Annette Michelson, "Joseph Beuys at the Guggenheim," *October* 12 (Spring 1980), pp. 3–21; and Benjamin Buchloh, "Beuys: Twilight of the Idol: Preliminary Notes for a Critique," *artforum* 18(5) (January 1980), pp. 35–43. For all the fusing of myth with fact, we know that Beuys was born in Krefeld in 1921, that he served as a combat pilot in the Luftwaffe from 1941 to 1945, and that he was interred as a prisoner of war in Cuxhaven, England, from 1945 to 1946. See as well Götz Adriani, *Joseph Beuys* (Cologne: Verlag M. Dumant Schauberg, 1973); Caroline Tisdall, *Joseph Beuys* (New York: Guggenheim, 1979); and Lynne Cooke and Karen Kelly, eds., *Arena* (New York: Dia Center, 1994).

22. As cited in Tisdall, *Joseph Beuys*, p. 23. The full citation reads: "I do not feel that these works were made to represent catastrophe, although the

experience of catastrophe has contributed to my awareness. But my interest was not in illustrating it. Even when I used such titles as 'Concentration Camp Essen' this was not a description of the event but of the content and meaning of catastrophe. The human condition is Auschwitz and the principle of Auschwitz finds its perpetuation in our understanding of science and of political systems, in the delegation of responsibility to groups of specialists and in the silence of intellectuals and artists."

23. The Mitscherlichs's book *Inability to Mourn* is particularly relevant in that its publication at once coincided with and helped to galvanize the burgeoning protest movement in West Germany. The authors' basic contention is that postwar Germans were unable, or, more appropriately, unwilling to mourn the loss, not of the Jews, as some would later misconstrue their argument, but of Hitler, as ego ideal. For an analysis of the climate of repressed memory in postwar Germany, one might look as well to Theodor Adorno, "What Does Coming to the Past Mean?" (1959), in *Bitburg in Moral and Political Perspective*, Geoffrey Hartman, ed. (Bloomington and Indianapolis: University of Indiana Press, 1986), pp. 114–29; and Judith Miller, *One, by One, by One: The Landmark Exploration of the Holocaust and the Uses of Memory* (New York: Simon and Schuster, 1990). It should also be noted that in the years since its publication, the descriptive and diagnostic veracity of the Mitscherlichs's study has not gone uncontested. See, for example, Ivo Frenzel, "Müssen wir trauern? Wiedergelesen: 'Die Unfähigkeit zu trauern' von Alexander und Margarete Mitscherlich," *Frankfurter Allgemeine Zeitung* (June 7, 1978); and Eckhard Henscheid, "Die Unfähigkeit zu trauern oder so ähnlich: Eine Spezialkapitel zur Kulturgeschichte der Mißverstandnisse," *Frankfurter Rundschau* 133 (June 12, 1993).

24. George Steiner, "The Hollow Miracle," *Language and Silence* (New York: Athenaeum, 1967), p. 95.

25. See, for example, Anson Rabinbach, "The Jewish Question in the German Question," *New German Critique* 44 (Spring/Summer 1988), pp. 159–92; and Frank Stern, *The Whitewashing of the Yellow Badge: Antisemitism and Philosemitism in Postwar Germany*, William Tampler, trans. (Oxford and New York: Oxford University Press, 1992).

26. Kiefer studied as well with Horst Antes and Peter Dreher.

1. "THOU SHALT NOT MAKE GRAVEN IMAGES"

1. Theodor Adorno, "Kulturkritik und Gesellschaft," written in 1949, published singly in 1951, collected in Adorno, *Prismen* (1955), and translated into English as "Cultural Criticism and Society," in *Prisms*, Samuel and Sherry Weber, trans. (London: Neville Spearman, 1967), p. 34.

2. Taken literally, Adorno's statement suggests not that it is "impossible" to write poetry after Auschwitz but, rather, that is "barbaric." However, it is not so much this literal interpretation that has endured but, instead, an interpretation that moves from the barbarism of poetry to the impossibility of any form of aesthetic representation. See, for example, such post-Holocaust collections as *Languages of the Unsayable: The Play of Negativity in Literature and Literary Theory*, Sanford Budick and Wolfgang Iser, eds. (New York: Columbia University Press, 1989); *Probing the Limits of Representation: Nazism and the "Final Solution,"* Saul Friedländer, ed. (Cambridge, Mass.: Harvard University Press, 1992); Dominick LaCapra, *Representing the Holocaust: History, Theory, Trauma* (Ithaca and London: Cornell University Press, 1994); and Andre Neher, *The Exile of the Word: From the Silence of the Bible to the Silence of Auschwitz* (1970), David Maisel, trans. (Philadelphia: Jewish Publication Society of America, 1981). It is in this broader sense that I will take up Adorno's dictum in this chapter.

3. On Adorno's messianic utopianism, see, for example, Martin Jay, *Adorno* (Cambridge, Mass.: Harvard University Press, 1984); Richard Wolin, "Utopia, Mimesis, and Reconciliation: A Redemptive Critique of Adorno's *Aesthetic Theory*," *Representations* 32 (Fall 1990), pp. 33–49; Terry Eagleton, "Art after Auschwitz: Theodor Adorno," *The Ideology of the Aesthetic* (London: Basil Blackwell, 1990), pp. 341–65; Lambert Zuidervaart, *Adorno's Aesthetic Theory: The Redemption of Illusion* (Cambridge, Mass.: MIT Press, 1991); and, most recently, Thierry de Duve, "Silences in the Doctrine," *Clement Greenberg between the Lines*, Brian Holmes, trans. (Paris: Dis Voir, 1996), pp. 39–86. More broadly, it is the work of Sander L. Gilman, particularly sections of *Jewish Self-Hatred: Anti-Semitism and the Hidden Language of the Jews* (Baltimore and London: Johns Hopkins University Press, 1986), that addresses the "Jewishness" of Adorno.

4. In fact, in "Utopia, Mimesis, and Reconciliation" Wolin posits the discussion of the utopian function of art in Adorno's *Aesthetic Theory* as a situation in which "Adorno comes close to violating the Judeo-Marxian *Bilderverbot* (the taboo against graven images) insofar as utopia is well-nigh concretely depicted" (p. 41). That is, for Adorno, according to Wolin, art is a form of remembrance, a wedding of past and present, a concrete utopian projection. One might look as well to "Something Missing: A Discussion between Ernst Bloch and Theodor W. Adorno on the Contradictions of Utopian Longing," in Ernst Bloch, *The Utopian Function of Art and Literature: Selected Essays*, Jack Zipes and Frank Mecklenburg, trans. (Cambridge, Mass.: MIT Press, 1988), pp. 1–17, in which Adorno quite explicitly links the Second Commandment with the category

of the "false utopia." As Adorno says, "And this is why I believe – all this is now very tentative – the commandment not to 'depict' utopia or the commandment not to conceive certain utopias in detail as Hegel and Marx have . . . Hegel did this insofar as he depreciated the world-reformer in principle and set the idea of the objective tendency in opposition – this is what Marx adopted directly from him – and the realization of the absolute. In other words, that which one could call utopia in Hegel's works, or which one *must* call utopia in his youth, originated right at this moment. What is meant there is the prohibition of casting a picture of utopia actually for the sake of utopia, and that has a deep connection to the commandment, 'Thou shalt not make a graven image!' This was also the defense that was actually intended against the cheap utopia, the false utopia, *the* utopia that can be bought" (pp. 10–11).

5. Hans-Jürgen Syberberg, *Vom Unglück und Glück in der Kunst in Deutschland nach dem letzten Krieg* (Munich: Matthes and Seite Verlag GmbH, 1990). I am grateful to Robert R. Shandley for the reference and the insight.

6. Gertrud Koch, *Die Einstellung ist die Einstellung: Visuelle Konstruktionen des Judentums* (Frankfurt am Main: Suhrkamp Verlag, 1992). It is the first section of her book "In Sachen Moses gegen Aron: Die Kritische Theorie und das Kino," particularly the chapters "Mimesis und Bilderverbot in Adornos Asthetik" (pp. 16–29) and *"Moses und Aron:* Musik, Text, Film und andere Fallen der Rezeption" (pp. 30–53), to which I am most indebted. (See as well the article by Gertrud Koch, "Mimesis and *Bilderverbot,"* *Screen* 34[3] [Autumn 1993], pp. 211–22.) I share this indebtedness with certain scholars in the field of post-Holocaust film studies. See, for example, Miriam Bratu Hansen, *"Schindler's List* Is Not *Shoah:* The Second Commandment, Popular Modernism, and Public Memory," *Critical Inquiry* 22 (Winter 1996), pp. 292–312.

7. For a deconstructive approach to the historiography of Dura Europas, one that challenges traditional Western conceptions of Jews as anti-iconic, see A. J. Wharton's "Good and Bad Images from the Synagogue at Dura Europas: Context, Subject, Intertexts," *Art History* 17(1) (March 1994), pp. 1–25.

8. I should mention that this initial reading I offer of the Second Commandment is purposefully emphatic in its literalness. I will go on to broaden that interpretation shortly. I should also mention at this juncture that Russell A. Berman, in "Avantgarde und Bilderverbot," *Kunst und Politik der Avantgarde* (Mousonturm: Künstlerhaus, 1989), pp. 49–64, theorizes the meaning and temporality of the avant-garde within the postmodern, suggesting that, in fact, and quite paradoxically, the *Bilderverbot*, the

Second Commandment, sanctions images or, in turn, art, at the same time that it would seem to forbid it. He writes, for example: "The Ark of the Covenant is to be understood here as the model of art work, as the production of the paradoxes of revelation, namely, of sensual idolatry and ascetic iconoclasm in a delicate unity." ["Die Bundeslade ist daher zu verstehen als das Vorbild des Kunstwerks, die Inszenierung des Paradoxen der Offenbarung, nämlich des sinnlichen Bilderdienstes und des asketischen Bildersturms in einer labilen Einheit."] (p. 60).

9. Paul Celan, "Tübingen, January," from the collection *Niemandsrose* ("The No One's Rose," 1963), reprinted and translated in John Felstiner, *Paul Celan: Poet, Survivor, Jew* (New Haven and London: Yale University Press, 1995), pp. 172–3.

10. Theodor Adorno, *Aesthetic Theory*, C. Lehnhardt, trans. (London and Boston: Routledge & Kegan Paul, 1984), p. 100.

11. Adorno, *Aesthetic Theory*, p. 444.

12. Adorno, *Aesthetic Theory*, p. 32.

13. If one looks beyond Adorno, one finds the historically induced hebraic thematics of impossibility emphatically and somewhat paradoxically expressed in the resolutely ahistorical terrain of postwar, poststructuralist theory, distilled in the formulation that all forms of representation are "always already" inadequate to the task with which they are charged. Of course, one could speak much more broadly of the interdiction against figuration, arguing that it is not so much specific to a post-Holocaust condition as to the constitution of modernism at large. That is, one could argue that the problem of historical representation and representability is at the very heart of modernism's project. However, insofar as mine is not a project that takes on or attempts to situate Kiefer's work within either historical modernism or the historical avant-garde, and, more important, insofar as Adorno's dictum and other writings in question emerged precisely in a post-Holocaust context, I will keep my discussion within those parameters.

14. Adorno, *Aesthetic Theory*, p. 22.

15. Adorno, *Aesthetic Theory*, p. 312.

16. Adorno, *Aesthetic Theory*, p. 16.

17. Jean-François Lyotard, "Jewish Oedipus" (1970), translated in *GENRE* 10 (Fall 1977), pp. 395–411.

18. Jean-Joseph Goux, "Moses, Freud and the Iconoclastic Prescription," in *Symbolic Economies: After Marx and Freud*, Jennifer Curtiss Gage, trans. (Ithaca: Cornell University Press, 1990), pp. 134–50. The essay, when originally published in France, was a section in *Les Iconoclastes* (Paris: Seuil, 1978), which explored the theoretical implications of iconoclasm

for such a range of subjects as the Marxist theory of the commodity fetish, the fall of the gold standard, the Nazi persecution of the Jews, and modern art. The subject of a "modern" or contemporary iconoclasm was addressed further in France at a colloquium in 1984, organized by Adelie and Jean-Jacques Rassial, the proceedings of which were published in the volume entitled *L'interdit de la représentation: Colloque de Montpellier* (Paris: Seuil, 1984).

19. One might look as well to Yosef Hayim Yerushalmi, *Freud's Moses: Judaism Terminable and Interminable* (New Haven and London: Yale University Press, 1991), for a suggestive and provocative rereading of Freud's *Moses and Monotheism* as at its essence a treatise on the personal, religious, ethical, and political implications of the Moses narrative; the presumptive repressed patricide upon which Judaism and monotheism is, on Yerushalmi's account, founded; and, finally, Freud's own attitude toward Judaism and his own Jewish identity.

20. Laura Mulvey, "Visual Pleasure and Narrative Cinema" (1973), *Visual and Other Pleasures* (Bloomington and Indianapolis: Indiana University Press, 1989), pp. 14–26. I am grateful to Robert R. Shandley for the initial connection.

21. Mulvey, "Visual Pleasure," p. 26.

22. Mulvey, *Visual and Other Pleasures*, p. ix.

23. Mulvey, "Afterthoughts on 'Visual Pleasure and Narrative Cinema,' inspired by King Vidor's *Duel in the Sun* (1946)" (1981), in *Visual and Other Pleasures*, pp. 29–38.

24. Laura Mulvey, "Pandora: Topographies of the Mask and Curiosity," *Sexuality and Space*, Beatriz Colomina, ed. (New York: Princeton Architectural Press, 1992), pp. 53–71.

25. Martin Jay, *Downcast Eyes: The Denigration of Vision in Twentieth Century French Thought* (Berkeley, Los Angeles, and London: University of California Press, 1993).

26. Jacques Lacan, *The Four Fundamental Concepts of Psycho-analysis*, Alan Sheridan, trans. (New York: Norton, 1981), p. 101.

27. Leviticus 5:1, "And if any one sin, and hear the voice of one swearing, and is a witness either because he himself hath seen, or is privy to it, if he do not utter it, he shall bear his iniquity."

28. The Mitscherlichs, *Inability to Mourn*.

29. Theodor Adorno, *Negative Dialectics* (1966) E.B. Ashton, trans. (New York: Continuum, 1973), p. 362.

30. I should note that Kiefer continues to return to the thematics of the Iconoclastic Controversy series, in the form of both paintings and books, demonstrating his sustained engagement with issues of iconoclasm and representation.

31. The Iconoclastic Controversy of Byzantium is relevant in the broader context of Kiefer's project, not only for its historical instantiation of the debates about figuration and representation catalyzed by the Second Commandment but also for the ways in which scriptural Judaism and the Jews were taken up in those debates, insofar as the Iconoclasts were equated with, or likened to the Jews. See, for example, Kathleen Anne Corrigan, *Visual Polemic in the Ninth-Century Byzantine Psalters* (Cambridge and New York: Cambridge University Press, 1992). See as well John Gager, *The Origins of Anti-Semitism: Attitudes toward Jews in Pagan and Christian Antiquity* (Oxford and New York: Oxford University Press, 1983); and Rosemary Radford Reuther, *Faith and Fratricide: The Theological Roots of Anti-Semitism* (New York: Seabury Press, 1979).

32. Composed not in a concentration camp – as has often been suggested – but in Czernowitz in late 1944, not long after Soviet troops reoccupied Bukovina, Celan's poem was nevertheless the work of a Jewish survivor of the Holocaust, written with the plural pronoun *wir* ("we") and in an insistent present tense, allowing the poem to read as if from a Nazi camp where the speaker is present, giving it an air of witness. See John Felstiner, "Translating Paul Celan's 'Todesfugue': Rhythm and Repetition as Metaphor," in *Probing the Limits of Representation*, p. 241.

33. Felstiner, *Paul Celan*, pp. 30–2.

34. As Christiane Hertel has suggested, this black paper covering may be an ironic motif, suggesting the literal *Verdunklung* ("blacking out") of windows during the war and the metaphorical *Verdunklung* of obedience and blindness.

35. It should be noted that there does (or did) exist a version of *Sulamith*, in the collection of the artist, in which a nude female figure appears before the backdrop of a densely packed urban skyline. Her treatment is formally expressionistic, and it is her long dark hair that dominates the composition, both cloaking the body and obscuring much of the underlying cityscape. In the dominance of the hair, it would seem that although figured, the representation of Sulamith remains fundamentally metonymic, her hair serving as a marker (much as in the accompanying *Margarethe* and the later projects involving Lilith and kabbalistic mysticism) of her identity.

36. Sidra DeKoven Ezrahi, "'The Grave in the Air': Unbound Metaphors in Post-Holocaust Poetry," in *Probing the Limits of Representation*, p. 260.

37. Such an argument is made by Andreas Huyssen in his "Anselm Kiefer: The Terror of History, the Temptation of Myth, *October* 48 (Spring 1991), pp. 85–101.

38. Here I am allying my reading of Kiefer's work with Kaja Silverman's work on postwar cinema, *Male Subjectivity at the Margins* (New York and

London: Routledge, 1992), in which she, at once building on and depart-
ing from Lacan and Žižek, posits history as the "traumatic kernel."

39. Pierre Nora, "Between Memory and History: *Les Lieux de Mémoire*," *Representations* 26 (Spring 1989), pp. 7–25.

40. James Young, *The Texture of Memory: Holocaust Memorials and Meaning* (New Haven and London: Yale University Press, 1993). Young curated a related show at the Jewish Museum in New York, The Art of Memory: Holocaust Memorials in History, which ran from April to July 1994.

41. Young, *The Texture of Memory*, p. 27.

42. The Scheunenviertel was a neighborhood in Berlin near the Alexanderplatz, which in the 1920s and 1930s became almost exclusively a neighborhood for working-class, unassimilated Jewish immigrants from Russia and Poland, their eastern origins earning them the appellation *Ostjuden*. The neighborhood's name derives from the *Scheune*, barns, which had been built in many backyards in the eighteenth and nineteenth centuries to house farm animals.

43. For a discussion of Boltanski's piece, see John Czaplicka, "History, Aesthetics and Contemporary Commemorative Practice in Berlin," *New German Critique* 65 (Spring/Summer 1995), pp. 155–87. Setting Boltanski's site-specific project against two more standard public commemorative sites in Berlin – the execution chambers used by the Nazis at the Plötzensee prison, where Nazis murdered resisters, and the Topography of Terror, a historical exhibition installed in the excavated basement cells of the former Gestapo headquarters, Czaplicka probes how and to what effectiveness the linking of an aesthetic representation with a presentation of historical facts sets the stage for a contemplative and enlightening engagement with history.

44. For a treatment of Lin's monument, see Daniel Abramson, "Maya Lin and the 1960s: Monuments, Time-Lines, and Minimalism," *Critical Inquiry* 22(4) (Summer 1996), pp. 679–709.

45. Here I would invoke again the writings of Slavoj Žižek and his articulation of what might be called a postmodern ethics. Writes Zizek, "The point is *not* to remember the past trauma as exactly as possible: such 'documentation' is a priori false, it transforms the trauma into a neutral, objective fact, whereas the essence of the trauma is precisely that it is too horrible to be remembered, to be integrated into our symbolic universe. All we have to do is to mark repeatedly the trauma as such, in its very 'impossibility,' in its nonintegrated horror, by means of some 'empty' symbolic gesture." *For they know not what they do: Enjoyment as a Political Factor* (London: Verso, 1991), p. 273.

46. "Kabbalah" is the traditional and most widely used term for the esoteric teachings of Judaism and for Jewish mysticism, especially the forms it

assumed in the Middle Ages, from the twelfth century forward. In its early formations, known as Merkabah mysticism (or, as Kiefer has transliterated the Hebrew word, Merkaba), it embraced an esotericism closely akin to the spirit of Christian Gnosticism. Only later, once it came into contact with medieval Jewish philosophy, did Kabbalah become systematically elaborated as a Jewish "mystical theology." The *Zohar*, written by Moses de Leon in 1280–6, is the central work of classical Kabbalah and centers on the doctrine of the *Sefiroth*, a doctrine that describes a structural system of divine emanations by which all reality is structured. See, for example, Gershom Scholem, *Kabbalah* (New York: Quadrangle/New York Times Book Company, 1974), and *The Origins of Kabbalah*, Allan Arkash, trans. (Princeton: Princeton University Press, 1987).

Kabbalah from the sixteenth century to the present is a second, or modern, Kabbalah, largely the creation of Isaac Luria of Safed in Palestine during the years 1534–72. In the Lurianic school of Kabbalah, creation occurred not through divine emanations but through God's withdrawal, God's self-contraction ("tzimtzum"), engendering a doctrine called the Breaking of the Vessels. As these divine emanations broke their vessels, rendering them nothing more than earthly or material fragments, it was the task of humanity to repair the vessels to bring about the redemption of the cosmos itself. See, for example, Gershom Scholem, *The Messianic Idea in Judaism and Other Essays on Jewish Spirituality* (New York: Schocken Books, 1971), and *Sabbatai Sevi: The Mystical Messiah* (Princeton: Princeton University Press, 1973).

47. One critic, Doreet LeVitté Harten, argues that it was "almost inevitable," given Kiefer's established techniques, that he would ultimately turn to Kabbalah. See her "Canticle for a God Unknown," in *Anselm Kiefer: Lilith* (New York: Marian Goodman Gallery, 1991), pp. 9–15. The essay appears in translation, though with a different title, in the catalogue for the Berlin retrospective of Kiefer's work in 1991 as "Bruch der Gefäße," Angelika Schweikhart, trans. *Anselm Kiefer* (Berlin: Staatliche Museen, Preußischer Kulturbesitz, 1991), pp. 20–8. As LeVitté Harten writes: "Anselm Kiefer had been applying cabalistic methods in his works long before he knew anything about Cabala. His whole approach to art with its migration of symbols and anagoges, his understanding of the artist's role and his sense of time – the way it should be applied and projected from the stuff created and the stuff remembered – the very state of fluctuation he was keen on carefully preserving in his works correspond to the main tenets of the Cabala. Kiefer discovered an ancient mirror reflecting his own ideas in that mystical Jewish doctrine. Before this encounter with the system his ideas had been formulated in different terms. The Cabala provided Kiefer with a more accurate glossary. . . . Alchemy is the wrong term to apply to the act

of transmutation in Kiefer's work. It had a deeper root, for an aesthetic system so complete and so compatible with the aesthetic revealed in Kiefer's work was concealed under the religious exterior of the Cabala. The eventual encounter between the two seemed almost inevitable."

LeVitté Harten fails to note that as early as 1986, well before Kiefer began his works indebted to Kabbalah, he expressed his knowledge of that Jewish mystical tradition in a conversation that deals as well with Jewish iconoclasm. As Kiefer stated in his remarks to Jannis Kounellis during a round-table dialogue, published as *Ein Gespräch = Una Discussione: Joseph Beuys, Jannis Kounellis, Anselm Kiefer, Enzo Cucchi,* Jacqueline Burckhardt, ed. (Zurich: Parkett-Verlag, 1986), "When one speaks of Israel, one must of course also speak of the intellectuality of representation. There they have no pictorial representation in the bible or the Kabbalah, but instead entirely intellectual representations . . . Naturally, as it is written in the Bible, 'In the beginning was the word.' Therefore letters, not pictures, were holy." ["Wenn man von Israel spricht, muss man natürlich auch von der Intellektualität der Vorstellung sprechen. Dort haben sie keine bildlichen Vorstellungen in der Bibel oder in der Kabbala, sondern ganz intellektuelle Vorstellungen Natürlich, denn in der Bibel steht: 'Am Anfang war das Wort.' Daher waren nie die Bilder, sondern die Buchstaben heilig."] (pp. 48–9).

48. See, for example, David Roskies, *Against the Apocalypse: Responses to Catastrophe in Modern Jewish Culture* (Cambridge, Mass.: Harvard University Press, 1984).

49. I am deeply indebted to Susan A. Handelman's excellent book *Fragments of Redemption: Jewish Thought and Literary Theory in Benjamin, Scholem, and Levinas* (Bloomington and Indianapolis: Indiana University Press, 1991), particularly her chapter "Memory Is the Secret of Redemption: Messianism and Modernity," pp. 149–73, which pointed me toward Scholem's reading of the Lurianic Kabbalah against a framework of historical trauma and catastrophe.

50. It should be noted that this space closely resembles and most likely is the brick factory in Buchen that Kiefer used as his studio space until his recent move to France and that appears as a backdrop in a number of his photographically based paintings and book projects.

51. Walter Grasskamp in his essay "Anselm Kiefer: Der Dachboden," in *Der vergeßliche Engel: Künstlerportraits für Fortgeschrittene* (Munich: Verlag Silke Schreiber, 1986), pp. 7–22, discusses a series of earlier pictures by Kiefer, the "attic" pictures, those conceived during the early 1970s when he worked in an abandoned schoolhouse in the Odenwald. For Grasskamp, the attic space represents the space of the "verbotene Bild," the "forbidden picture," as, for example, Oscar Wilde's *The Portrait of*

Dorian Gray. On Grasskamp's account, Kiefer's pictures at once figure and occupy that attic space insofar as they delve into taboo or repressed subjects and do so in the architectural space of the attic. One might point to such works, all from 1973, as *Nothung; Germany's Spiritual Heroes; Father, Son, and Holy Ghost; Quaternity;* and *Faith, Love and Hope*, all of which take as their basis the wood-grained attic space (the top floor of the converted schoolhouse in which Kiefer was then living and working). From the Wagnerian sword of Siegfried in *Nothung* to the idiosyncratic Valhalla of German philosophers, artists, and writers inscribed in name alone upon the bare wooden floors of *Germany's Spiritual Heroes*, Kiefer constructs a space for a tabooed national past. That Kiefer then moves to representing the deeper regions of the cellar space (also determined by his move to the abandoned brick factory), the darkened, cryptlike spaces that frame so many of his works during the 1980s, suggests a further symbolic movement into the recesses of collective memory.

52. See Scholem, "The Symbolism of the Shekkinah and the Feminine: The Jewel," in *Origins of Kabbalah*, pp. 162–80.

53. Central to these works is the kabbalistic figure of Lilith, the mystical counterfigure to Eve and mythic demoness, the archetypal bad woman, seductive and destructive, recognizable in many accounts by her long black hair. In the painting *Lilith*, 1990, a tress of black hair hovers atop a dense, urban landscape that is partially obscured by a swirl of smoglike gray paint. Above the tress, amid the painterly clouds of smog, Kiefer has inscribed, in looping cursive, the name Lilith. In other images involving Lilith, for example, *The Daughters of Lilith*, 1991, hair is accompanied or replaced by smocklike, often ash-covered white dresses. Lilith the demoness, Lilith the woman-warrior, Lilith the literal and metaphorical mother of melancholy. Lilith is also, according to certain books of Kabbalah, the transformed image of the biblical Sulamith, her dark side.

54. In his recent work *The Jew's Body* (New York and London: Routledge, 1991) Sander Gilman speaks of the growing invisibility of the Jew in fin-de-siècle German society, an invisibility engendered by assimilation. But if the German Jew (that is, the middle- and upper-middle-class secularized German Jew) was rendered virtually invisible through assimilation in pre-war Germany, the Jew in postwar Germany has been rendered quite literally invisible as a result of the destruction of the population of European Jewry carried out during the Third Reich and as a result of wartime and postwar emigration. It should be noted, of course, that since 1989 there has been an increasing level of immigration of Jews to Germany, primarily from the former Soviet Union.

55. One might look as well to the representation of the Jew in other spheres of postwar German culture. From the first restaging of Lessing's *Nathan the*

Wise in the rubble-strewn landscape of a capitulated Berlin at the Deutsches Theater on September 7, 1945 to Alexander Kluge's first film *Yesterday's Girl* in 1966 to the extremely controversial staging of Fassbinder's play *Garbage, Death, and the City* in Frankfurt in 1985, the Jew has been figured, theatrically and cinematically, within the predictable gamut of philo- and anti-Semitic stereotypes, from the unquestionably "good" Jew, Lessing's wise Nathan, to the "wandering," homeless Jew, Kluge's Anita G., to the "bad" Jew, Fassbinder's avaricious real-estate speculator. *New German Critique* 38 (Spring/Summer 1986), entitled "Special Issue on the German-Jewish Controversy," devoted itself to the circumstances of and responses to Fassbinder's play, one based on the contemporaneous *Häuserkampf*, the housing controversy inspired by the plan of a group of predominantly Jewish real-estate speculators to transform the West End of Frankfurt from a run-down residential area into a business district. See, for example, Andrei S. Markovitz, Seyla Benhabib, and Moishe Postone, "Rainer Werner Fassbinder's *Garbage, the City and Death*: Renewed Antagonism in the Complex Relationship between Jews and Germans in the Federal Republic of Germany," pp. 3–27; Gertrud Koch, "Torments of the Flesh, Coldness of the Spirit: Jewish Figures in the Films of Rainer Werner Fassbinder," pp. 28–38; and Sigrid Meuschel, "The Search for 'Normality' in the Relationship between Germans and Jews," Benjamin Gregg, trans. pp. 39–56.

56. Theodor Adorno, "Commitment," in *Aesthetics & Politics: Ernst Bloch, Georg Lukacs, Bertolt Brecht, Walter Benjamin, Theodor Adorno*, Ronald Taylor, trans. (London: Verso, 1977), p. 188. Of course, as articulated in Adorno, *Aesthetic Theory*, art, specifically modern art at its best, offers a utopian moment, the possibility of social change, a state of nonidentity that, as opposed to the legacy of German idealism which Adorno sees as a philosophy of identity in which the subject always takes a relation of domination to the object, stresses the difference between the subject and the object, and with that, some kind of ethical mandate for a relation without domination. For a more extensive account of Adorno's philosophy of nonidentity, and with that, modern art, see J. M. Bernstein, *The Fate of Art: Aesthetic Alienation from Kant to Derrida and Adorno* (University Park: Pennsylvania State University Press, 1992).

2. OUR FATHERS, OURSELVES

1. Susan Neiman, *Slow Fire: Jewish Notes from Berlin* (New York: Schocken Books, 1992), p. 28.
2. Harold Bloom, *The Anxiety of Influence: A Theory of Poetry* (London, Oxford, and New York: Oxford University Press, 1973), p. 11.

3. As Helke Sanders's 1980 film *The Subjective Factor* highlights in its incisive critique of the male-dominated student movement, the Rudi Dutschke-led movement was one based on male role models, heroism, and male bonding. Despite its spawning of numerous feminist groups, women were relegated to a largely secondary position within the radical student movement, the *Sozialistischer Deutscher Studentenbund*, the SDS. The conclusions of Sanders's film are echoed in Gabriele von Arnim's memoir *Das große Schweigen: Von der Schwierigkeit, mit den Schatten der Vergangenheit zu leben* (Munich: Kindler Verlag GmbH, 1989), in which her recollections of her involvement in the student movement ultimately tell less her story than that of an exclusive dynamic of sons rebelling against their fathers. Writes Arnim, "Today it is apparent that the 'generation-conflict' which was ignited by the issue of fascism was a conflict between yesterday's perpetrators and their sons. We used and abused the 'Auschwitz-argument' as a particularly powerful weapon in the battle against our fathers." ["Heute nämlich zeigt sich, daß der Generationskonflikt, der sich am Faschismusthema entzündete, ein Konflikt zwischen den Tätern von gestern und ihren Söhnen war. . . . Das Auschwitz-Argument hatten wir als besonders schlagkräftige Waffe im Kampf gegen die Väter gebraucht und also mißbraucht."] (p. 84). See as well Helmut Schödel, "Gespensterrepublik Deutschland: Untote gehen um: Der vergebliche Kampf der Söhne gegen die Väter," *Die Zeit* 42(46) (November 13, 1987), p. 65.

4. For more detailed discussions of this literary phenomenon and cultural moment, see Hermann Glaser, *Kulturgeschichte der Bundesrepublik Deutschland* (Munich: Carl Hanser Verlag, 1986); Jost Hermand, *Der Kultur der Bundesrepublik 1965–1985* (Munich: Nymphenburger, 1988); Richard W. McCormick, *Politics of the Self: Feminism and the Postmodern in German Literature and Film* (Princeton: Princeton University Press, 1991); and the collection of conference papers, organized by Karl Ermert and Brigitte Striegnitz, *Deutscher Väter: Uber das Vaterbild in der deutschsprachigen Gegenswartliteratur* (Rehburg-Loccum: Evangelische Akademie, 1981). The article that has done most to underscore the perception of the dynamic as one of fathers and sons is Michael Schneider's "Fathers and Sons Retrospectively: The Damaged Relationship between Two Generations," Jamie Owen Daniel, trans., *New German Critique* No. 31 (Winter 1984), pp. 3–51. The article first appeared as "Väter und Söhne, posthum: Das beschädigte Verhältnis zweier Generationen" in Schneider's collection of essays *Den Kopf verkehrt aufgesetzt oder Die melancholische Linke: Aspekte des Kulturzerfalls in den siebziger Jahren* (Darmstadt and Neuwied: Hermann Luchterhand Verlag GmbH, 1981), pp. 8–64.

Some representative examples of this literary phenomenon would begin with Bernward Vesper's autobiographical work *Die Reise: Romanessay* (Jossa: Zweitausendeins, 1977) and include Christoph Meckel, *Suchbild: Über meinen Vater* (Dusseldorf: Claasen, 1980); Ruth Rehmann, *Der Mann auf der Kanzel* (Munich: Hanser, 1977); Peter Härtling, *Nachgetragene Liebe* (Darmstadt: Luchterhand, 1980); Sigrid Gauch, *Vaterspuren* (Königstein: Athenäum, 1979); Brigitte Schwaiger, *Lange Abwesenheit* (Wien: Zsolnay, 1980); Heinrich Wiesner, *Der Riese am Tisch* (Basel: Lenos, 1979); Paul Kersten, *Der alltägliche Tod meines Vaters* (Cologne: Kiepenheuer und Witsch, 1978); E.A. Rauter, *Brief an meine Erzieher* (Munich: Weismann, 1979); and Thomas Brasch, *Vor den Vätern sterben die Söhne* (Berlin: Rotbuch Verlag, 1977). The examples could be extended as well to Peter Schneider's fictionalized account of an encounter between Joseph Mengele and his son, *Vati: Erzählung* (Darmstadt: Luchterhand, 1987); and to the purposefully English-language work by Sabine Reichel, *What Did You Do in the War, Daddy?* (New York: Hill and Wang, 1989).

It bears mentioning that Art Spiegelman's two-volume "comix" project *Maus* represents another dimension of the filial preoccupation with the enduring legacy of the Third Reich. Spiegelman, the American son of a Jewish survivor of Auschwitz, tells the story of his father, in word and image. Significantly, this story is simultaneously framed by another story, that of his own coming to terms with his father, his father's past, and their relationship in the present. See Art Spiegelman, *Maus I: A Survivors's Tale: My Father Bleeds History* (New York: Pantheon, 1986), and *Maus II: A Survivor's Tale: And Here My Troubles Began* (New York: Pantheon, 1991).

5. Klaus Theweleit, *Male Fantasies: women, blood, bodies, history,* Vol. I, Stephen Conway, trans., in collaboration with Erica Carter and Chris Turner, with a foreword by Barbara Ehrenreich (Minneapolis: University of Minnesota Press, 1987); and Vol. II, *Male Bodies: psychoanalyzing the white terror,* Chris Turner, trans., in collaboration with Stephen Conway, with a foreword by Jessica Benjamin and Anson Rabinbach (Minneapolis: University of Minnesota Press, 1989). Alice Yaeger Kaplan brings forth the centrality of Theweleit's filial and oedipal thematics in her essay "Theweleit and Spiegelman: Of Mice and Men," *Remaking History,* Barbara Kruger and Phil Mariani, eds. (Seattle: Bay Press, 1989), pp. 150–72. It bears noting that her ensuing memoir, *French Lessons* (Chicago and London: University of Chicago Press, 1993), becomes at least in part her own work of *Vaterliteratur* as she comes to terms with the legacy and memory of her own father, a prosecuting attorney at the Nuremberg trials of German war criminals.

6. The only notable female practitioner of a neo-expressionistic style is Ina Barfuß. But not only is her work part of the second generation of these painters, and quite distinct thematically, but it never elicited the fervent response or attracted the audiences of the male practitioners. The most glaring exceptions to this masculinist culture would be in the realm of film (e.g., Helma Sanders-Brahms's *Deutschland, Bleiche Mutter*, 1980, and Margarethe von Trotta's *Die bleierne Zeit*, 1981); and, perhaps most interestingly, terrorism (e.g., Gudrun Ensslin and Ulrike Meinhof), in which daughters defined their identities in the present in and against both maternal and paternal legacies. The case of terrorism (to a degree figured and thematized in von Trotta's film) is perhaps most fascinating, given the unprecedented number and prominence of women within the German terrorist group the Baader-Meinhof. For a discussion of the role of women within the Baader-Meinhof and within terrorist organizations more broadly, see Eileen MacDonald, *Shoot the Women First* (New York: Random House, 1991). For a history of the Baader-Meinhof, see Stefan Aust, *The Baader-Meinhof Group: The Inside Story of a Phenomenon*, Anthea Bell, trans. (Topsfield, Mass.: The Bodley Head/Salem House, 1987). One might theorize, both in the case of New German Cinema and in German terrorist organizations, how each was defiantly defining itself less within than against masculinist or patriarchal models and culture, which in turn allowed for a more active and even central role for women than that offered within the recuperative visual practice of so-called neo-expressionism.

7. Benjamin Buchloh addresses this question briefly in terms of the issues of authoritarianism, repression, and bourgeois conceptions of the avant-garde as the domain of heroic male sublimation in his article "Figures of Authority, Ciphers of Regression: Notes on the Return of Representation in European Painting," first printed in *October* 16 (Spring 1981), pp. 39–68, and reprinted in *Art after Modernism: Rethinking Representation*, Brian Wallis, ed. (Boston: Godine, 1984), pp. 107–35. Writes Buchloh, "Inasmuch as this sexual and artistic role is itself reified, peinture – the fetishized mode of artistic production – can assume the function of an aesthetic equivalent and provide a corresponding cultural identification for the viewer. Not surprisingly, then, both German neo-expressionists and Italian Arte Cifra painters draw heavily upon the stock of painterly styles that predate the two major shifts in twentieth-century art history: fauvism, expressionism, and Pittura Metafisica before Duchamp and constructivism; surrealist automatism and abstract expressionism before Rauschenberg and Manzoni – the two essential instances in modern art when the production process of painting was radically questioned for its claim to organic unity, aura, and presence, and replaced by heterogeneity, mechanical procedures, and seriality" (p. 123).

8. That Markus Lüpertz's *Black, Red, and Gold Dithyramb* of 1972, shown at the exhibition A New Spirit in Painting at the Royal Academy of Arts, London, 1981, could have inspired the comment that it exhibited "all the subtlety of a visual gangbang" (Stuart Morgan, "Cold Turkey – A New Spirit in Painting at the Royal Academy of Arts, London," *artforum* 19(8) [April 1981], p. 47) demonstrates the way in which the massive, bombastic scale, aggressive palette and brush stroke, and public posturing of the artist reinscribe neo-expressionism within the myth of the virility and potency of the male artist.

9. Alexander Mitscherlich, *Auf dem Weg zur vaterlosen Gesellschaft: Ideen zu Sozialpsychologie* (Munich: R. Piper & Company Verlag, 1963).

10. One might look as well for a treatment of this phenomenon of the "absent" father and its effect on the second generation, particularly in terms of the forms of cultural production and patterns of social engagement it engendered, to Karl Markus Michel's "Intelligenz II: Muster ohne Wert: Westdeutschland 1965," *Kursbuch* 4 (February 1966), pp. 161–212. Of particular relevance is Michel's analysis of literary production in the postwar era (p. 167), in which he discusses the problem for writers of finding either figures for identification or models for aesthetic production when all that remained after 1945 were lost fathers and rubble.

Mitscherlich's claim in *Auf dem Weg zur vaterlosen Gesellschaft* is also somewhat belatedly supported in a conversation between the filmmakers Bernhard Sinkel and Alexander Kluge, occasioned by Sinkel's film *Väter und Söhne: Eine deutsche Tragödie*, which was aired as a TV film and published as a screenplay, along with the transcript of the conversation, in 1986. The film tells the story of Sinkel's family during the years 1911–48. Sinkel's great grandfather had been a founding partner of I.G. Farben, a business that was subsequently passed down to his grandfather and father. As Sinkel stated: "In this film I focused particularly on men because during my childhood, 1940–1945, the men weren't there. I grew up in a time when there were no men. . . . And then the men came back and laid claim to the women. Fundamentally, I had very ambivalent feelings towards men, towards fathers. And I believe that it is from this that my feeling comes that men are actually superfluous." ["Ich habe mich in diesem Film besonders mit den Männern beschäftigt, weil in meiner Kindheit, also 1940 bis 1945, die Männer nicht da waren. Ich bin aufgewachsen in einer Zeit, in der es keine Männer gab. . . . Und dann kamen die Männer zurück und haben die Frauen wieder beansprucht. Im Grunde genommen habe ich immer sehr ambivalente Gefühle gegenüber den Männern, den Vätern gehabt. Und ich glaube, daß von daher dieses Gefühl kommt, daß Männer eigentlich überflüssig sind."] In "Gespräch

über die Väter und die Söhne," in Bernhard Sinkel, *Väter und Söhne: Eine deutsche Tragödie* (Frankfurt am Main: Athenäum, 1986), p. 414.

11. The most disturbing and extreme manifestation of this societal and cultural preoccupation with the father or paternal signifier was an emergent cultural preoccupation with Hitler. By the late 1970s, that cultural preoccupation was so pronounced that it warranted an appellation, namely, the Hitler Wave. Traced in part to the release of Joachim Fest's hagiographic film biography of Hitler, *Hitler: A Career*, 1977, the Hitler Wave came to comprise a flood of similar products within West German media and popular culture, as well as a nostalgic boom in Nazi relics in West German flea markets. There, Nazi regalia, yellow stars, and original copies of *Mein Kampf* were avidly collected. And even more alarming, the nostalgia craze was accompanied by a marked growth in neo-Nazi organizations.

For an account of this cultural phenomenon, which was linked as well to the broadcasting of the American TV drama *Holocaust*, see Jean-Paul Bier, "The Holocaust and West Germany: Strategies of Oblivion, 1947–1979," Michael Allinder, trans. *New German Critique* 19 (Winter 1980), pp. 9–29; and Siegfried Zielenski, "History as Entertainment and Provocation: The TV Series 'Holocaust' in West Germany," Gloria Custance, trans. *New German Critique* 19 (Winter 1980) pp. 81–96. The issue is taken up most pointedly, particularly in regard to the growth of neo-Nazi organizations, in Jeffrey Herf, "The 'Holocaust' Reception in West Germany: Right, Center and Left," *New German Critique* 19 (Winter 1980), pp. 30–52.

12. See, for example, Heinrich Böll's essay "Bekenntnis zur Trümmerliteratur" ("Declaration of Rubble Literature"), so named for the state of ruin in which postwar Germany found itself and that the literature described. The essay appears in *Aufsätze, Kritiken, Reden* (Cologne and Berlin: Kieperhauer & Witsch, 1967).

13. Although taken up by Siegfried Gohr in his article "In the Absence of Heroes – the Early Work of Georg Baselitz," *artforum* 20(10) (June 1982), pp. 67–9, Gohr views the work "largely in terms of the need for an image reconciling the conflict between the realistic tradition of nineteenth-century art and modern painting's own epistemological need," ignoring the way in which these paintings may figure not just in formal terms an epistemological need within painting but, formally and thematically, a psychological, or ontological, need of postwar Germany society.

14. As cited in an essay by Joseph Thompson, "Blasphemy on Our Side: Fates of the Figure in Postwar German Painting," for the catalogue *Refigured Painting: The German Image 1960–1988*, Thomas Krens, Michael Govan, and Joseph Thompson, eds. (New York: Guggenheim and Prestel

Verlag, 1989), p. 28. An article by Klaus Kertess, "The Other Tradition," in *The Figurative Fifties: New York Figurative Expressionism*, organized by Paul Schwimmer and Judith Stein (Newport Beach, Calif.: Newport Harbor Art Museum, 1988), pp. 17–24, develops an argument about the continuity of style and form specifically denied to the German figurative painters by the Second World War. Kertess cites Baselitz as referring to these German figurative painters as a "fatherless generation," suggesting at once Mitscherlich's paradigm and the rupture in German painterly practice occasioned first by Nazism and then by abstraction. It should be noted as well that Lüpertz does a painting that, if only through its titling, thematizes the father/son issue, as his painting *Väter und Söhne (Fathers and Sons)* of 1983 demonstrates (see figure 46, p. 112, Krens catalogue). The abstract, at once mechanical and anthropomorphized forms – black figures surrounding red, both set against a deep blue background – are not immediately legible as figuring this dynamic, though the binarism of color and form would suggest, if not conflict, some form of opposition.

15. Lurking behind my theoretical formulations here is the work of Sigmund Freud, Jacques Lacan, and Kaja Silverman. It is in reading Silverman's *Male Subjectivity at the Margins* (New York: Routledge, 1992), particularly her chapter "Historical Trauma and Male Subjectivity," that I have found a theoretical apparatus and language with which to articulate the psychosocial problematic I see at work in the artistic endeavors of Kiefer and his contemporaries. Silverman analyzes how postwar Hollywood cinema dramatized the vulnerability of conventional masculinity – in this case, by demonstrating that the traumatically unassimilable nature of the war brought a large group of male subjects into such an intimate relationship with lack that they were unable to sustain a belief in the equation of penis and phallus – and thus the dominant fiction. But unlike her work, which in the chapter in question focuses on the imaging through filmic narratives of the "lived" experience and repercussions of trauma, my work involves an analysis of a generation at one remove from the trauma, in which the deferral so common to theories of trauma is made all the more manifest in that it is not *their* trauma. That they are a generation of sons who may lack the ability or choose not to recognize themselves in the paternal imago is one issue – they are less a generation that can no longer recognize themselves in their fathers as a generation that chooses not to, or fears the possibility of recognizing themselves in the paternal imago. Even more important is that their experience of trauma is deferred, *"nachträglich,"* in a very literal sense. It has not only been repressed but it was never theirs to begin with. At the same time, if we accept that this trauma was not worked through, it comes to function as a primary trauma nonetheless.

16. This posture is epitomized in the macho posturing of Baselitz, Lüpertz, and

Schnabel in a photograph from *Die Zeit* in 1987. The photograph accompanies Joachim Riedl and Karlheinz Schmid's article "KUN$T: Die starken Männer auf dem Kunstmarkt," *Die Zeit* 14 (March 27, 1987), pp. 49–56.

17. Despite repeated attempts to procure a photographic reproduction of the painting from the Galerie Springer in Berlin, through whom the "rediscovered" painting was exhibited in the late 1980s, I was unable to obtain it.

18. It should be noted that "Heroic Symbols" was the title given the essay in one thematically organized issue of *The Art of the Third Reich* 7(2) (February 1943), an issue beginning and ending with images of Arno Breker sculptures and filled throughout by images, portraits, and texts extolling "heroism" past. Further, and this is a separate point, we could read this image as more than a simple reassertion of Nazism and perhaps as a comment on the legacy of fascism in postwar Germany. For if the pose conjures up Nazism, the drab green color of the coat is more suggestive of militarism in the postwar era. The color is that of military fatigues, of border police uniforms, and even of the police uniforms in many former West German states. As such, it may be linked to a series of paintings by Lüpertz, deploying a similar, if more abstracted, iconography and color symbolism, his so-called "German Motifs," 1970–4. See Dorothea Dietrich, "Allegories of Power: Markus Lüpertz's 'German Motifs,'" *Art Journal*" 48(2) (Summer 1989), pp. 164–70. The Kiefer painting carries an additional charge, it being, until recently, a generally unknown, unexhibited painting in Kiefer's oeuvre. See Bazon Brock, "Der Künstler und der imperiale Gestus," *Pan* 2 (1990), pp. 56–8.

19. For a treatment of Kiefer's studio process, see, for example, Dorothea Dietrich's "Anselm Kiefer's *Johannisnacht II: A* Textbook," *The Print Collector's Newsletter* 15(2) (May/June 1984), pp. 41–5.

20. Kiefer's seemingly playful, or even farcical, repetitions might be set against the oft-cited introduction of Marx's *The Eighteenth Brumaire of Louis Bonaparte,* in which he writes, "All great historical events are repeated twice, the first time as a tragedy, the second time as farce." For it is ultimately a certain oedipal anxiety of influence that could be seen to drive sons, haunted by the ghost fathers who haunt the family romance of heroic manhood, to repeat as farce the tragedies of their forefathers. Walter Benjamin muses on this in his *Understanding Brecht,* Anna Bostock, trans. (London: Verso, 1984), particularly in his discussion of Brecht's *A Man's a Man,* as does Terry Eagleton in his *Walter Benjamin, or, Towards a Revolutionary Criticism* (London: Verso and New Left Books, 1985).

21. For a discussion of the (im)possibilities of framing, an issue central to the politics of Kiefer's representations, see, as discussed in relation to postcolonial scholarship, Mieke Bal's "The Politics of Citation," *Diacritics* 21(1) (Spring 1991), pp. 25–45.

22. Benjamin Buchloh, in conversation on the occasion of the meeting of the Study Group on Twentieth-Century German Culture at the Center for European Studies, Harvard University, December 2, 1993. See as well Wulf Herzogenrath's "Bilder entstehen nicht nur aus 'nach-denken' sondern aus 'vor-leben,'" in the exhibition catalogue *Anselm Kiefer* (Berlin: Staatliche Museen, Preußischer Kulturbesitz, 1991), pp. 93–100.

23. See J. Laplanche and J.-B. Pontalis, *The Language of Psychoanalysis*, Donald Nicholson-Smith, trans. (New York: Norton, 1973).

24. Quoted in Axel Hecht and Werner Krüger, "Venedig 1980: Aktuelle Kunst Made in Germany," *Art: Das Kunstmagazin* (June 1980), p. 52, as cited and translated in Mark Rosenthal, *Anselm Kiefer* (Chicago and Philadelphia: Chicago Institute of Art and Philadelphia Museum of Art, 1987), p. 17.

25. According to Kiefer, in an interview with Mark Rosenthal in 1986 (see Rosenthal, *Anselm Kiefer*, p. 156, fn. 10), after taking the individual photographs in 1969, he named them *Occupations* (*Besetzungen*) and incorporated a number of them the 1969 book *Heroic Symbols* (*Heroische Sinnbilder*), as well as, if we look carefully at the contemporaneous project, *For Genet*. About two years later, he arranged the photographs in the sequence subsequently published as "Besetzungen 1969" in *Interfunktionen*, No. 12 (1975), pp. 133–44.

26. See Edmund White, *Genet: A Biography* (New York: Alfred A. Knopf, 1993).

27. As Alice Kaplan notes in "Theweleit and Spiegelman," the preface to Theweleit's *Male Fantasies* reveals Theweleit's indebtedness to his wife, an analyst, whose clinical experiences with schizophrenics allows him to claim their psychic state, in all of its freedom from conceptual authority, as fascism's polar opposite (pp. 160–1).

28. Again, I would ally my reading with the theoretical work of Kaja Silverman, in her theorizing of the historical as the traumatic kernel. She sets her ideas in juxtaposition with those of Slavoj Žižek, as articulated in *The Sublime Object of Ideology* (London: Verso, 1989), who conceives of Lacan's *das Ding* as the traumatic kernel in the midst of the symbolic order, as an "undigestible nut at the heart of the symbolic," one that is, to Žižek, radically nonhistorical. As Silverman argues, in opposition to Žižek's theorization of Lacan's *das Ding*, "it has emerged here precisely as a 'historical' agency, not only because the catastrophes through which it expresses itself are often experienced in our directest encounters with history, but because it works to expose the constructedness and impermanence of what a given socius has long assumed to be 'actuality.'" See Silverman, *Male Subjectivity at the Margins*, pp. 400–1, fn. 34.

29. The palette appears not only in *Nero Paints* but in several other paintings

from 1974, *Painting = Burning, Heaven-Earth*, and *Painting of the Scorched Earth*. As in *Nero Paints*, the palette is inscribed in a gestural and loosely rendered outline, hovering above a densely worked, precipitously pitched landscape.

30. Beginning in 1975, Kiefer literalized this visual evocation of burning, actually employing fire as a part of his creative process. In his *Cauterization of the Rural District of Buchen*, 1975, for example, Kiefer carbonized a number of paintings, cut them up, and bound them together as a book project.

31. It could also be argued that Kiefer's palette/Icarus paintings recapitulate Lacan's reinterpretation of Freud's narrative of the dream of the burning child, who whispers the words, "Father, don't you see I'm burning?" As Cathy Caruth argues in her excellent book *Unclaimed Experience: Trauma, Narrative, and History* (Baltimore and London: Johns Hopkins University Press, 1996), although the child is *heard* in the dream, the dreamed child is asking to be *seen*, to be *witnessed*, if not saved, through an appeal to the *visual*. See, in particular, her chapter "Traumatic Awakenings (Freud, Lacan, and the Ethics of Memory)," pp. 91–112. As Caruth notes, Lacan writes in the seminar "The Unconscious and Repetition": "What is the point, then, of sustaining the theory according to which the dream is the image of a desire with an example in which, in a sort of flamboyant reflection, it is precisely a reality which, incompletely transferred, seems here to be shaking the dreamer from his sleep? Why, if not to suggest a mystery that is simply the world of the beyond, and some secret or other shared by the father and the son who says to him, Father, don't you see I'm burning? What is he burning with, if not with that which we see emerging at other points designated by the Freudian topology, namely the sins of the father, borne by the ghost in the myth of Hamlet, which Freud couples with the myth of Oedipus? . . . [T]his too ideal father is constantly being doubted" (p. 145, fn. 15).

32. I might point as well, by looking back to the transitional period of *Nero Paints*, to Kiefer's 1973 painting *Nothung*, in which the spectator is brought into the space not of the historically and nationally inscribed landscape but of the attic, the space of (repressed) memory. I have discussed these attic spaces in more detail in Chapter 1, with reference to Grasskamp's chapter "Anselm Kiefer: Der Dachboden" in his *Der vergeßliche Engel*. *Nothung* is particularly significant, within a framework of oedipal thematics, for its inclusion of a bloodied sword, Siegfried's sword, whose identity and legacy is marked by the inscription "Ein Schwert verhieß mir der Vater," "my father promised me a sword." With its Wagnerian identification, the bloodied sword references not only a cul-

tural past but its tainted legacy and its repression, located in the historically amnesiac space of the postwar present, as signified by the otherwise entirely emptied space of the attic, the typical repository for (familial) memory.

33. Another important work during this period is a relatively small painted work, *The Painter's Studio*, of 1980. Constructing his painting upon a 1971 black and white photograph of a stair leading to a door, Kiefer used oil, acrylic, and emulsion to transform that architectural photographic subject into another image of impending self-destruction. The stair, whose wood grain is heightened with thick, dark lines, bears the inscription "des Malers Atelier," "the painter's studio." That identification of the photographically represented studio is further underscored by the symbolic inscription of the palette form upon the door. Surrounding the stairs, the rail, and even reaching toward the very threshold of the door are billowing flames of orange and red paint. I discuss this image in the notes because it does not invoke Nazi architecture but rather a vernacular, if not domestic, architecture.

34. See Nicolas Abraham and Maria Torok, "A Poetics of Psychoanalysis: 'The Lost Object – Me,'" *SubStance* No. 43, 13(2) (1984), pp. 3–18.

35. When I suggested to Hans Dickel, a professor of art history in Berlin and Kiefer's former secretary, in a conversation in March 1993 in Berlin, that the figure in the watercolor was a far more direct visualization of Celan's "Fugue of Death" than the later painted series *Margarethe* and *Sulamith*, Dickel responded with a rather surprising comment. He was dismissive of the identification of the figure as Sulamith. In fact, he thought that it could not be Sulamith because he had always read the watercolor as a self-portrait of Kiefer.

 With this identification of the beheaded figure as Kiefer, the watercolor conjures up images as well of Heiner Müller's *Hamletmaschine*, in which the protagonist states, "I felt MY blood come out of MY veins/And turn MY body into the landscape/of My death." As cited and translated in Johannes Birringer, "Medea – Landscapes Beyond History," *New German Critique* 50 (Spring/Summer 1990), pp. 85–112 (quote, p. 86). For in Müller's language, we not only have the historically burdened and incapacitated postwar German subject speaking as victim but as victim who bleeds upon the landscape. In both Kiefer and Müller, there is a linguistic and pictorial topography constructed in which the body and self are seen to dissolve into the landscape, a landscape populated by sons haunted, like Hamlet, by the sins of the father.

36. Eric Santner, *Stranded Objects: Mourning, Memory and Film in Postwar Germany* (Ithaca and London: Cornell University Press, 1990), pp. 101–2.

37. The Mitscherlichs, *Inability to Mourn*.

38. As the Mitscherlichs wrote, "To millions of Germans the loss of the 'Führer' (for all the oblivion that covered his downfall and the rapidity with which he was denounced) was not the loss of someone ordinary; identifications that had filled a central function in the lives of his followers were attached to his person. The loss of an object so highly cathected with libidinal energy – one about whom nobody had any doubts, nor dared to have any, even when the country was reduced to rubble – was indeed reason for melancholia. Through the catastrophe not only was the German ego ideal robbed of the support of reality, but, in addition, the Führer himself was exposed by the victors as a criminal of truly monstrous proportions. With this sudden reversal of his qualities the ego of every single German individual suffered a central devaluation and impoverishment. This creates the prerequisites for a melancholic reaction" (*Inability to Mourn*, p. 26).

39. I should mention that I am not entirely alone in theorizing Kiefer's work as the inscription of a melancholic subjectivity, although I would claim my theorization differs significantly. Donald Kuspit, in an essay entitled "Mourning and Melancholia in German Neo-Expressionism: The Representation of German Subjectivity," in his collection *Signs of Psyche in Modern and Postmodern Art* (Cambridge and New York: Cambridge University Press, 1993), pp. 212–27, makes a case for Kiefer's and Baselitz's work as expressions of ineffectual mourning and thus of melancholia. On Kuspit's ultimately transhistorical account, Germany is a country that from its origins as a nation was especially attuned to melancholy. As Kuspit claims, in resisting conquest by Mediterranean Rome, Germany experienced a Pyrrhic victory of sorts, gaining independence but losing the "civilization" it would have gained had it become integrated into Rome. If this "loss" suggests for Kuspit the reasons for a perpetual state of melancholia, it also explains what Kuspit sees as a specifically German, narcissistic pathology. All of this, coupled with the legacy of history and guilt after the war, produces then yet another instance of German melancholy, evidenced in an art riddled with images of death and destruction, and reflective of a culture haunted by its barbarism.

It should be noted that although Kuspit now sees Kiefer's work as evidence of a cyclical German self-doubt, self-hatred, and melancholia, he earlier viewed Kiefer's works in quite different terms. He saw them as redemptive, heroic efforts to "master" the German past, an interpretation that, as Andreas Huyssen commented in his "Anselm Kiefer: The Terror of History, the Temptation of Myth," p. 26, "reads like the Bitburg of art criticism, if not worse." Wrote Kuspit, "Kiefer's use of paint is like the use of fire to cremate the bodies of the dead, however dubious, heroes, in the expectation of their phoenix-like resurrection in another form. The new

German painters perform an extraordinary service for the German people. They lay to rest the ghosts – profound as only the monstrous can be – of German style, culture, and history, so that the people can be authentically new. . . . They can be freed of a past identity by artistically reliving it." Donald Kuspit, "Flak from the 'Radicals': The American Case Against German Painting" (1983), in Brian Walls, ed., *Art after Modernism: Rethinking Representation*, (Boston: Godine, 1983), p. 141.

3. THE SONS OF LILITH

1. Of course, the paradoxical nature of melancholia, its being at once a subjective disposition that threatens an individual with incapacitating sadness and at the same time a contemplative disposition that allows for a sophisticated insight and creativity, is embedded in its very conception. See, for example, Walter Benjamin, "Trauerspiel and Tragedy," *The Origins of German Tragic Drama*, John Osborne, trans. (London: Verso, 1977). This paradox, or what could be termed a "melancholy dialectics," has been addressed in the writing of Walter Benjamin by Max Pensky in his book *Melancholy Dialectics: Walter Benjamin and the Play of Mourning* (Amherst: University of Massachusetts Press, 1993).

2. In 1988, seventeen of Kiefer's paintings and nine of his books were included in the group exhibition Saturn in Europe. Interestingly, the works included did not explicitly reference Saturn or melancholy but were selected instead on the basis of their perceived "saturnine," or "melancholic," qualities. Included, for example, were the works *Martin Heidegger*, *Isis and Osiris*, and *Elizabeth von Österreich*. The exhibition, organized by the museums of the city of Strasbourg, included, in addition to works by Kiefer, works by Joseph Beuys, Christian Boltanski, Marcel Broodthaers, Gerard Collin-Thiebaut, Jan Hamilton Finlay, Thomas Huber, Jannis Kounellis, Gerhard Merz, Claudio Parmiggiani, Giuseppe Penone, and Sarkis. See the exhibition catalogue, entitled *Saturn en Europe*, Roland Recht, ed. (Strasbourg: 1988).

3. Raymond Klibansky, Erwin Panofsky, and Fritz Saxl, *Saturn and Melancholy: Studies in the History of Natural Philosophy, Religion, Art* (1964) (Nendeln/Lichtenstein: Kraus Reprint, 1979), p. 317. In considering Kiefer's return to Dürer's engraving, it would be interesting to consider the argument advanced by Keith Moxey in regard to Panofsky's "overdetermined" reading of Dürer's image, a reading of Dürer that has had an enduring legacy within the field of art history. See Keith Moxey, "Panofsky's *Melencolia*," in *The Practice of Theory: Poststructuralism, Cultural Politics, and Art History* (Ithaca and London: Cornell University Press, 1994), pp. 65–78. For according to Moxey, the theorist must make mani-

fest in Panofsky's reading of Dürer (and Panofsky's celebration of Dürer's graphic art as one of Germany's great artistic moments), Panofsky's own position as a German Jew at a precarious moment in history. Moxey draws upon the work of George Mosse, who argues that the Enlightenment ideal of reason gave Jews an ideal with which to identify and become assimilated. See George Mosse, *German Jews Beyond Judaism* (Bloomington: University of Indiana Press, 1975). Following Mosse, Moxey suggests that this ideal was then threatened with destruction by the irrational forces of Nazism, which corrupted the Enlightenment ideal and posed a grave threat to Jews, who regardless of their level of assimilation and their upholding of German cultural ideals, would be the victims. To Moxey, it is the necessary task of the interpreter to make manifest the paradox of Panofsky's affirmation of German cultural greatness, a culture with which he, as assimilated Jew, had so strongly identified, at precisely the moment when his status as Jew excluded him from this culture.

The image becomes, on Moxey's account, an embodiment not just of the Renaissance idea of melancholia as an intellectually and culturally productive state but as an embodiment of a state of blocked mourning. For it is an image that produces a precarious vision of genius, one that oscillates between a medieval and humanist conception of melancholia, between reason and unreason, between possibility and impossibility. It is an image that embodies precisely this duality within German cultural and intellectual history, the duality of the forces of rationality and irrationality. And Panofsky's reading, then, is one that expresses his own inability to mourn the destruction of his ideal of German culture with which he, as an assimilated German Jew, had identified so strongly.

4. It is interesting to note that the saturnine figure is personified in Dürer's engraving as a winged female figure. That Dürer's figure is not embodied as male, but as female, suggests less the personification of Saturn than the embodied presence of Lilith. It might be asked, then, in light not only of Panofsky's and Moxey's reading but of Benjamin's reading of the insistent dualism of the figure of melancholia, how much the medieval and Renaissance conceptions of melancholia are dually inscribed in this winged figure, one who may embody both the medieval Lilith and the Renaissance Saturn. Might not the kabbalistic figure of Lilith be a repressed subtext in the humanistic conception of melancholia?

5. One might look to Simon Schama's chapter *"Der Holzweg:* The Track Through the Woods,"* particularly section iv, *"Waldsterben,"* the term coined within German environmental politics to refer to the deaths of forests from sulfur dioxide emissions, for an evocative treatment of Kiefer's forest scenes and their foundational myths and histories. See his *Landscape and Memory* (New York: Alfred A. Knopf, 1995), pp. 120–34.

6. As stated in Rosenthal's catalogue essay, citing an interview with the artist, December 1986, p. 60, fn. 50.

7. Although more typically Kiefer's subsequent projects are created with techniques other than burning, the end result is a painting, or more typically, a book, that is subsumed by or consumed in paint, matter, or sand.

8. As recorded in Tisdall, *Joseph Beuys*, p. 10.

9. As I discussed in the Introduction, this and other aspects of Beuys's mythic artistic autobiography have been discussed and discounted by Benjamin Buchloh in his article "Beuys: Twilight of an Idol" and in the round-table discussion involving Buchloh, Rosalind Krauss, and Annette Michelson, both of 1980.

10. I am made to think once more of the work of Slavoj Žižek, this time of his book *Enjoy Your Symptom: Jacques Lacan in Hollywood and Out* (New York and London: Routledge, 1992). If the title alone suggests a cause for comparison, particular passages in the text suggest a relationship between trauma and history, a relationship articulated far more clearly than in his *Sublime Object of Ideology*, which I cited in Chapter 2, in which trauma remains in the realm of Lacan's *das Ding*. I would point to those passages in section 2.1, pp. 31–46, "Why Is Suicide the Only Successful Act?" particularly his section on Roberto Rossellini's *Germany Year Zero*, shot in the rubble of postwar Berlin, as a moment of historical concretization of the Lacanian unsymbolizable Real (pp. 31–7).

11. As Beuys states, discussing the therapeutic and shamanistic role of art and the artist, "The whole thing is a therapeutic process. For me it was a time when I realized the part the artist can play in indicating the traumas of a time and initiating a healing process." As quoted in Tisdall, *Joseph Beuys*, p. 21. Interestingly, Beuys subsequently voiced his disdain for a more purely psychoanalytic process, referring to Alexander Mitscherlich and his discipline as "bad shit" ("schlechter Mist"). This statement is referenced in Buchloh's "Twilight of an Idol," 1980. Buchloh identifies the psychoanalyst as Alexander "Mitscherion," but this must surely constitute either a typographical or an editorial error.

12. Walter Benjamin, "Allegory and Trauerspiel," *Origins*, pp. 183–4. Benjamin's interest in allegory and *Trauerspiel* ("tragic drama," or literally "mourning play") in the work of German baroque drama acts as a counterbalance or counterargument to his earlier reading of Romanticism in his Ph.D. thesis *Der Begriff der Kunstkritik in der Romantik*. *The Origins of German Tragic Drama* was written in response to the Romantic valorization of the symbol, against which Benjamin set the baroque aesthetic, the allegory, the ruin of the sign, or the sign as ruin, where meaning and materiality are irrevocably separate, where unity and meaning are ultimately

impossible. Allegories are, to quote Rosen, "never understood easily and naturally, but decoded: they require effort, which takes time, so sign and meaning are never simultaneous, even fused." See Rosen, "The Ruins of Walter Benjamin," in *On Walter Benjamin: Critical Essays and Recollections*, Gary Smith ed. (Cambridge, Mass.: MIT Press, 1991), p. 149.

13. Benjamin, *Origins*, p. 166.

14. A show of his work at the Paul Maenz gallery in Cologne from November 1989 through January 1990 entitled Der Engel der Geschichte (The Angel of History) underscores in its titling, which comes out of the titling of one of Kiefer's own works, the purposeful "presence" of Benjamin within Kiefer's works. The title itself invokes the oft-quoted Benjamin passage from his "Theses on the Philosophy of History": "A Klee painting named 'Angelus Novus' shows an angel looking as though he is about to move away from something he is fixedly contemplating. His eyes are staring, his mouth is open, his wings are spread. This is how one pictures the angel of history. His face is turned toward the past. Where we perceive a chain of events, he sees one single catastrophe which keeps piling wreckage upon wreckage and hurls it in front of his feet. The angel would like to stay, awaken the dead, and make whole what has been smashed. But a storm is blowing from Paradise; it has got caught in his wings with such violence that the angel can no longer close them. This storm irresistibly propels him into the future to which his back is turned, while the pile of debris before him grows skyward. This storm is what we call progress," as translated by Harry Zohn in *Illuminations* (New York: Schocken Books, 1969), pp. 257–8.

15. Benjamin, *Origins*, p. 81.

16. The same sort of archeological operations are thematized in contemporaneous literature, interestingly, most explicitly in the work of a female author. In Karin Struck's novel *Klassenliebe: Roman* (Frankfurt am Main: Suhrkamp, 1973), writing serves as a political act and an archeological operation. As Struck writes, writing is an attempt to delve into the rubble of history, "Schreiben als Archäologie. Archäologie des Möglichen." ("Writing as archeology. Archeology as possibility.") Later, she writes, "Alles ist so verschüttet. Verborgen. Die Partikel der vergangenen und gegenwärtigen Unterdrückungen zusammensammeln." ("Everything is so buried. Hidden. (The task of writing is) to gather together the particles of the past and present oppressions.") (pp. 166–7).

17. The exhibit, entitled Topography of Terror, has also been condensed into book form, *Topographie des Terrors: Gestapo, SS und Reichssicherheitshauptamt auf dem "Prinz-Albrecht-Gelände": Eine Dokumentation*, (Berlin: Verlag Willmuth Arenhövel, 1987). For a discussion of the site

and its activation of memory, see John Czaplicka, "History, Aesthetics, and Contemporary Commemorative Practice in Berlin," *New German Critique* 65 (Spring/Summer 1995), pp. 155–87.

18. See, for example, Ingrid Ruin's article, "Blinder Fenster zur Vergangenheit: Der Anselm-Kiefer-Raum im Lehnbachhaus München," *Süddeutsche Zeitung*, Nr. 207 (September 9–10, 1989), p. 16; or Bernard Marcadé, "This Never-Ending End . . ." *Flash Art*, 18(124) (October/November 1985), p. 39.

19. While the following is not to condone the ways in which Kiefer's work may obscure or mystify history, I would suggest the ways in which entombment and burial can be seen, not just as an act of repression but as an act of preservation. The operations of the melancholic are those of someone who cannot let the lost object go. But if that lost object is history, its entombment may mean it remains preserved. From the preserved cities of Pompeii and Herculaneum, entombed by volcanic ash, to Norman Bates's mother in the basement of the house in Alfred Hitchcock's *Psycho*, their "burial" ensures their unchanging survival, albeit in a deadened form.

20. As I will discuss in Chapter 4 when I deal with Kiefer's reception history, there have been moments in the history of the postwar Federal Republic when the presumptive occurrence of mourning has been heralded and celebrated, as, for example, was the case after the broadcasting of the NBC miniseries *Holocaust*. As *Der Spiegel* asked its readers in February 1979, "Was this finally the catharsis? Was this, thirty-four years after the end of the Nazi era, the end of the 'inability to mourn'?" The citation was translated in Jeffrey Herf's "The 'Holocaust' Reception in West Germany: Right, Center and Left," *New German Critique* 19 (Winter 1980), pp. 39–40. The "mourning" heralded in the German viewing of *Holocaust*, a moment of societal mourning that was ultimately shortlived, brings to mind the darkly satirical chapter "The Onion Cellar" in Günter Grass's *The Tin Drum* (1959). For in that cellar, it is a physiological response to the activity of cutting onions, rather than the psychological engagement with the sorrows of the world, that allows for human tears.

One might look as well to an essay by Adorno, written in 1959, that also takes issue with the operations of mastery, if not repression, at work in psychoanalytically infused conceptions of mourning. In his essay "What Does Coming to Terms with the Past Mean?" (1959), in *Bitburg in Moral and Political Perspective*, Hartman, ed., pp. 114–29, Adorno proposed an "Aufarbeitung" of the past, an active process of working through the past, one that involves an activation of memory, whose goal was as much political and social as it was psychological.

21. Yve-Alain Bois, "Painting: The Task of Mourning," in *Painting as Model*

(Cambridge, Mass.: MIT Press, 1992). It is perhaps worthy of note that in Bois's recent essay for the Mondrian retrospective, he claims that the death of painting, of modernism, was figured, and figured triumphantly in Mondrian's New York paintings, particularly *Broadway Boogie-Woogie*, which destroyed painting, destroyed the very premise of modernism, by destroying the mythic ground upon which that master narrative of modernism had been constructed, the integrity and essential importance of the two-dimensional canvas. For in figuring the meshlike grid that social art historians have consistently read as Mondrian's encounter with the vibrant urban space of New York City, Mondrian, on Bois's account, in fact, represented the fundamental instability of the woven, braided surface upon which the modernist project had been founded.

22. Julia Kristeva, *Black Sun: Depression and Melancholia* (1987), Leon S. Roudiez, trans. (New York and Oxford: Oxford University Press, 1989).

23. This is the fundamental framework with which Freud, "Mourning and Melancholia" (1917), the Mitscherlichs, *Inability to Mourn* (1967), and Abraham and Torok, "A Poetics of Psychoanalysis: 'The Lost Object – Me,'" (1984), work.

24. Kristeva, p. 12.

25. Kristeva, p. 13.

26. Within the Jewish mysticism of Kabbalah, which I have already discussed in Chapter 1, there are recurrent and varying descriptions of a counter-figure to Eve. She is Lilith, who in her various incarnations is most often conceived as a monstrous demoness. Made of the same earth as Adam, she refuses to submit to him sexually and flies off to become a vengeful spirit, an evil temptress, and a strangler of newborn children. Whereas Lilith's successor, Eve, named in the Hebrew Bible and made not of the earth but of Adam's rib, tempted Adam with the forbidden fruit from the tree of knowledge, the spirit Lilith will tempt Adam's male descendants not with knowledge but with sexual self-gratification. See Gershom Scholem, *Kabbalah* (New York: Quadrangle/New York Times Books, 1974); and Harold Bloom, *Kabbalah and Criticism* (New York: Continuum Publishing House, 1975).

27. Scholem, *Kabbalah*, p. 356. For a discussion of Saturn, melancholia, and the humanist tradition, see Klibansky et al., *Saturn and Melancholy*.

28. Again, as cited in Chapter 1, Scholem provides an account of Lurianic Kabbalah that situates its mystical account of catastrophe against the historical catastrophe of Jewish history – in this instance, the expulsion of the Jews from Spain. Again, see Handelman, *Fragments of Redemption*.

29. Günter Grass, *From the Diary of a Snail*, Ralph Manheim, trans. (New York: Harcourt Brace Jovanovich, 1976), p. 310.

30. For a treatment of the artist as melancholy genius, see, for example, Rudolf and Margot Wittkower, *Born under Saturn: The Character and Conduct of Artists: A Documented History from Antiquity to the French Revolution* (New York: Random House, 1963); Ernst Kris and Otto Kurz, *Legend, Myth, and Magic in the Image of the Artist: A Historical Experiment* (New Haven: Yale University Press, 1979); and Susan Sontag, *Under the Sign of Saturn* (New York: Farrar, Straus & Giroux, 1980).

At the same time, I must assert and acknowledge the ways in which Kiefer's work, in the insistently oedipal logic of its thematics, reinscribes that authorial construct of humanist melancholia in all of its transhistorical, masculinist assumptions. For an extensive critique of the masculinist assumptions inherent in the literary/humanist and psychoanalytic constructions of melancholia, up to and including Kristeva's *Black Sun*, see Juliana Schiesari, *The Gendering of Melancholia: Feminism, Psychoanalysis, and the Symbolics of Loss in Renaissance Literature* (Ithaca and London: Cornell University Press, 1992).

4. KIEFER: A PAINTER FROM GERMANY

1. See, for example, Wolfgang Iser, *The Act of Reading: A Theory of Aesthetic Response* (Baltimore: Johns Hopkins University Press, 1978); Hans Robert Jauss, *Toward an Aesthetic of Reception*, Paul de Man, introduction, Timothy Bahti, trans. (Minneapolis: University of Minnesota Press, 1982); and Robert Holub, *Reception Theory: A Critical Introduction* (London and New York: Methuen, 1984).

2. "Besorgnis und Genugtuung spalten das Auslandsecho," *Der Tagesspiegel*, Nr. 14, 377 (November 10, 1992), p. 2.

3. One of the major and most respected Berlin dailies, the *Tagesspiegel*, for example, has a daily column on its second page, "Aus anderen Blättern," the sole purpose of which is to represent a summation of national and international coverage of major news stories, with an emphasis on the international coverage. The title of a later article written in this vein, following the deaths of five Turkish residents of the West German town of Solingen in yet another neo-Nazi arson attack in a year marked by such violence, makes this preoccupation with image all the more clear. Its title, "Das Deutschland-Bild ist schwer beschädigt" ("The Image of Germany Is Badly Damaged"), underscores what is at stake for Germany. "Das Deutschland-Bild ist schwer beschädigt: Scharfe Reaktionen und heftige Vorwürfe in der türkischen Öffentlichkeit," *Der Tagesspiegel*, Nr. 14, 571 (June 1, 1993), p. 2.

4. An additional example of the perhaps excessive concern for the "image of

Germany" abroad can be seen in an attempt at damage control by the German government. Reacting to the American coverage of the escalation of neo-Nazi violence against asylum-seeking refugees in Germany, from Hoyersweda to Rostock and beyond, on the weekend of September 25, 1992, the German government invited a group of American Jewish journalists to Berlin so that, under the auspices and direction of government officials, they could learn about and examine first-hand the situation facing foreigners, asylum seekers, and Jews in Germany. The majority, but not the entirety, of the journalists worked for Jewish papers, but major dailies like *The Wall Street Journal* were included as well.

5. To the initiate, the distinctions between the right-wing, neo-Nazi and the left-wing, anarchist skinhead, albeit at times subtle, are purportedly nonetheless legible. For a "guide" to picking out neo-Nazis, see the rather tongue-in-cheek piece, "Has My Child Become a Neo-Nazi? A Checklist for Parents," *Granta* 42, Special Issue on the Germans, "Krauts!" (Winter 1992), reprinted from *Bild* (December 3, 1992), which ran the piece the day after Lars Christiansen, age nineteen, was arrested for the murder of a Turkish woman and two children in the arson attack in Mölln.

6. The proposed revision was an attempt to staunch the flow of asylum seekers into Germany, a political move seen by many on the left to be playing into the hands and demands of right-wing, neo-Nazi extremists. For it would seem that in the aftermath of attacks on refugees and foreigners, taken to the extreme of burning down their hostels and homes, the government responded neither by strengthening support networks for refugees and foreigners nor by cracking down on neo-Nazis. Rather, the government responded by deliberating on how to keep foreign immigrants out of Germany, precisely the desire of neo-Nazis. Significantly, in late May 1993, the Bundestag did indeed vote to amend Grundgesetz (Article) 16, restricting for the first time since the founding of the Federal Republic and its constitutional democracy the conditions on right to asylum in Germany. For a discussion of the issues at stake in the asylum debates, see Jürgen Habermas, "The Asylum Debate (Paris Lecture, January 14, 1993)," *The Past as Future*, Max Pensky, trans. and ed., Peter Hohendahl, introduction (Lincoln: University of Nebraska Press, 1994).

7. Jürgen Habermas, "A Kind of Settlement of Damages," Jeremy Leaman, trans. *New German Critique* 44 (Spring/Summer 1988), pp. 25–39. The article first appeared in *Die Zeit* (July 11, 1986).

8. Santner, *Stranded Objects*, p. 151.

9. The American celebration of Kiefer, verging on apotheosis, which took place in publications ranging from *Time* and *Newsweek* to the arts pages of *The New York Times*, is documented and analyzed in Peter Schjeldahl,

"Our Kiefer," *Art in America* 76(3) (March 1988), pp. 116–27; Peter von Berg, "Engel der Nazistischen Apokalypse. Zur Anselm-Kiefer-Rezeption in den USA," *Süddeutsche Zeitung*, Nr. 282 (December 7, 1988), p. 37; Werner Spies, "Gebrochener Zauber: Der Fall Kiefer, ein Maler-Problem und seine zwiespältige Wirkung," *Frankfurter Allgemeine Zeitung*, Nr. 24 (January 28, 1989); and Andreas Huyssen, "Kiefer in Berlin," *October* 62 (Fall 1992), pp. 85–7.

10. The first major one-person show of his work in Germany was organized by the Städtische Kunsthalle, Düsseldorf, in the spring of 1984. It contained fifty-seven paintings, over one hundred works on paper, and a number of books exhibited in vitrines. The exhibition then traveled to the ARC/Musée d'Art Moderne de la Ville de Paris and to the Israel Museum, Jerusalem.

11. Habermas himself coined the term *Linksfaschismus*, "fascism of the left," to describe what he perceived to be the ideological rigidity of the student movement.

12. See "Expressionism: Its Significance and Decline," in *Essays on Realism*, David Fernbach, trans., Rodney Livingstone, ed. (Cambridge, Mass.: MIT Press, 1981), pp. 76–113. See as well *Aesthetics & Politics*, particularly the essays by Bloch and Lukacs.

13. Hans Magnus Enzensberger's journal, *kursbuch*, typically debated the issue of aesthetics on a decidedly theoretical level. For example, he published an interview with Sartre, which first appeared in France in *Clarté* (March/April 1964), in which the question of realism, the role of literature and art in society, and their revolutionary capabilities and responsibilities are all addressed. See Yves Buin, "Interview mit Jean-Paul Sartre," *kursbuch*, 1 (June 1965), pp. 134–51. *Tendenzen: Zeitschrift für engagierte Kunst*, in contrast, typically approached the issue from a more pragmatic angle, publishing a number of articles on realism, both in its incarnation as a historic practice and as a viable and important avenue for contemporary practice. See, for example, the special issue of *Tendenzen*, "Tendenzen des Realismus Heute," *Tendenzen* 38 (April/May 1966), which contained the following articles: Richard Heipe's "Das Gespenst des Realismus" and "Situation 66: Moderne realistische Kunst aus Europa in Augsburg" and Alfred Heinziger's "Plädoyer für die Wirklichkeit: Realisten in der Bundesrepublik."

14. Beyond traveling exhibitions of pop art within the Federal Republic in the early 1960s, the collecting patterns of Peter Ludwig contributed to the influx of this new form of realism into Germany. For a more detailed discussion of the role of pop in Germany, see Rainer Crone, *Andy Warhol*, John William Gabriel, trans. (New York: Praeger Press, 1970).

15. Andreas Huyssen, "The Politics of Pop," *New German Critique* 4 (Winter 1975), p. 77.

16. The years 1965–77 witnessed no less than ten exhibits on *Neue Sachlichkeit*. See Jost Hermand, *Kultur in der Bundesrepublik*, p. 354. Another exhibition of great significance, particularly given Kiefer's (and neo-expressionism's) international exposure in 1980, was an English exhibition that made expressly manifest the aesthetic and political connections between "critical realism" of the 68-generation and the art of the 1920s. Entitled Berlin: A Critical View: Ugly Realism 20s–70s, the Institute of Contemporary Art (ICA) in London united the work of these two generations of realists under one roof. Within the framework of the exhibition, the work of Max Beckmann, Otto Dix, and George Grosz could be viewed as antecedents for that of Wolfgang Petrick, Klaus Vogelgesang, and Ernst Volland, the work of John Heartfield for Jürgen Holtfreter, and so forth.

17. This position is exemplified, albeit retrospectively, in the work of Benjamin Buchloh. See, for example, the round-table discussion "Joseph Beuys at the Guggenheim," *October* 12 (Spring 1980), pp. 3–21.

18. Benjamin H. D. Buchloh, "Figures of Authority, Ciphers of Regression: Notes on the Return of Representation in European Painting," *October* 16 (Spring 1981), pp. 39–68. Of course, it is interesting to remember that Buchloh was the editor of *Interfunktionen* when it ran Kiefer's *Occupations* project in 1975. That the journal suffered a boycott in the aftermath of this editorial decision suggests that Buchloh's later critical aversion to Kiefer's work might in part stem from this incident.

19. For a more extensive account of the "rappel à l'ordre," see Kenneth Silver, *Esprit de Corps: The Art of the Parisian Avant-Garde and the First World War, 1914–1929* (London: Thames and Hudson, 1989).

20. O. K. Werckmeister, "Der grösste deutsche Künstler und der Krieg am Golf," *Kunstforum International* 123 (1992), pp. 209–19.

21. For a history of the German Pavilion, see Annette Lagler, "Biennale Venedig: Der Deutsche Pavilion 1949–1988." *Jahresring*, Vol. 36 (Munich: Silke Schreiber Verlag, 1989), pp. 78–133.

22. I should just note that the controversial nature of Kiefer's work was augured in the boycott *Interfunktionen* faced after its publiction of the 1975 *Occupations* project.

23. Although Gallwitz had also selected Markus Lüpertz for the German Pavilion, Lüpertz declined, stating that he did not want his work to be exhibited next to that of other artists. See Petra Kipphoff, "Die Lust an der Angst – der deutsche Holzweg," *Die Zeit* Nr. 24 (June 6, 1980), p. 42.

24. Further, it was not as if other German artists were unrepresented in other

exhibition spaces at the Biennale. Jörg Immendorff, Luciano Castelli, Gerhard Richter, and Sigmar Polke were also included in the 1980 Biennale. Nevertheless, it is true that the German Pavilion was the centerpiece of the West German contribution to the Biennale, the space in which Germany was most purposefully "representing" itself to the international artistic community. As documented in the catalogue, *La Biennale di Venezia, Settore arti visive: catalogo generale 1980* (Venezia: La Biennale di Venezia, 1980), these German artists were exhibited within the categories "Aperto 80" and "L'arte regli anni settanta."

25. An exhibition checklist for the Biennale indicates that in addition to Baselitz's sculpture, entitled *Model for a Sculpture*, 1980, he exhibited three large oil paintings, *The Studio*, *The German School*, and *The Family*, all of 1980. Kiefer's contribution was more comprehensive and extensive, both in terms of span of years and quantity. It comprised eight large works on canvas and seventeen books. Generally, the paintings attracted the most critical attention, particularly such emphatically Germanic works as *Germany's Spiritual Heroes*, 1973; *Parsifal*, 1973; and four different versions of *Ways of Worldly Wisdom*, 1977–80.

26. I should note that Baselitz's sculpture bears a striking resemblance, albeit in a fundamentally different form, to Kiefer's *Heroic Symbols* paintings and his *Occupations* project, neither of which were exhibited at the Biennale.

27. Werner Spies, "Überdosis an Teutschem: Die Kunstbiennale von Venedig eröffnet," *Frankfurter Allgemeine Zeitung*, Nr. 126 (June 2, 1980), p. 19. ["sofort mit einem deutschen Gruß gleichgesetzt wurde."]

28. Spies ["Das schwarz-weiß-rote Kolorit mag Imperialismus zustande bringen."]

29. Spies ["eine Reihe von Besuchern (vorerst Nichtdeutsche)."]

30. The lone defenses of the German Pavilion offered in the German press were Klaus Wagenbach's "'Neue Wilde,' teutonisch, faschistisch?" *Freibeuter* 5 (1980), pp. 138–41, significant not only for its dissenting opinion but for the fact that Wagenbach was a part of the liberal left; and Rudi Fuchs's defense of Gallwitz in response to what Fuchs saw as an unwarranted critical lambasting, "Die Kritik riecht Blut und greift an," *Der Spiegel* 26 (June 23, 1980), pp. 157–8.

31. Gerd Kairat and Thomas Ayck, "Kultur Aktuell," ARD/NDR (June 5, 1980), as cited in Jens Scholz, "Anselm Kiefer: Studien zu Werk und Rezeption," Wissenschaftliche Hausarbeit zur Erlangung des akademischen Grades ein Magister Artium der Universität Hamburg, 1986. ["Anselm Kiefer: Er vertritt auf der Biennale den künstlerischen Standort der Bundesrepublik. Diese Auswahl ist ein großes Mißverständnis. Der Museumleiter Klaus Gallwitz glaubt vielleicht daran, einen 'Neuen Wilden' gefunden zu haben; so werden nämlich die expressiven Maler der Gegen-

wart genannt. Aber ein 'Neuer Wilder' ist Anselm Kiefer nicht. Er ist allen-
falls ein neuer Reaktionär."]

32. Peter Iden, "Die Lieben der Kommissare: Zur Eröffnung der diesjährigen
Kunst-Biennale von Venedig," *Frankfurter Rundschau*, Nr. 128 (June 4,
1980), p. 7. ["Art von Hiltergruß" and "Es kommt in den Nebenräumen
noch schlimmer: Anselm Kiefer nimmt da Gelegenheit, seine ideologisch
verquaste, thematisch überfrachtete Malerei zur Schau zu stellen: Vor-
gebliche Auseinandersetzungen mit deutschen Traditionen in riesigen Bild-
räumen, eine technisch jämmerliche, in Farbgebrauch und Komposition
hilflose pathetisch verblasene 'Malerei,' die sich in gefährliche Nähe zur
Verherrlichung deutscher Großmannssucht begibt."]

33. Petra Kipphoff, "Die Lust an der Angst – der deutsche Holzweg: Ausstel-
lung: Biennale '80 in Venedig," *Die Zeit*, Nr. 24 (June 6, 1980), p. 42.

34. Kipphoff [". . . werden Angst, Brutalität, Verletzung zitiert, nicht um sie
zu denunzieren, sondern um sie feiernd zu perpetuieren."]

35. Kipphoff ["ein Spiel mit dem Irrationalismus und der Brutalität."]

36. Kipphoff ["seine Vernichtungsspiele im Atelier."] Kiefer himself makes
quite explicit just how he views his artistic process, titling his entry to the
Biennale "Verbrennen, Verholzen, Versenken, Versanden" (given the mul-
tiple meanings of these words, I give when appropriate more than one
translation, "burning/scorching, hacking/felling, sinking, silting/sand-
ing"). We might think as well of such paintings, discussed in Chapters 2
and 3, as *Nero Paints*, or *Painting = Burning*, in which Kiefer thematizes
that act of burning and destruction, or the Buchen book project, a work
made entirely from burnt canvases.

37. Kipphoff ["die ganze Kiefersche Thematik und die hier applizierte The-
atralik für viele, denen deutsche Größenwahn fast die Existenz vernichtet
hat, einfach unerträglich sein muß."]

38. In addition to the articles from the *Frankfurter Allgemeine Zeitung*, the
Frankfurter Rundschau, and *Die Zeit* cited above, the German Pavilion,
and Kiefer's work in particular, were discussed in "Schwieriger Siegfried:
Zwei Maler vom 'Rande der Krisenplätze.' Georg Baselitz und Anselm
Kiefer, vertreten die Bundesrepublik bei der Biennale in Venedig," *Der
Spiegel* 22 (May 26, 1980), pp. 218–22; "Dunkles Pulsieren: Die Bien-
nale in Venedig definiert die Kunst der 80er Jahre: Wieder ein Aben-
teuer," *Der Spiegel* 23 (June 2, 1980), pp. 213–14; Wolf Schöb, "Vor-
sicht, die Deutschen kommen: Venedigs 39. Biennale: Rückblick auf die
siebziger, Vorschau auf die achtziger Jahre," *Rheinischer Merkur*, 23 (June
6, 1980), p. 17; Wolfgang Rainer, "Deutsches muß nicht typisch sein:
Unser Biennale-Beitrag im Wettstreit der Pavillions," *Stuttgarter Zeitung*
(June 7, 1980), p. 37.
 The fears of an unreflective engagement with and reassertion of Nazi

identity and ideology that characterized Kiefer's early reception were by no means singular in the field of German cultural criticism. Syberberg's 1978 film *Hitler – A Film from Germany*, a phantasmagoric narrative of the catastrophes of European history, spawned a critical reception at home that was remarkably similar to that surrounding Kiefer. On art and culture pages throughout Germany, from Hamburg and Frankfurt to Munich, Syberberg and his film were treated with exceptional harshness. Like Kiefer's early reception, the criticism was marked by derision, mockery, cynicism, and sharp polemic. And, as in the Biennale criticism, German film critics were extremely wary of Syberberg's presumed relation to the history of fascism, the Third Reich, and Hitler. Fundamentally, they saw Syberberg not only as reactionary but as politically naive, his film falling prey to mythologizing the very history that was its object. For a treatment of this reception history, see Klaus Eder, *Syberbergs Hitler-Film* (Munich: Carl Hanser Verlag, 1980).

39. Charles Mark Werner Haxthausen, "The Word, the Book and Anselm Kiefer," *Burlington Magazine*, 133(1065) (December 1991), p. 846.

40. As Charles Maier has written about the virtual recreation of postwar Germany, "Its state had to be recreated, its cities rebuilt, its values transformed, its society opened up along more meritocratic lines than before 1945," in Charles S. Maier, *The Unmasterable Past: History, Holocaust and German National Identity* (Cambridge, Mass., and London: Harvard University Press, 1988), p. 138.

41. This psychosocial dynamic is enacted and thematized quite vividly in the autobiographical film by Marianne S. W. Rosenbaum, *Peppermint Frieden*, 1982–3, in which the American G. I. (played by Peter Fonda and dubbed "Mr. Frieden," in part for the peppermint gum he readily dispenses to the German children in his district) comes to represent in the eyes of the children (i.e., the young German nation, returned to a metaphorical state of infancy in the new beginnings of the postwar era) the magically heroic paternal figure of the American.

42. See Slavoj Žižek's chapter "'Che Vuoi?'" in *The Sublime Object of Ideology* (New York: Verso, 1989), p. 133.

43. The articles and documents generated by the Ludwig controversy are gathered in Klaus Staeck, ed., *Nazi-Kunst ins Museum?* (Göttingen: Steidl Verlag, 1988). Ludwig's plea for Arno Breker and the exhibiting of Nazi art is also discussed in Walter Grasskamp's "Die unbewältigte Anti-Moderne: Zur Rezeption der nationalsozialistischen Kunst," in *Die unbewältigte Moderne: Kunst und Öffentlichkeit* (Munich: Verlag C.H. Beck, 1989), pp. 147–57.

44. Interview, *Der Spiegel*, 36 (September 1, 1986), pp. 13–14. ["Ich halte es

für eine Blickverengung, zwölf Jahre aus der deutschen Geschichte ausradieren zu wollen. Auch damals hat es großartige Musik gegeben. Natürlich gab es Literatur im Dritten Reich. Es ist eine absurde Vorstellung, am 30. Januar 1933 hätte die Bildkunst aufgehört. Aber unsere Museen tun heute so."]

45. "Aufruf vom 6. September 1986," Düsseldorf, as reprinted in Staeck, *Nazi-Kunst*, p. 19. ["Mit Einschüchterung, mit Terror und Verbrechen hat sich die Nazi Kunst in der Hitler-Zeit Eingang in die Museen verschafft. Die großen Künstler unseres Jahrhunderts wurden verfolgt, mit Berufsverbot belegt, ermordet und ins Exil getrieben, damit eine willfährige Staatskunst mit drittklassigen Werken die ideologischen Gebote der Diktatur verkünde. Nazi-Kunst von künstlerischer Qualität ist uns nicht bekannt, wie dies durch mehrere Ausstellungen in den letzten Jahren immer wieder deutlich wurde. Die deutschen Museen werden deshalb das fortsetzen, was sie in den letzten 40 Jahren in ihrem Wirken für die Kunst getan haben: sie werden Maßstäbe setzen. Kunst hat auch mit Ethik zu tun. Deshalb rufen wir erneut öffentlich auf: Nazi-Kunst gehört nicht in unsere Museen."]

46. As cited in Staeck, p. 17. First printed in *Kölner Stadtanzeiger* (September 19, 1986). ["Ich habe mich nicht dafür eingesetzt, daß Nazi-Kunst gezeigt wird, sondern daß Kunst aus den Jahren 1933 bis 1945, Kunst, die in Deutschland entstanden ist, auch solche, die damals ausgestellt wurde, nicht mit einem generellen Tabu belegt wird, nicht mit einem praktisch durchgeführten Ausstellungsverbot. Ich will keine Verherrlichung von Nazi-Kunst, sondern ich will Kunst aus der Zeit von 1933 bis 1945 nicht ausgeschlossen sehen von jeder sachlichen Diskussion."]

47. For a treatment of the historical and political issues involved in the planning and debates surrounding two museums of German history in Bonn and Berlin (the commission for the Berlin museum, which was to have been designed by Aldo Rossi at the time of Maier's book, has since been given to I.M. Pei); see Charles Maier, "A Usable Past? Museums, Memory, and Identity," in Maier, *The Unmasterable Past*, pp. 121–59.

48. An exhibition was organized in 1987 in West Berlin at the Neue Gesellschaft für Bildende Kunst in Kreuzberg, entitled Inszenierung der Macht. Ästhetische Faszination im Faschismus, (Production of Power. The Aesthetic Fascination of Fascism) that explored precisely this issue. Hal Foster's essay on neo-expressionism in his *Recodings: Art, Spectacle, Cultural Politics* (Seattle: Bay Press, 1985) explores the "grisly chic" of using fascist motifs. See as well the sources for Foster's argument: Susan Sontag's "Fascinating Fascism" (1974) in *Under the Sign of Saturn* (New York: Farrar, Straus & Giroux, 1980), pp. 73–105; and Saul Friedländer's

Reflections of Nazism: An Essay on Kitsch and Death, Thomas Weyr, trans. (New York: Harper & Row, 1982).

I have treated the significance of exploring the "phenomenon" of fascism in Chapter 2, "Our Fathers, Ourselves: Icarus, Kiefer, and the Burdens of History," with reference not only to the work of Susan Sontag and Saul Friedländer on the topic but in relation to the social phenomenon of a fascination with fascism, Hitler, and Nazi paraphernalia that swept Germany in the 1970s, following the opening of, among other things, Joachim Fest's cinematic biography of Hitler, and which became known as the Hitler Wave. I have addressed the aesthetic or voyeuristic lure of the image in Chapter 1, "Thou Shalt Not Make Graven Images: Adorno, Kiefer, and the Ethics of Representation."

49. Of course, we could also see in this American acceptance of Kiefer a certain naïvité or blindness in regard to the troubling aspects of Kiefer's work – its ambiguous framing of the aesthetic, historical, and ideological legacy of Nazism.

50. See Calvin Tomkins, "The Art World: An End to Chauvinism," *The New Yorker* (December 7, 1981), pp. 146–54. I should note that Hans Haacke offered another explanation for their American success, pointing to the power and will of Cologne gallery owner Michael Werner, who represented Kiefer and the other neo-expressionists during the 1970s and 1980s. (In the late 1980s, it should be noted, an acrimonious dispute between Werner and Kiefer resulted in the complete severing of ties.) Commented Haacke, "Der Werner ist aufgetreten wie ein Panzer, seine Wilden haben sich aufgeführt wie die Fürsten. Seit einigen Jahren glaubt jede amerikanische Galerie, daß sie einen deutschen Künstler haben muß. . . ." ("Werner acted like a tank, his 'Wilden' conducted themselves like princes. For several years every American gallery has believed it must have a German artist.") As quoted in Riedl and Schmid, p. 53.

51. Hanno Reuther, "Fresken fürs künftige Reich? Werkschau Anselm Kiefer in Düsseldorf," *Frankfurter Rundschau* Nr. 104 (May 4, 1984), p. 21. ["der Hofmaler der Bonner Wende" and "ein Virtuose kruder Mischungen, ein Kompostierer deutscher Ideologie, Mythen-Recycling sein Spezialität."]

52. Christian Herchenröder, "Ein Meister der Innerlichkeit und starker Kunstmarkt-Magnet: Kiefer – Zur Ausstellung in der Düsseldorf Kunsthalle," *Handelsblatt* Nr. 65 (March 30–31, 1984), p. B9. ["sicherlich keine profaschistische Attitüde, aber doch eine Faszination durch Phänomene, die wir längst überwunden glaubten."]

53. Petra Kipphoff, "Verbrannte Erde und gestürzter Trommler. Zwei Künstler des deutsche Dilemmas," *Die Zeit* 16 (April 13, 1984), pp. 43–4.

54. Kipphoff ["Daß er ein Nachgeborener ist, ist Kiefers Thema."]
55. Kipphoff ["der Prozeß ihrer Identitätssuche."]
56. Haxthausen, "The Word, the Book and Anselm Kiefer," p. 846.
57. Thomas Elsaesser in his essay "Primary Identification and the Historical Subject: Fassbinder and Germany" (1980), published in *Narrative, Apparatus, Ideology: A Film Theory Reader*, Philip Rosen, ed. (New York: Columbia University Press, 1986), pp. 548–9, draws a similar conclusion about New German Cinema. Writes Elsaesser: "One of the problems of the New German Cinema is that it is only slowly and against much resistance finding the audience inscribed in its texts – German intellectuals and the middle class. The major successes have been in the capitals of Western Europe and on American university campuses . . . the popularity which the films of Fassbinder, Herzog, Wenders have achieved abroad, and above all the critical attention given to them by magazines, at conferences, or in seminars, have, in a considerable way, strengthened their directors' chances of gaining more financial support in their own country from the government. This repeats the structure (on the level of production) which I tried to indicate is present in the texts themselves: the Germans are beginning to love their own cinema because it has been endorsed, confirmed, and benevolently looked at by someone else – for the German cinema to exist, it first had to be seen by non-Germans. It enacts, as a national cinema, now in explicitly economic and cultural terms, yet another form of self-estranged exhibitionism."
58. As Anton Kaes wrote, in the wake of its broadcasting in 1979 "a new historical consciousness emerged in the Federal Republic. The past suddenly seemed very present. German film makers felt challenged to come to terms with German history and its images." See Kaes, *From Hitler to Heimat*, p. 38. One might look as well to *New German Critique* 19 (Winter 1980), an issue devoted entirely to the reception and impact of the German broadcast of *Holocaust*.
59. Its reception in the United States had already raised issues about whether the melodramatic form of the fictional, made-for-TV miniseries, tracing the lives and sagas of two families, one Jewish, one German, at the expense of a broader, more representative account, was the appropriate format for such a subject. One of the most outspoken voices of critique was Elie Wiesel, whose article, "The Trivialization of the Holocaust: Half-Fact, Half-Fiction," ran on the op-ed page of *The New York Times* on April 16, 1978, and set the tone and the terms for the dissenting opinion on the miniseries, one that was often quoted in the debates about the broadcasting of the series in Germany. See, for example, Sabina Lietzmann, "Die Judenvernichtung als Seifenoper. 'Holocaust' –

eine Serie im amerikanischen Fernsehen," *Frankfurter Allgemeine Zeitung* (April 20, 1978), written in response to the American broadcasting of *Holocaust*.

This reception might be fruitfully compared to that surrounding Steven Spielberg's 1993 film *Schindler's List*, which opened in Germany in the spring of 1994. For although some have hailed it as the greatest nondocumentary, narrative film about the Holocaust ever made, others have condemned it as deeply problematic, troubling, and simply bad. For an example of the range of responses, see "Spielberg, the Holocaust & Memory: Why Is 'Schindler's List' Different from All Other Movies? A Debate," with Wanda Bershen, Richard Goldstein, J. Hoberman, Annette Insdorf, Ken Jacobs, Gertrud Koch, Art Spiegelman, and James Young, *The Village Voice* 39(13) (March 29, 1994), pp. 24–31.

60. A similar argument about the shift in the discursive field around the issue of the past is made by Andreas Huyssen in his article "The Inevitability of Nation: German Intellectuals after Unification," *October* 61 (Summer 1992), p. 66.

61. The earliest *Margarethe* and *Sulamith* paintings were first exhibited at the Museum Folkwang, Essen, in late 1981, from where the exhibition traveled to the Whitechapel Gallery, London. Interestingly, the critical reception of the German show was sparse, one of the few articles expressly devoted to the exhibition being Wolfgang Minaty's "Sulamith im Grab in den Lüften: Bilder zu Celans 'Todesfuge' – Anselm Kiefer im Essener Museum Folkwang," *Die Welt* Nr. 276 (November 27, 1981), p. 19. *Sulamith*, or that version of the painting which I invoke here and which I discussed in earlier chapters, was not completed until 1983.

62. Reuther, "Fresken fürs Künftige Reich?" p. 21. ["amerikanisch gemacht."]

63. Jürgen Hohmeyer, "Bleigewicht für die Ordnung der Engel," *Der Spiegel* 41(2) (January 5, 1987), p. 157. ["Die internationale Resonanz auf Kiefer steht in sensationellem Mißverhältnis zu den Vorbehalten daheim. In der Liste von 37 öffentlichen Sammlungen zwischen Eindhoven und Minneapolis, zwischen London und Sydney, die Kiefer-Werke besitzen, machen die deutschen nicht einmal ein Drittel aus."]

64. Richard Beuth, "Weg ohne Wiederkehr in Sibiriens Totenhäuser: Vehement gegen den Geschichtsverlust anmalen: Amerikanische Museen zeigen den Werk von Anselm Kiefer," *Die Welt*, Nr. 292 (December 17, 1987), p. 19. ["Daß man seine wichtigsten Werke eher in einem ausländischen als in einem deutschen Museum (Ausnahme: Staatsgalerie Stuttgart) findet, stimmt sehr bedenklich. Daß aber diese erste umfassende Kiefer-Reptrospektive ganz weit weg von Deutschland stattfinden muß, das spricht Bände."] One might also muse on the resonance

of this display abroad with Kiefer's *Occupations* project, the photographs for which *had* to be shot abroad.

65. Again, the American celebration of Kiefer's greatness, which took place in publications ranging from *Time* and *Newsweek* to the arts pages of *The New York Times*, is documented and analyzed in Peter Schjeldahl, "Our Kiefer," *Art in America*, 76(3) (March 1988), pp. 116–27; Peter von Berg, "Engel der Nazistischen Apokalypse. Zur Anselm-Kiefer-Rezeption in den USA," *Süddeutsche Zeitung*, Nr. 282 (December 7, 1988), p. 37; Werner Spies, "Gebrochener Zauber: Der Fall Kiefer, ein Maler-Problem und seine zweispältige Wirkung," *Frankfurter Allgemeine Zeitung*, Nr. 24 (January 28, 1989); and Andreas Huyssen, "Kiefer in Berlin," *October* 62 (Fall 1992), pp. 85–7.

66. Petra Kipphoff, "Das bleierne Land. Im Odenwald entstanden, in London ausgestellt und bewundert: 'Zweistromland,' die erste große Skulptur des Künstlers," *Die Zeit* Nr. 31 (July 28, 1989), p. 36. ["Daß [die Werke] Anselm Kiefer heute in Jerusalem so begehrt sind wie in New York oder LA und daß sie sich zur guten Hälfte im Besitz jüdische Sammler befinden, reduziert die Ambivalenz seiner Thematik durchaus nicht, sondern bestätigt die doppelbödige Faszination."]

67. See Andreas Huyssen, "Kiefer in Berlin," *October* 62 (Fall 1992), p. 86, in which he makes reference to, among other articles, Eduard Beaucamp's "Der Prophet und sein Bildtheater," *Frankfurter Allgemeine Zeitung* Nr. 74 (March 28, 1991).

68. Axel Hecht and Alfred Nemeczek, "Bei Anselm Kiefer im Atelier," *art: Das Kunstmagazin* No. 1 (1990), p. 47. ["95 Prozent aller amerikanischen Sammler, die Bilder von mir haben, sind Juden. Das ist sicherlich nur ein Aspekt von Amerika, aber ein sehr wichtiger."] I might just add that in studying the names of collectors lending works to various exhibitions, it is highly doubtful that the figure can possibly be accurate, although it is true that a number of the private collectors of Kiefer's work have been Jewish. This exaggeration might be linked to the earlier hysteria about his Germanness.

69. For a lengthier discussion of that political culture, see Stern, *The Whitewashing of the Yellow Badge*.

70. Hans-Jürgen Syberberg, *Vom Unglück und Glück der Kunst in Deutschland nach dem letzten Krieg*, p. 152. ["Das Herz Europas schlägt in Israel, konnte für das Europa der Nachkriegszeit gesagt werden."] Although Syberberg has often been set up as the cinematic counterpart to Kiefer, or vice versa, particularly in reference to his film *Hitler – A Film from Germany*, it is this overtly conservative and anti-Semitic tract that unquestionably differentiates the two. And how different are such statements or

critical insinuations from the assertion by Schönhuber, the head of the right-wing German political party, the Republikaner, who stated, over and over again, that "the Jews were 'a fifth occupying force,' after the Allies, in Germany"? As quoted in Amity Shlaes, *Germany: The Empire Within* (New York: Farrar, Straus & Giroux, 1991), p. 221.

INDEX